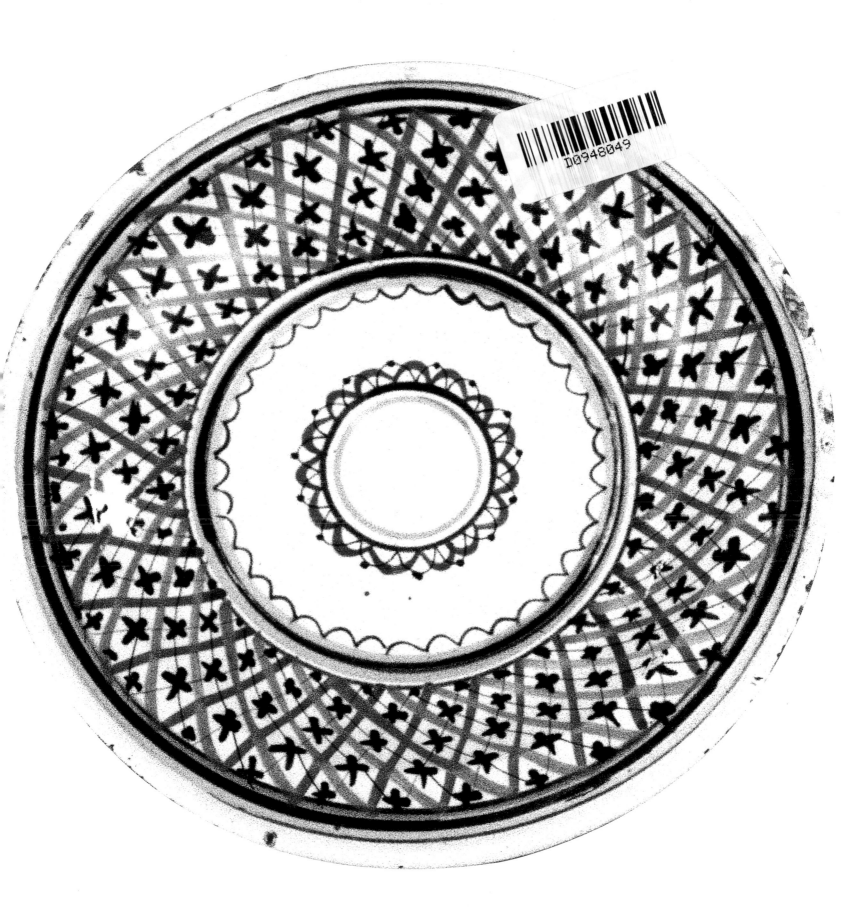

By Florence C. Lister
and Robert H. Lister

Photography by
Paul Smutko

Museum of
New Mexico Press
Santa Fe

Maiolica Olé

Spanish and Mexican
Decorative Traditions

Featuring the collection
of the Museum
of International Folk Art

Project editor: Mary Wachs
Design and production: David Skolkin
Maps: Deborah Reade
Composition: Set in Goudy and Goudy Sans
Printed in Hong Kong
10 9 8 7 6 5 4 3 2 1

Library of Congress Cataloging-in-Publication Data:
Lister, Florence Cline.
 Maiolica olé : Spanish and Mexican decorative traditions featuring the collection of the Museum of International Folk Art / by Florence C. Lister and Robert H. Lister ; photography by Paul Smutko.
 p. cm,
 Includes bibliographical references and index.
 ISBN 0-89013-388-3 (cloth) – ISBN 0-89013-389-1 (pbk.)
1. Majolica, Mexican—Catalogs. 2. Majolica, Spanish—Catalogs. 3. Pottery—New Mexico—Santa Fe—Catalogs. 4. Museum of International Folk Art (N.M.)—Catalogs. I. Lister, Robert Hill, 1915- II. Museum of International Folk Art (N.M.) III. Title

NK4320.M5 L49 2001
738.3'0946'07478956—dc21 2001042805

Credits
Purchased by the International Folk Art Foundation: figures 3–10, 12–13, 17–26, 28–33, 35–41, 43–49, 51–52, 54–60, 81, 112, 120, 125a, 125d, 126, 132-40, 142a–d, 143–145. Houghton Sawyer Collection: figures 34, 63–71, 73–80, 82–83, 85–101, 102a–c, 103–108, 109a–d, 110b, 111a–b, 113–14, 116, 118–19, 122a–b, 127–29, 130a–b, 131. Purchased by the Museum of International Folk Art: figures 2, 53, 117. Gift of the Heard Foundation: figures 11, 14, 15, 16, 72. Charles D. Caroll Bequest: figures 125b–c, 141. Gift of Mr. And Mrs. William J. Wilson: figure 27 (two plates). Gift of William Ilfeld: figure 42. Gift of Florence Dibell Bartlett: figures 50, 84, 110a, 115, 123–24. Gift of Mrs. Edgar L. Rossin: figures 121a–b.

Contents

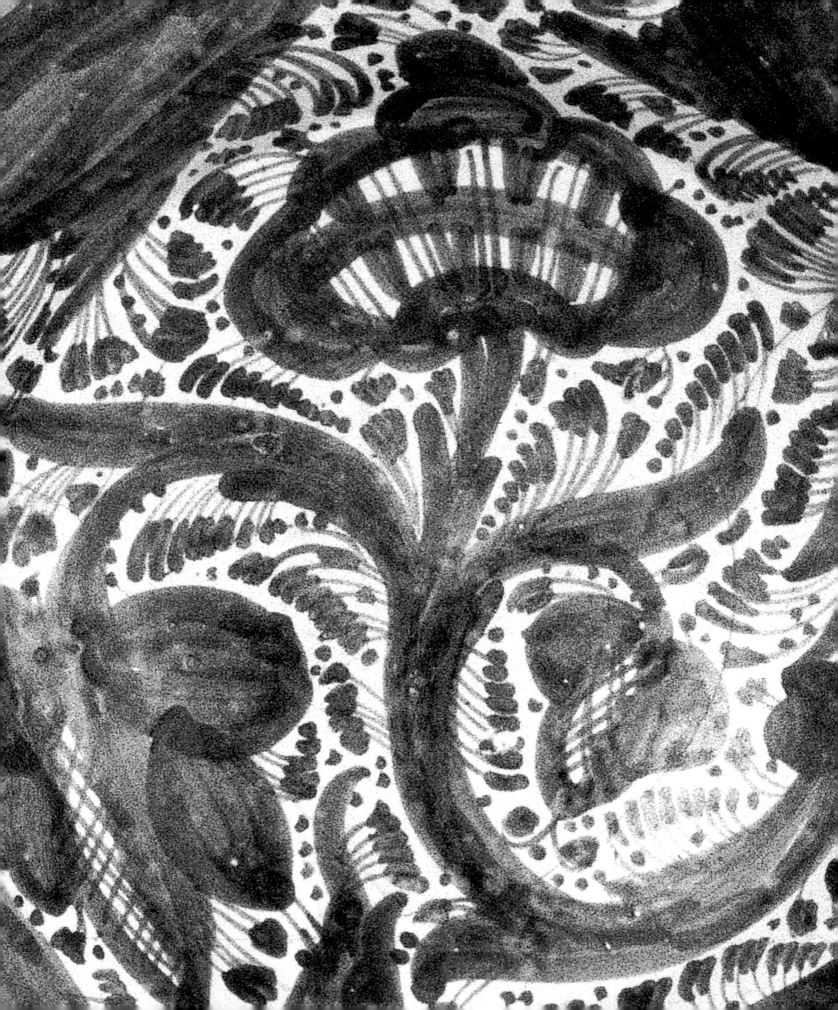

Foreword

IN THE LATE 1800s, a young California architect named Houghton Sawyer had the opportunity to visit Mexico several times. Although he was a connoisseur neither of ceramics nor of colonial art, he was struck during these visits by the blue-and-white pottery of colonial Mexico that was produced primarily in Puebla between the sixteenth and eighteenth centuries. This now-rare pottery had been an important commodity on both the domestic and international markets of Mexico and throughout Spain's New World colonies but its daily use greatly reduced the number of pieces that were passed to subsequent generations. Between 1891 and 1895, Houghton Sawyer built a collection of more than one hundred pieces that was unsurpassed in the United States. How this collection, still one of the finest in the country, came to the Museum of International Folk Art (MOIFA) in Santa Fe is as interesting as the objects themselves.

Knowing little about ceramics, Sawyer bought his first pieces of colonial Mexican maiolica based on "their original and striking design and good form and color." It wasn't until a decade later that the collections of the Metropolitan Museum of Art, the Philadelphia Art Museum, the Hispanic Society of America, and the Art Institute of Chicago were formed by other prescient collectors. Sawyer had the collection transported to California where they were displayed in both his home and office in Piedmont. The devastating 1906 earthquake destroyed close to half of the collection.

After this loss, Sawyer apparently either was unable or unwilling to try to recreate his collection but he did continue to study the remaining pieces and their history and origin. In 1918 he produced a catalogue, never published, of the collection, " . . . the result," he wrote, "of personal observation and study covering a period of over thirty-eight years." (The original manuscript is in the Museum's collection.) In it he made one of the earliest attempts to place a chronological framework on the production of blue-and-white maiolica. He shared his thoughts with other early collectors such as Edwin Atlee Barber and Emily Johnston De Forest.

The history of the collection from this point is obscure until 1967, when it was exhibited at the California Palace of the Legion of Honor, in San Francisco. The person selected to write the text for the exhibition was E. Boyd, one of the leading scholars of Spanish Colonial art in the country and the curator of the Spanish Colonial department at MOIFA. Sawyer's collection was later loaned, and subsequently gifted to MOIFA in 1969 by Sawyer's daughter, Ursula Sawyer, and her husband, John Holstius. That same year the collection was exhibited at MOIFA.

In 1968, Florence and Robert Lister, pioneering archaeologists of the southwestern U.S., were awarded a grant from the International Folk Art Foundation (IFAF) specifically for the study of maiolica in Spain, Portugal, and Morocco. While documenting contemporary ceramic methodology and researching historic collections, they also purchased fifty-four objects with funds from IFAF to supplement the museum's already fine collection.

The Listers received a second grant from IFAF in 1970 to study in Mexico's historic ceramic centers of Mexico City, Puebla, Guanajuato, and Dolores Hidalgo. The Board funded the project in part owing to its relevance to the recently acquired Houghton Sawyer collection. During their sojourn in Mexico, the Listers were able to create a collection of potsherds with a sampling of some of the earliest wares that were produced in Mexico in the colonial period. The sherds, which came from the Mexico City subway excavations, had been given to them by the Mexican government. This sherd collection was deposited at the MOIFA for the benefit of archaeologists and curators alike.

In 1975, with a third grant from IFAF, the Listers undertook the examination and documentation of MOIFA's Spanish and Mexican maiolica collection. At this time, the collection numbered some 150 pieces, including the Houghton Sawyer collection, the collection of the museum's founder, Florence Dibbell Bartlett, subsequent gifts, and the Lister's own purchases. It is from this study that the present work evolved.

In the late 1990s, the Museum of International Folk Art began to organize an exhibit on this collection of Spanish and Mexican maiolica. Working with local scholars as well as curators from other institutions in Spain and Mexico, time and again we were referred to the numerous works of Florence and Robert Lister. Not only have they published more than anyone else on this particular topic, but their work—even that published more than thirty years ago—still stands as some of the finest, most up-to-date and in some cases the only research on numerous aspects of these ceramics.

Florence Lister's career has been long and impressive, and through it all runs a single thread: ceramics. From Japan to Morocco she has pursued the elusive story in the pot—studied the clay, the temper, the firing methods, kick wheels, hand building, paints, and glazes. She and her husband Robert had the rare vision to take their studies beyond their cozy environment to look at global patterns, and Florence has taught world ceramics. Their explorations are documented in their numerous publications.

In the last forty years, MOIFA's Spanish and Mexican maiolica collection has continued to grow with both purchases and gifts. It now numbers more than 250 pieces, ranging from fifteenth-century works to the ceramics of today. The collecting emphasis in the last decade has been the work of contemporary potters in

Spain and Mexico who continue to work within the tradition, throwing their own pots, making their own pigments and glazes, and firing in the traditional kiln, the *horno árabe*. But today's additions would have little significance without the foresight of Houghton Sawyer, and without the scholarship of Florence and Robert Lister. This book is the result of the fruitful encounter between these inquisitive minds.

ROBIN FARWELL GAVIN
Curator of Spanish Colonial Collections
Museum of International Folk Art, Santa Fe

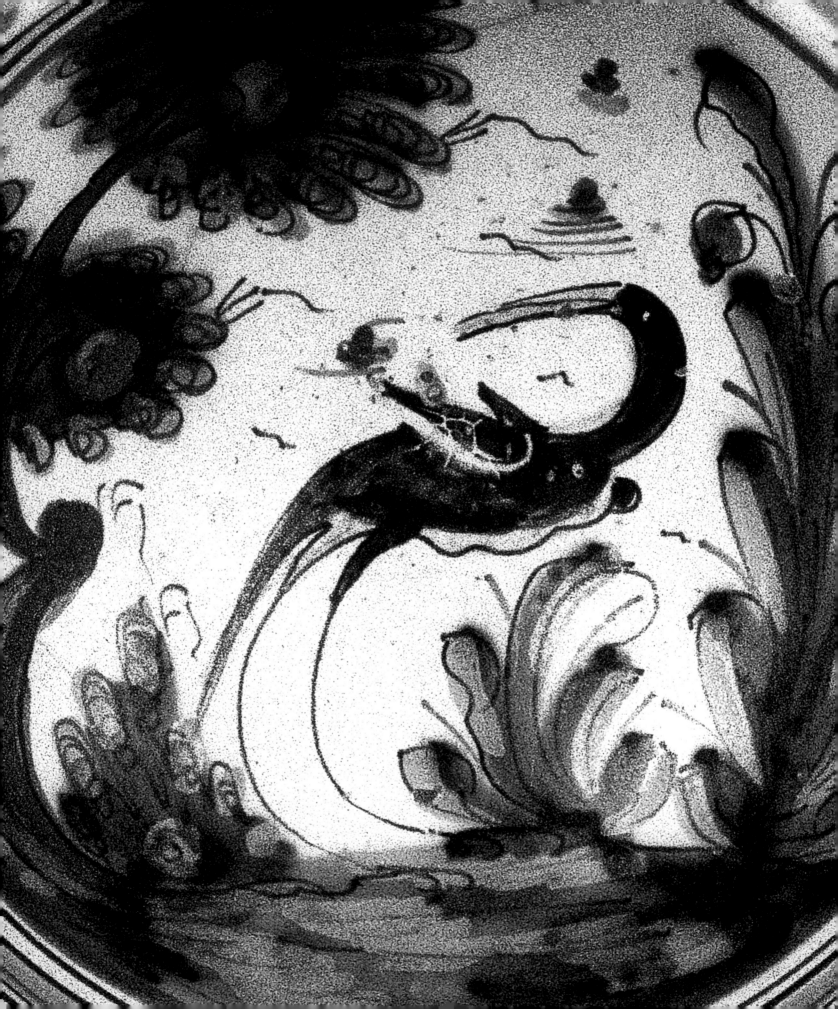

Preface

NO RELATIVELY SMALL COLLECTION such as that considered here (143 specimens) can possibly illustrate all the many evolutionary nuances known to have surfaced during the history of Spanish-tradition maiolica. Not only does that development cover almost a millennium in Spain, a country with the most convoluted artistic soil of any in Europe, but maiolica grew regionally both in Iberia and in the Spanish overseas colonies in the hands of artisans representing several distinct entities who, because of historical circumstances, were themselves influenced by diverse aesthetic forces. Furthermore, as with most collections, over a long period of time this one has grown piecemeal and randomly through the efforts of a number of persons. There has been fortuitous acquisition of outstanding specimens, lack of success in obtaining others needed to fill certain obvious stylistic gaps, and unavoidably a heavier concentration upon some types and areas than upon others.

Nonetheless, in addition to a straightforward physical description of individual specimens, sufficient regional, temporal, and decorative variations are present within the collection to permit their use to elucidate, in general terms, the growth of Spanish maiolica and its subsequent transfer to and florescence in the sector of colonial Nueva España to become modern Mexico. Thus all the vessels illustrated in the pages to follow are at the Museum of International Folk Art. It is thought that the collection, representing, as it does, the production through time of various potteries, can be best appreciated by *aficionado* (devotee) and artist in such historical context. Students of culture should find supportive substance for a theoretical view of the basic universality of certain aspects of man's endeavor in a survey of this collection and, beyond that, of one multifaceted craft. For the archaeologist the collection has added value in revealing in complete form what he usually sees only in fragmentary state. For him to visualize a comprehensive pattern from a few tiny, unrelated fragments is analogous to attempting selection of a color for walls of a room from a two-by-two-inch paint chip. He further needs to know how his fragments may fit into a mode continuum, as well as into one specific decorative expression. For example, most of the blue-on-white ceramics typifying seventeenth- and eighteenth-century Mexican work, and which make up the bulk of the maiolica finds along the northern

frontiers of colonial Nueva España, generally go under the generic name of Puebla Blue on White. It can be demonstrated through this collection that during the course of at least some one hundred fifty years a number of distinctive stylistic clusterings occurred within that broad category, although oyster-white grounds continued to be painted only in cobalt blues. If this evidence for decorative groupings presented here were to be extended through further research, it is anticipated that more discrete classification of sherd lots could lead to refinements in dating, temporal as well as historical perspectives being fundamental to archaeology.

However, all readers should be aware that presently many blank pages remain in the story of Spanish-tradition maiolica on both sides of the Atlantic Ocean because of lack of documentary or archaeological evidence, not to mention lack of insight on the part of researchers, including these authors. Until such groundwork has been accomplished, a major problem lies in the dating of specimens. The times of manufacture offered here must be taken only as suggestions based largely upon comparative stylistic analyses, ours and those made by others. Evolutionary tides in decorative arts do not easily confine themselves to rigidly defined references such as years, decades, or even centuries. In the need for ordering a mass of detail, such a chronological framework, spanning the four hundred fifty odd years between the middle of the fifteenth to the end of the nineteenth centuries, is imposed upon these data.

The strength of the Museum of International Folk Art maiolica collection lies with its large number of Mexican samples. The nucleus of this assortment was gathered in Mexico in 1893 by Houghton Sawyer, a San Franciscan who became intrigued by the unusual beauty of those ceramics and who fortunately recognized their value to historians of decorative art. So far as is known, he anticipated other well-known American collectors by a decade. Sawyer concentrated upon finding vessels of the earliest periods of Mexican production of which he was aware, namely the late seventeenth through the eighteenth centuries. Of course, what he found were special objects which had been safeguarded in Mexico through the turbulent times following their manufacture, which included one destructive national revolution, innumerable local uprisings during early Mexican independence from Spain, and an invasion by a foreign power which culminated in a major battle near Puebla, the principal pottery center. Unfortunately, much of the collection did not so happily survive the 1906 San Francisco earthquake and fire. Over half the specimens were stored in the part of the city leveled during that disaster. The vessels illustrated in this study were those Sawyer had in his private residence located in another section of town. The size and beauty of the remaining collection, as well as its probable unintentional focus upon ersatz Orientalism, should not obscure the fact that at the same time these pieces were in use in elite places primarily in central Mexico other styles and lower grades of companion wares, made by potters of lesser talents or expertise who were journeymen rather than master craftsmen, also were coming from kilns in Puebla and in Mexico City. These were ceramics meant for modest establishments in central Mexico and her outlying provinces. If seen, Sawyer did not consider them "collectable."

Using this core of early specimens as a starting point, the Museum of International Folk Art has acquired a sizable sample of later Mexican types to the point where Mexican vessels outnumber those from

Spain. This situation only reflects the proximity of Mexico to New Mexico and the greater local availability of such pottery.

The imbalance in terms of number of Spanish and Mexican samples in the total collection has caused the sections of this book dealing with Spain and Mexico to be viewed differently. So far as possible both are presented with regional groupings, provinces in the case of Spain and cities in the case of Mexico, which in turn are arranged temporally. It is felt that the scope of the Spanish assortment allows no detailed analysis beyond a simple historical reconstruction. The extraordinary quality and large number of Mexican examples of one particular period have prompted a detailed analysis of style as it emerged at Puebla.

European students of ceramics have not adopted a precisely defined system for naming stylistic modes comparable to that used by anthropologists in certain regions of the Americas. Hence no formal type names appear here in the sections dealing with Spanish maiolica. Such a taxonomy has been proposed for the fifteenth- and sixteenth-century Spanish wares found in the Caribbean basin, no examples of which are in this collection, and for a series of types believed to have been made in Mexico from the sixteenth through eighteenth centuries (Goggin 1968; Lister and Lister 1982). Even though names in themselves are recognized as convenient descriptive tools, none of the suggested labels are used in either these general discussions of Mexican maiolica or in the descriptions of particular vessels because of prevailing dissatisfaction with many aspects of the nomenclature as it has been applied to these internationally distributed wares and to the ambiguity of some categories.

To further expound upon this point, *all* of the blue-on-white specimens of this Mexican collection thought to have been made over a one-hundred-fifty-year period from the mid-seventeenth to the end of the eighteenth century can be fitted into the single designation of Puebla Blue on White. Not only is this time period too long to permit the kind of refined dating most students of culture prefer, but a perusal of the illustrations of the sample reveals such great divergence in style, form, and grade encompassed within this one type as to make the name virtually meaningless for precise interpretation. Its hollow repetition in these discussions would serve no purpose. The Puebla Blue on White group as presently defined is too broad but cannot be narrowed into smaller, more useful complexes until further analyses are made of collections such as this and of additional archaeological materials obtained under controlled circumstances.

The other series of specimens in the Mexican collection for which a type name has been offered is the blue-ground one dating from the end of the eighteenth into the early decades of the nineteenth centuries. This presently is called Tumacacori Polychrome. It is an easily identifiable stylistic entity apparently produced for a comparatively restricted time, and hence it is a useful grouping. However, the writers consider the name itself to be objectionable. In proposing it, John M. Goggin (Goggin 1968) followed a binomial procedure established and proven for archaeological ceramics in the American Southwest wherein a geographical designation is followed by a descriptive term. In practice the geographical unit refers to the site or region where the kind of pottery in question is first identified or first appears significantly abundant. Such a naming method has obvious drawbacks when used on an intercontinental basis, which this specific type

name well illustrates. Tumacacori was a poor mission site on the very fringe of the Viceroyalty of Nueva España some thirteen hundred miles from the place of manufacture of the blue-ground type bearing its name. That in itself is not important if the person studying the pottery fully understands the looseness of the name. Nevertheless, there is the unfortunate possibility that site and type will be erroneously correlated. We choose not to perpetuate any such probable misconceptions. In our opinion, with further analyses beyond the scope of this study, names such as Tumacacori Polychrome need to be replaced with others having less specific connotation or ones closer to known sources of wares.

As yet no formal names have been proposed for the remaining styles in this Mexican collection.

Included in the references indicated for each specimen of the collection are various museum collections where similar examples have been seen personally. Such a listing is not intended to be exhaustive.

In the opinion of some scholars, the word *maiolica* came into general usage in Spain from an Italian corruption of Majorca in the mistaken belief that lustered earthenware traded to Italy from the West during the fourteenth and fifteenth centuries was made in the Balaeric Islands. Others suggest Málaga as the derivation for the term.

The original draft of this manuscript was prepared in 1975–76. Inasmuch as little archaeological or historical research has been accomplished or published since then, other than our own work, and few relevant specimens have been added to this collection, we feel the data and observations presented in this publication remain current.

Grateful acknowledgment is made of permission and support from the International Folk Art Foundation to allow this study to be consummated. Our sincere thanks also go to Dr. Yvonne Lange, Judy Chiba, Judy Gleye, and all others on the staff of the Museum of International Folk Art for many courtesies extended. We further express appreciation to our late friend, Dr. Isabel Kelly, Tepepan, Mexico, for confirming the identification of vessels from Sayula, Jalisco.

For this updated version, we are deeply indebted to Robin Farwell Gabin, curator of Spanish Colonial art at the Museum of International Folk Art; and to Mary Wachs, editorial Director of the Museum of New Mexico Press, and her assistants.

SPANISH MAIOLICA

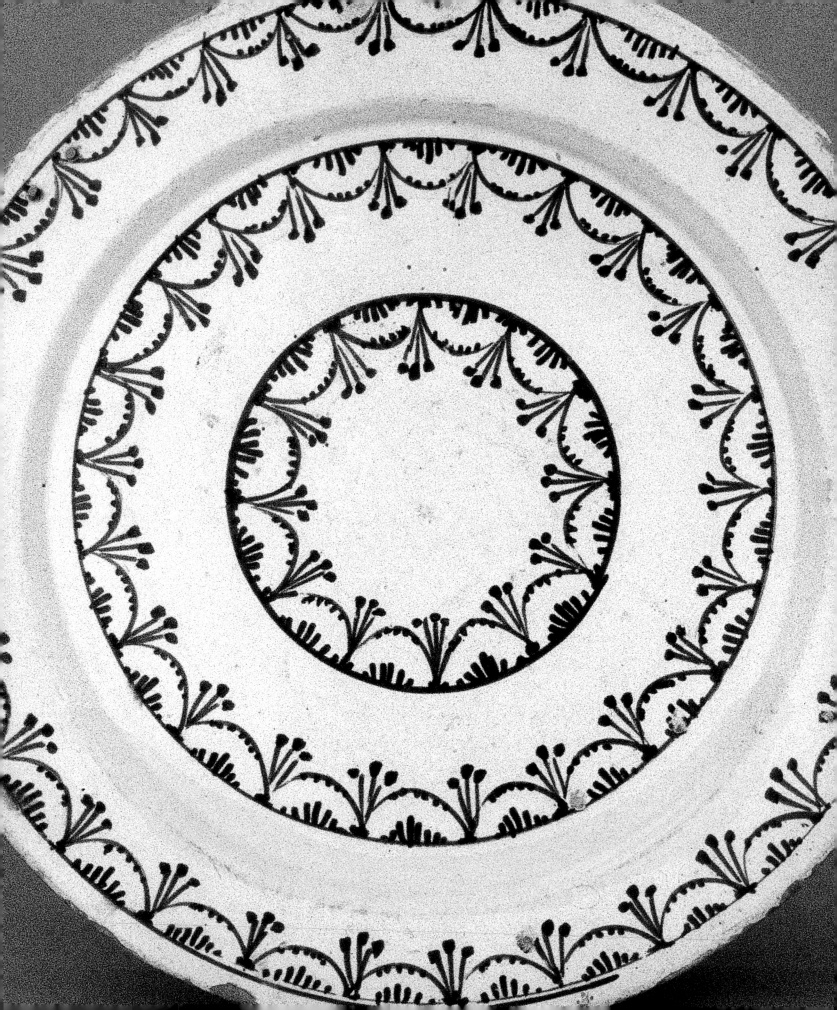

Introduction

ALTHOUGH POTTERY MADE BY ROMAN AND VISIGOTHIC PEOPLES is found in various parts of the Iberian peninsula, it was not until the Arab occupation beginning in the eighth century that ceramics became commonplace. During the course of the next eight centuries almost every type of earthenware known to Muslim craftsmen infiltrated Spanish workshops.

The Arabs came out of a sector of the eastern Mediterranean where the oldest pottery yet known in the Western world has been found. Likewise the oldest potter's wheels and kilns have been identified there. Also, present evidence suggests that it was in this crucible of civilization where alkaline and lead glazes were first invented. The Arabs inevitably drew upon that accumulated potting experience, which spanned some eight thousand years. Their fundamental methodology had been tested and proven long before them, but to their credit they worked out new processes and finely honed refinements which in time placed them among the world's most accomplished potters. At the time they overran Andalusia; however, many of the improvements and innovations for which they were to gain fame still lay ahead.

Elsewhere it has been demonstrated that when the potter's wheel has been adopted by a group, the craft has passed from being a household chore of women, who customarily were the creators of hand-modeled vessels, to being a commercial activity of men. In a male-dominated society such as that of the Muslims, it can be assumed that the total group lumped together as potters—those who formed the vessels and those who decorated them—without exception were men. Generally they have remained anonymous.

From the beginning of the Spanish Muslim period, the complex craft of pottery-making was stratified. Fired brick and roof tile used in construction were fashioned by unskilled workers who needed no special training and were the lowest stratum of the work force. Other items for construction, such as drainpipes and water conduits; utilitarian domestic jars of many sizes needed for storage of foodstuffs and oils; or the bowls, basins, bottles, and serving dishes which furnished every kitchen, were the responsibility of more advanced potters who had mastered rapid manipulation of the potter's wheel. At the top of the craft hierarchy were those with not only manual skills but artistic sensibilities and the expertise to apply them. These persons

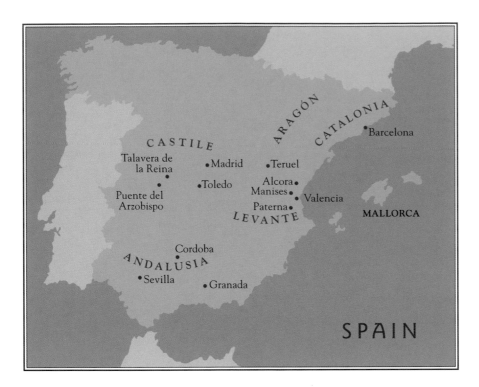

Figure 1
Major Maiolica-Producing Centers
in Spain

produced the decorated objects for special usage, and it is largely through their efforts that distinctive, identifiable styles made an appearance.

Formed of common secondary clays, Spanish Muslim earthenware objects were fashioned in great volume by means of the simple mechanization afforded by the potter's wheel. Typically this device was of the kick-wheel type wherein a heavy flywheel at foot level was connected by a vertical axis to a small wheel head upon which the clay to be thrown was placed. Through a forward thrust of his right foot, the artisan propelled the flywheel, which in turn revolved the upper wheel. Aided by the momentum so generated, both hands were freed to mold the clay. Such kick wheels were standard throughout the Mediterranean world and remain today as the usual implement of nonindustrialized production. The actual placement of the Spanish Muslim wheel within a work compound was unique. It was situated in a trench in the ground so that the potter sat on a seat or bench in a pit, his wheel head slightly to his left but at ground level. This had the advantage of providing a large surrounding surface which could be used as an area on which to place hand tools, buckets of lubricating slurry, or freshly thrown vessels. With the wheel located to one side rather than directly in front of him, a potter could more easily see the base of the object being thrown. Today the pit wheel continues to be used in Granada (Lister and Lister 1987, 51, fig. 36; Llorens Artigas and Corredor Matheos 1970, 148), the last stronghold of the Moors in Spain, and it is usual in most Moroccan workshops to which the Moors and *moriscos* (converted Muslims) expelled from Spain periodically fled (Lister and Lister 1975b, 290). There is little doubt but that it was the typical arrangement in Spanish *ollerías* prior to the sixteenth century (Frothingham 1944a, 90). The pit wheels were roofed over or were in outbuildings where processed deposits of moist, ripening clay were on hand. Long hours spent seated on the ground in the dark, dank atmosphere of such a work area must have promoted a variety of physical ailments about which documentary records say nothing (Lister and Lister 1987, 277–79).

The Arab kiln transferred to Spain was built of rocks or bricks mudded together and chinked with potsherds. A chamber for consuming fuel was partially subterranean so that the encompassing earth would but-

tress the walls as they expanded under heat. It was vented to an upper chamber, located either directly over the fuel box or slightly to one side, in which several hundred pots could be stacked for baking. On occasion this upper chamber was left open to the sky, sealed with broken vessel fragments during use, or was topped with a low, rounded roof having vents for adequate draw (González Martí 1944: Vol. 1, fig. 5; Lister and Lister 1987, 51–53, fig. 37). Fuel depended upon local environment but was usually furze, chamisa, brush, or, after the introduction of olive groves, the skins and pits left from the oil extraction process. Temperatures in the range of 990° to 1,115° C. were required to mature most red clays, these usually achieved in a day's firing. Unglazed or slip-decorated vessels were baked only once, but glazed pieces underwent a second firing. Long, cylindrical rods of fired clay formed platforms or shelving on which glazed vessels were placed, and tripod clay cockspurs kept them separated so they would not fuse together when molten glaze hardened (Lister and Lister 1982, fig. 5.3; 1987, fig. 158f). During the Arab period, there is no evidence for the use of saggars, or protective boxes, of refractory clay, although large bisqued pots might have served that purpose from time to time (González Martí 1944: Vol. 1, 248).

Because of the kind of clays used, utilitarian pieces usually emerged from the kilns a reddish-brown color. In certain parts of Andalusia, however, beds of light-burning calcareous clays produced white pottery. Decoration took several forms. The soft surfaces of some greenware were stamped or tooled, or leather-hard vessels were covered in part or all over in a dark engobe through which patterns were etched to reveal the body clay beneath the coating or over which designs in white were painted. Many bisqued vessels were covered additionally with transparent lead glazes which fired colorless, amber, or green.

In the ninth to eleventh centuries when the Córdoban caliphate was flourishing as the western capital of Islam, Arab potters to the east for the first time were being exposed to the dramatic impact of Oriental ceramics which were being traded across and around Asia. Two subsequent important diffusionary waves from China to the Near East brought further stimuli, one during the Sung Dynasty in the twelfth century and another in the fifteenth century (Lane 1957, 3–4). The first two periods of such interaction culminated in improved Arab methodology, the third in an assimilation on the part of the Muslims of many Eastern design conventions. In addition to obtaining cobalt from Mohammedan Persia, Chinese artisans themselves absorbed some Western ideals as they associated with an area where underglaze painting was commonly practiced (Liverani 1960, 68; Pope 1956, 44). Each of these major artistic exchanges eventually produced results which filtered through the Arab world to reach its westernmost extremities in Spain.

The development of the kind of ceramics now known as maiolica came about indirectly as a result of the first arrival in the Near East of Chinese ceramics. In the effort to duplicate grounds similar to those seen on Sung vessels, Arab potters found that the addition of a small amount of tin oxide to their common lead-fluxed glaze base would form not only a stable coating but an opaque white one which concealed the body clay beneath it. They then discovered that designs painted in various mineral oxides over that ground would sink into the glaze as it softened and matured during firing, thus permanently fixing the pattern. Such technique had special appeal to a people creating a vernacular in all decorative arts strongly focused upon elaborate surface enrichment. It quickly became their routine way of processing decorated wares.

In Spain tin-glazed pottery began to appear with some frequency during the thirteenth century in areas where Muslim artisans dominated the craft of pottery-making. Thus from Andalusia on the southern Atlantic coast, around the bulge of the old Kingdom of Granada and the Levante, and up into Aragón, maiolica-making occupied a considerable number of potters. Because the main evolution of tin wares came after the reconquest of Toledo in the north, Castilian *mudéjares* (Spanish Muslims under Christian political rule) and Christians did not share in the early phases of this ceramic history, with the exception of the possible manufacture of *cuerda seca*. This was a process whereby a tinted, greasy substance outlined a pattern filled with colored glaze. After firing, the outlines emerged as dark matte borders. The mode is also called the dry-cord style and continued through the fifteenth and early sixteenth centuries (Lister and Lister 1987, 46–47, 115–117, fig. 75). When maiolica production began in Castile during the sixteenth century, technology and style were adopted through Italian rather than Muslim agents.

From the time it first appeared in Spain maiolica seems to have evolved simultaneously on several levels. One series of wares was made rapidly in large numbers to meet most usual household and commercial needs which required vessels with impervious surfaces, and another was representative of the finest expressions of ceramic achievement of which the craftsmen were capable and was restricted to special purposes and clientele. Lusterware, or *reflejo metálico*, was the most elaborate example of the latter (Lister and Lister 1987, 87–90). It was maiolica bearing an overglaze patterning in oxides of copper or silver, which needed a brief third firing in a muffle kiln in addition to the two more usual firings at higher temperatures in an updraft kiln. It became a specialty of the Muslim Kingdom of Granada. Undoubtedly the luster method was borrowed from elsewhere in the Arab world, but Granadine decorators achieved an individualistic local statement. Using forms already current in the repertoire, for palace enrichment potters exaggerated their size and appendages to make them exotic carriers of meticulously executed, densely applied tracery, escutcheons, stylized florals, and occasional figural elements which duplicate in ceramics contemporary artistic expressions in stone, stucco, metal, textiles, and wood. Some of the designs were drawn in cobalt prior to the glaze firing in the typical maiolica method which allowed decoration to fuse into the glaze, but it was the final painting in metallics which rode as a very thin layer over the glaze base that made the ware unique. For export, which during the thirteenth and fourteenth centuries became of great importance to the Nasrid economy, workshops at Málaga, and perhaps also at Granada and Almería, favored large conical bowls, flat-bottomed plates, and tall drug jars which were sold to wealthy Christian customers throughout western Europe.

During the late fourteenth century as the tides of political fortune began to flow against the Nasrid enclaves, the secrets for making gleaming lustered maiolica were carried by itinerant Muslim craftsmen northeastward along the Mediterranean coast to the vicinity of Valencia, where more traditional pottery-making long had been a flourishing enterprise. There, at the small settlement of Manises, now a ten-minute bus ride from the city, potters who sprang from Moorish, *morisco*, and Old Christian backgrounds embarked upon a long, distinguished endeavor in the creation of *reflejo metálico* vessels. Even while Granada still

existed as the last outpost of Islam on Spanish soil, Manises was becoming known for the kind of luxury ceramics the Nasrids first had introduced to Europe. At Manises, the technology adopted from Granadine sources remained relatively unchanged. The use of molds or jiggers and jolleys became almost universal. Decorative styles, however, reflected a cultural hybridization which through the next several centuries increasingly pulled away from Islamic roots.

Another Nasridian specialty was *alicatado* tile panels. These were intricate mosaics composed of colored, glazed fragments of various sizes and shapes. The Alhambra in Granada and the Alcázar in Sevilla were enriched with brilliant *alicatado* walls installed during the fourteenth and fifteenth centuries. The vogue ended in Spain with the expulsion of the Muslims in 1492.

In contrast, during the fifteenth century Christian potteries turned out a wide range of domestic wares such as chamber pots, bowls, plates, porringers, candleholders, and drug jars. When covered with a thin, tin-opacified glaze and if decorated at all, they bore a band of debased cufic inscriptions drawn in purple and blue pigments or one or two blue encircling lines. This type of pottery was brought by the first Spaniards coming to the New World (Deagan 1987, fig. 4.26; Lister and Lister 1982, figs. 4.11–4.17; 1987, figs. 61, 63–69; Pleguexuelo Hernández 1985, Pl. 19).

The only special sort of pottery produced by non-Muslims during this period was some *cuerda seca* or *cuenca* tiles and plates. The latter were greenware impressed with stamps so that ridges prevented molten glaze from flowing. These types do not seem to have reached America in any appreciable number.

As the fifteenth century concluded, Italian ceramists moved to Sevilla, bringing with them fanciful Renaissance notions of design. Some opened pottery workshops with improved types of potter's wheels and kilns and a host of decorative innovations in color and pattern. Threadbare Muslim traditions finally wore out. Flat-surfaced polychromatic tiles introduced by Italians (*azulejos*) became a Sevillian stock-in-trade during the sixteenth and seventeenth centuries. Hollowware also reflected Italianate themes. It was at this time in the middle of the sixteenth century that Talavera de la Reina in Castile came to the forefront of Spanish pottery production. The influence of this center was so great that both Spanish and Mexican maiolicas often were called Talavera ware.

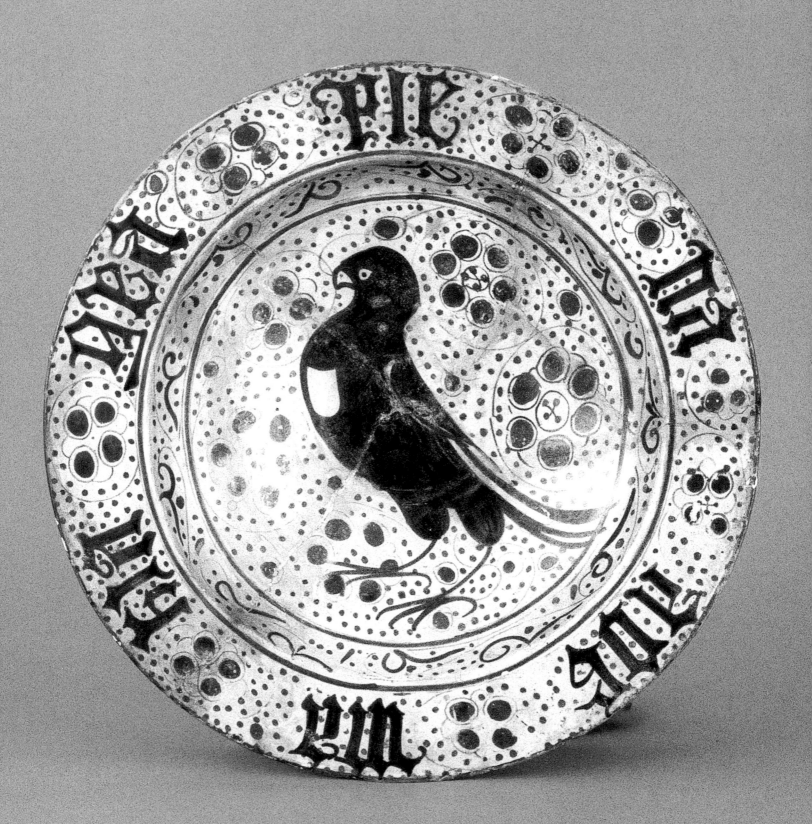

The Spanish Collection

LUSTERED MAIOLICA

Inasmuch as lustered maiolica, also called Hispano-Moresque ware, was generally confined to eastern Spain, no regional subdivisions are necessary for the descriptions to follow.

The oldest specimen in the Museum of International Folk Art collection of Spanish maiolica was made in Manises during the first half of the fifteenth century (Figure 2). It is a lusterware bowl or deep dish of a type in Spain called a *brasero* (brazier). It is flat-bottomed with a central depression which humps up lowly on the interior surface. A narrow, perpendicular cavetto, or wall, curves slightly outward to a flat, wide brim terminating in a vertical edge. The use of a mold for basic shaping is apparent.

The vessel is covered on both surfaces with a cream-colored glaze, perhaps applied over a light slip, and is overlaid across the bowl center with a Gothic decoration consisting of a sharply defined falcon in very dark blue. Detailing of beak, breast, and eye is left in reserve. On the brim appears an inscription in blue Gothic letters containing the words AVE MARIA and three syllabic excerpts from the Latin prayer. The brim, cavetto, and center are delimited by narrow encircling lines of copper and dark blue cobalt. Background fillers are disc rosettes of three to seven dots encircled by a thin line, smaller random dotting, very fine stem lines, and calligraphic hooked scrolls, all executed in a silver-and-copper pigment which, because of overfiring, dulled to a chestnut color lacking metallic sheen. Such treatment provides a unique, but harmonious, ground to enliven the rather stiff centerpiece, the use of dotted ground fillers having been an ancient Muslim technique (Allan 1971, 11, fig. 6; Lister and Lister 1987, figs. 35, 52d; Wilkinson 1973, 42, 149, 204, 252). A neat overall effect is gained, but close inspection reveals the almost casual spontaneity with which the piece is decorated. Variations exist within elements, spacing between parts of the inscription differs, and careless draftsmanship has allowed the terminals of lines to intersect and dots to be lopsided.

Figure 2
Brasero
Manises, First-half 15th Century
Dia. 34 cm.

Earthenware with tin glaze and cobalt in-glaze decoration and copper–silver oxide overglaze decoration.

The exterior bears a band of framed diagonal hatchures on the wall and a spoked circle within the basal depression. These lines are drawn in silver-copper pigment which fired to the same dull chestnut color as interior decoration. Although the luster, or third, firing of this piece reveals one drawback to the traditional construction of the usual kilns in allowing uneven temperatures, the clay used had a sufficiently high shrinkage rate as to almost eliminate crazing defects in the glaze.

Obviously a Christian prayer in Gothic script emanates from European sources. Many similar specimens are known from the Manises area. Some bear this identical inscription, which reads: AVE-MA-RIA-GRA-PLE-NA. It is taken from Luke 1.28, "Ave [Maria] gratia plena," the salutation of Gabriel to the Virgin Mary. The words AVE MARIA are so frequently used that the entire group is referred to as the Ave María series. However, on vessels of the same form and decoration, occasionally no inscription appears at all. Whether these vessels might have been used in religious establishments is unknown, but that would seem likely, particularly since they are believed to have been used for washing hands prior to dining or devotions. Other birds or animals, such as deer or hares, also are used as centerpieces. One example of a human figure as a central motif is known.

The Ave María style, characteristic of the early fifteenth century, already represented a sharp drift away from Moorish beginnings. The technique of manufacture remained that had been adopted originally from Malagan workshops, but the form and principal decoration evolved as a response to an increasing awareness of Gothic conventions and the preferences of the clients, who were Christian Europeans. There was a notable retention of some minor Muslim ideas concerning ground fillers.

During the remainder of the fifteenth and sixteenth centuries, refinements of potting and decorating brought great fame to the artisans of Manises and the florescence which is regarded as the Golden Age of Spanish lusterware. A number of vessel shapes evolved, many of which were copied from metal prototypes. Design grammar for obverses of open forms was based on a combination of small, repetitive geometrics and the heraldry of purchasers. Large-scaled, rampant animal figures or geometrics were used for reverses. The *morisco* population, comprising a high percentage of the potting force in Valencia, was exiled in 1609–10 to bring about a notable decline in the quality of lusterware.

After the craze for gadrooned and Baroque molded forms and densely applied small geometric designs of the sixteenth century had passed, Manises factories turned back to simpler shapes and decorations. In this collection a moldmade shallow bowl with a characteristically deepened central well and a lighter naturalistic patterning is typical of the late seventeenth century (Figure 3).

Glaze remains creamy though of a pinker hue than the fifteenth-century example illustrated in Figure 2, probably because of a redder paste and thinner glaze coating containing a lower tin content. Design is carried only in copper pigment, which fired to a brilliant red tone characteristic of the period. Even though other colors were not used, the vessel would have required three firings—the first to bisque the object, the second to mature the glaze, and the third to affix the overglaze decoration. A large bird with reserve detailing moves across the center field occupying cavetto and well. Its tail is depicted by the same pyramid of

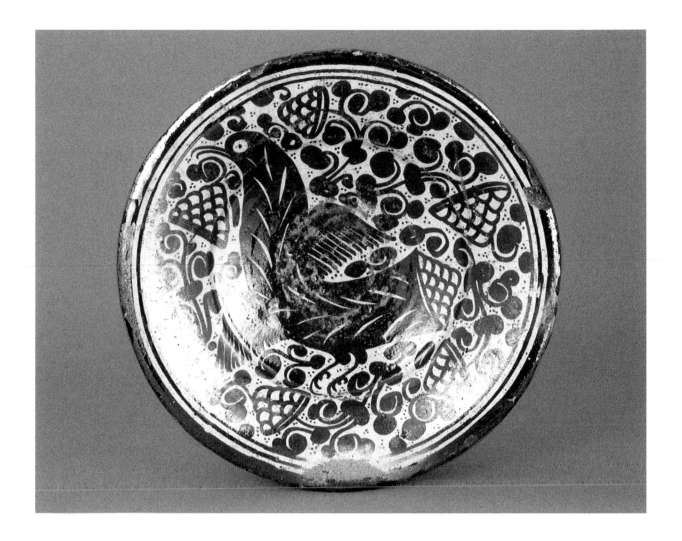

Figure 3
Bowl
Manises, Last-quarter 17th Century
Dia. 32.5 cm.

Earthenware with tin glaze and copper oxide overglaze decoration.

arched lines that represent five flowers placed around the wall. Curved stems and cherrylike petals fill the background additionally occupied by minute clusters of two to five dots. The entire field is encircled by a pair of medium-width lines below a wider band at the rim. Exterior design consists of nine circular swipes around the upper wall, six near the low ring foot, and one within the ring.

Drawing of interior elements is carefully done, but imprecision of details remains characteristic. The configuration of the bird and the curvilinear lines and placement of surrounding floral elements impart a sense of movement, as contrasted to the static rigidity of earlier armorial patterns of precisely placed geometrics around a central escutcheon. The rudimentary exterior patterning is dramatically different from that utilized during the best of earlier periods which saw the reverse almost as important to design as the obverse. The pigment, brilliant and red in tone, probably represents an economical substitution for the more costly silver used earlier. Cockspurs, which separated vessels during glaze

firing, left three scars on the interior surface. At the apogee of lusterware production at Manises, most plates were fired on edge to avoid such blemishes (Frothingham 1951, 198). This vessel thus represents a period of declining luster techniques, but the quality nevertheless was good.

As the knowledge of processes for making lusterware diffused through eastern Spain, a coarsening of the craft broadened the potential market base. No longer was lustered maiolica meant only for display. Illustrative of the vessels aimed for more common domestic purposes is a small porringer (*escudilla*) (Figure 4), which resembles many recovered from seventeenth-century kilns in the Barcelona and Reus areas. Its characteristic flat-lobed appendages are known in Spain as *orejas*, or ears. Decoration in copper pigment is one of very simplified geometrics. A dark starred motif divides the field, the segments of which are filled with nested half circles. Handle lobes are decorated on upper surfaces only with solid outer areas and a chevron line containing a central dot. The exterior bears two sets of nested half circles on the sides and another set in the small basal depression which took the place of a ring foot. This is a cursory treatment suitable for necessary rapid mass production to meet the needs of a thriving seaport. Three scars from use of cockspurs during glaze firings mar the interior surface of the cream-colored glaze, further underscoring the common nature of these ceramics.

By the eighteenth century, lusterware had deteriorated to a stage represented by the specimen illustrated in Figure 5. A large, flat-bottomed, shallow bowl, well and brim separated by a slight molded angle, its decoration is carried in a golden-copper pigment. The central motif within the well remains a bird, called a *pardolot* in Valencian vernacular, which has become so stylized as to be almost unrecognizable. The head is minimal without indication of beak or eye. The body is divided

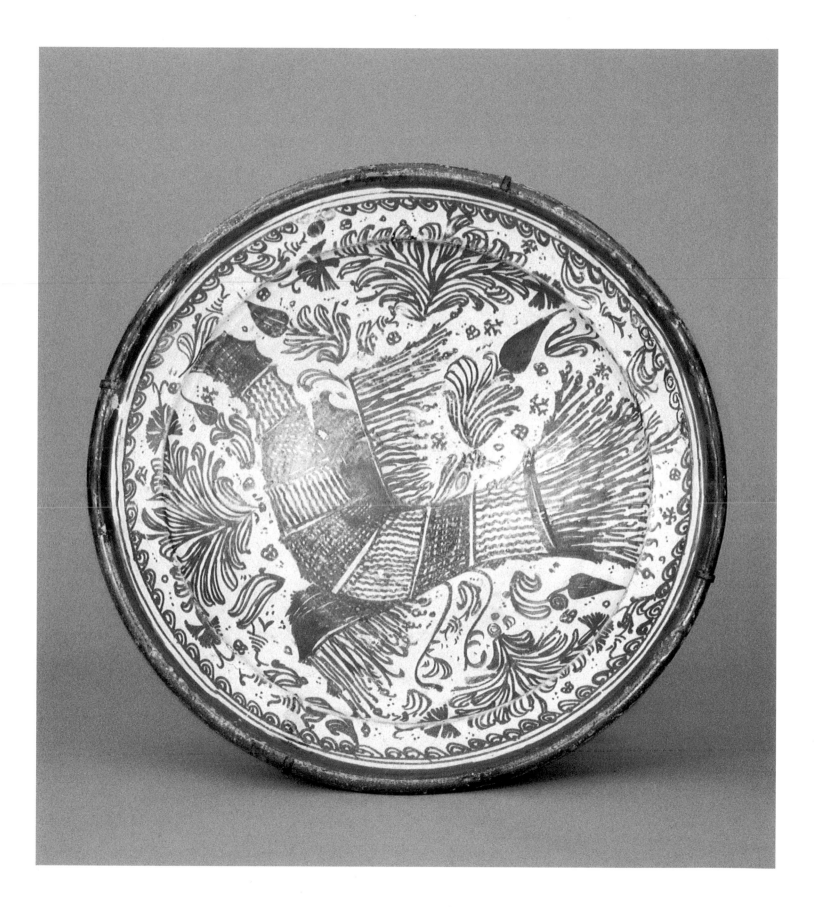

into zones of wavy parallel lines and crosshatchure. Wings and a prominent tail are roughly parallel crooked lines almost vegetal in nature, which are echoed by three fronds spaced around the outer well and extending up on the brim. Several fine lines at the outer edge frame the pattern, one having a pendant wave elaboration. A broad copper band covers the thickened rim. Casually executed and randomly placed background fillers of pointed flowers and stems, assorted dots, graduated fine lines, circles, and crossed lines make for a busy but light pattern. The bowl exterior exhibits a few broad horizontal brush marks but no set motif.

MAIOLICA

Levante

Copper-green and manganese-brown had been used in Spain to decorate Islamic ceramics made during the ninth to eleventh centuries at Córdoba. It was therefore expectable that these two pigments would continue to be employed for vessel ornamentation as a tin-opacified glaze became more common. Scattered fragments indicate that such was the case, but so far as is presently known, this particular palette did not receive wholesale adoption until a large pottery-making industry was established in the Levante. There, at a place called Paterna, during the thirteenth to fifteenth centuries a body of predominately *morisco* craftsmen, working under the patronage of a noble Christian family which had been granted rights to the land and utilizing large deposits of good pottery clays, produced maiolica wares almost exclusively decorated in green and brown, although in late years cobalt blue was sometimes substituted. The fact that local ordinances required potters periodically to place their mass of wasters in large pits has enabled modern archaeologists to recover thousands of vessels or fragments for study (González Martí 1944: Vol. 1, 107; Llubiá 1967, 158). Forms were those of the table: wheel-thrown of modest size, without fancy appendages, and turned out in tremendous volume. Designs upon these pieces show a curious blend of Islamic and Christian themes, or *mudejargóticos*, the elements themselves being solid zones of green outlined or detailed in brown. It is noteworthy that in general these motifs did not pass to the later makers of lusterware at neighboring Manises, who also produced a hybrid style which assimilated Islamic and Christian conventions. A very unique situation thus is observable in two production centers located side by side, emerging from the same cultural matrix, but achieving totally distinctive artistic languages. In the divergent quality of the two industries, as well as the passage of time which brought new social perspectives, must lie the fundamental reasons for such differences.

There are no specimens in the collection of the archaic maiolica period at Paterna. That town faded and finally was superseded by neighboring Manises, where from the fifteenth through eighteenth centuries potters concentrated almost exclusively upon lusterware, as illustrated above. As a result, a notable hiatus in the nonlustered maiolica chronology exists in the Levante.

In 1727, a factory to make *loza fina*, or high-grade maiolica, was established at Alcora by the Counts of Aranda. The entire production was geared to making French-style sculptured pieces, vessels modeled after

metal services, and various Rococo fancies. The immediate popularity of these Alcoran ceramics with their delicate, refined decoration was one of the contributing factors to the decline of Castilian maiolica and Valencian lustered earthenware at the end of the eighteenth century. However, during the next century a revival appears to have occurred at nearby Manises, long dormant in the slow dissipation of the luster tradition, perhaps as an effort to fill the vacuum left when creamware and porcelain dictated ceramic markets. In particular, medium-sized plates were mass-produced at nineteenth-century Manises. They were molded as relatively thin-walled vessels having flat bottoms and gently sloping sides terminating in slightly rounded rims (Figures 6–18).

Figure 6
Plate
Manises, 19th Century
Dia. 34.5 cm.

Earthenware with tin glaze and cobalt, iron, and copper in-glaze decoration.

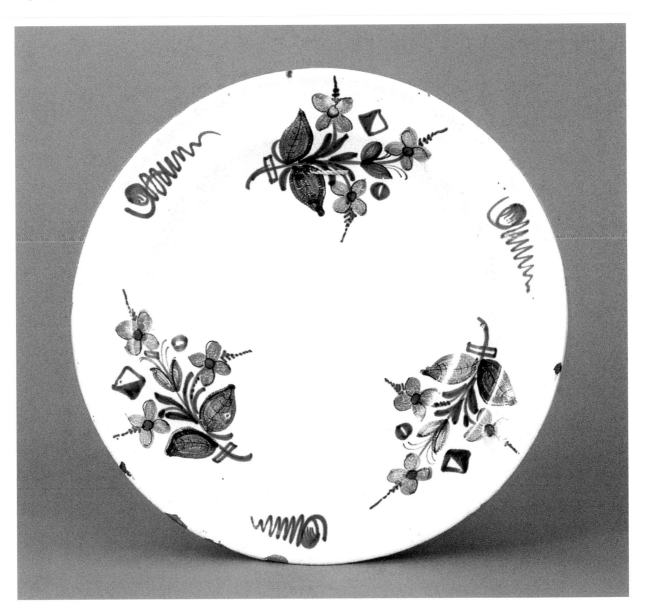

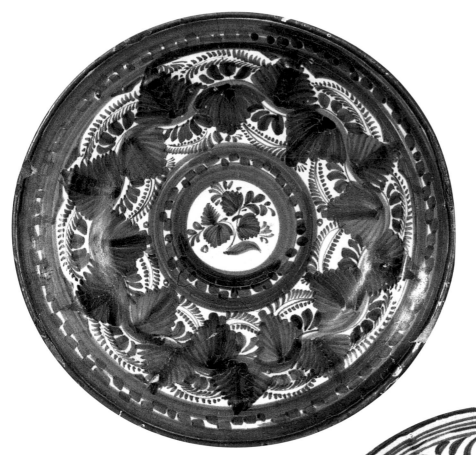

Figure 7
Plate
Manises, 19th Century
Dia. 30.7 cm.
Earthenware with tin glaze and cobalt
in-glaze decoration.

Figure 8
Plate
Manises, 19th Century
Dia. 31 cm.
Earthenware with tin glaze and cobalt
in-glaze decoration.

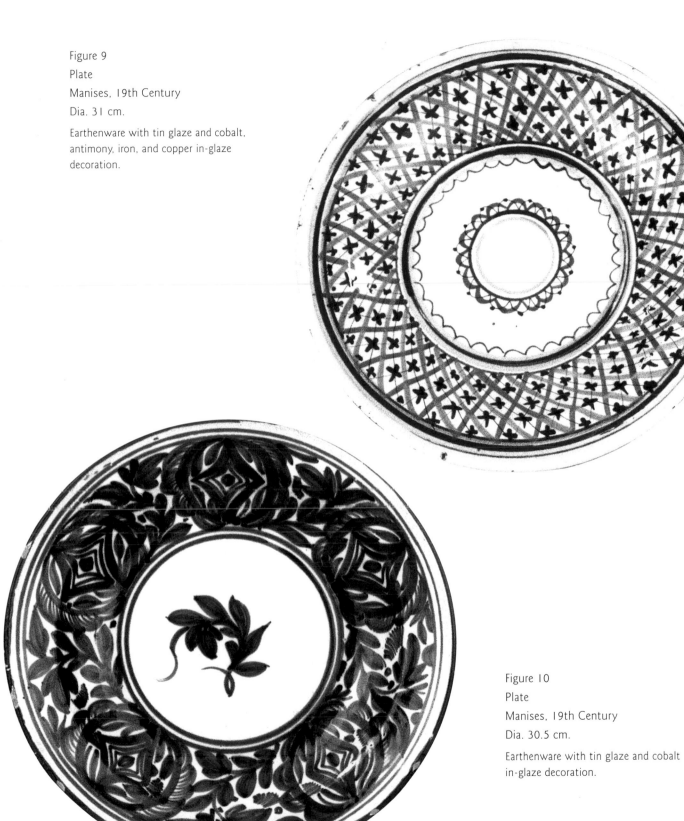

Figure 9
Plate
Manises, 19th Century
Dia. 31 cm.

Earthenware with tin glaze and cobalt, antimony, iron, and copper in-glaze decoration.

Figure 10
Plate
Manises, 19th Century
Dia. 30.5 cm.

Earthenware with tin glaze and cobalt in-glaze decoration.

31

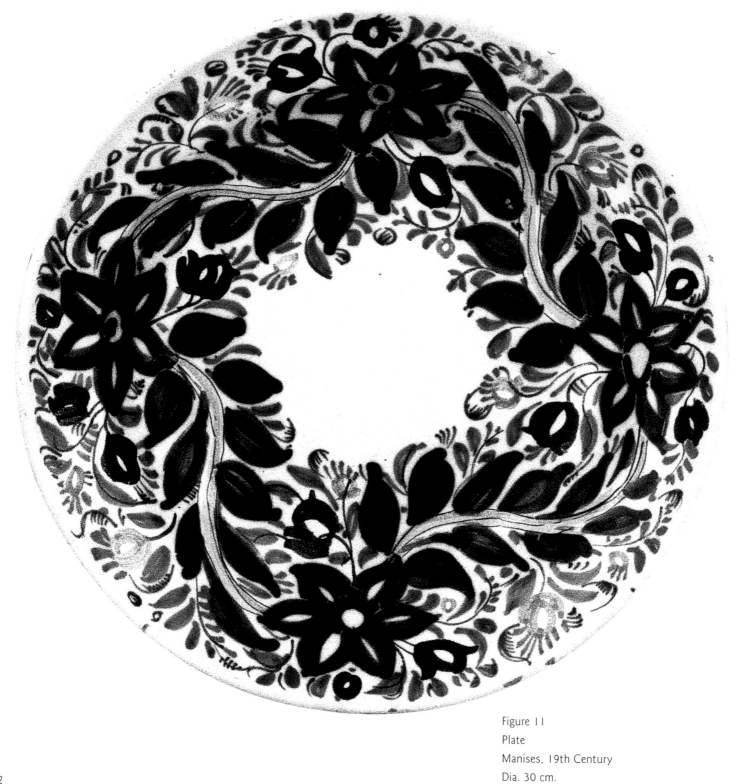

Figure 11
Plate
Manises, 19th Century
Dia. 30 cm.

Earthenware with tin glaze and cobalt,
iron, copper, and antimony decoration.

32

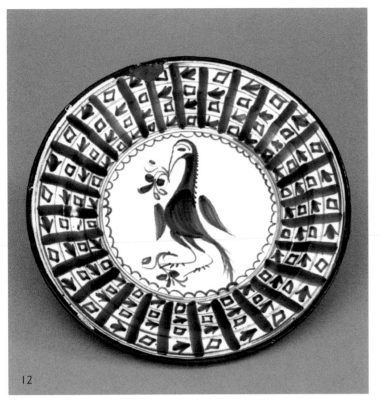

12

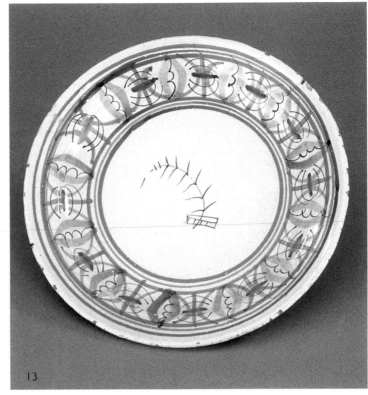

13

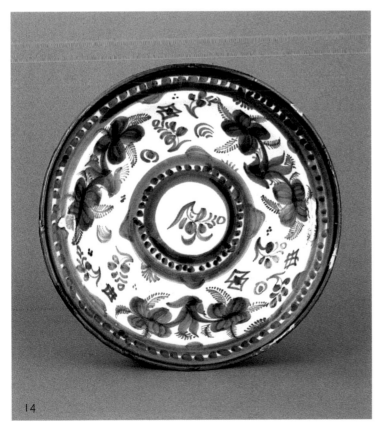

14

Figure 12
Plate
Manises, 19th Century
Dia. 30.5 cm.
Earthenware with tin glaze and cobalt in-glaze decoration.

Figure 13
Plate
Manises, 19th Century
Dia. 32 cm.
Earthenware with tin glaze and cobalt, copper, iron, and antimony in-glaze decoration.

Figure 14
Plate
Manises, 19th Century
Dia. 30.5 cm.
Earthenware with tin glaze and cobalt in-glaze decoration.

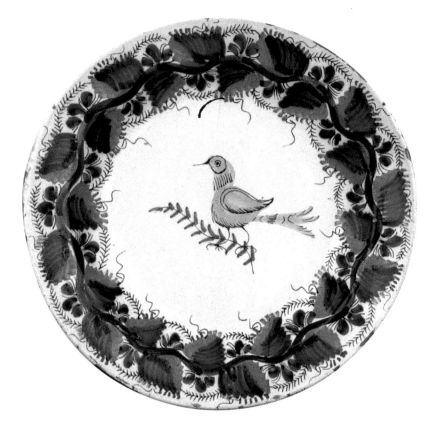

Figure 15
Plate
Manises, 19th Century
Dia. 30 cm.

Earthenware with tin glaze and cobalt, antimony, copper, manganese, and iron in-glaze decoration.

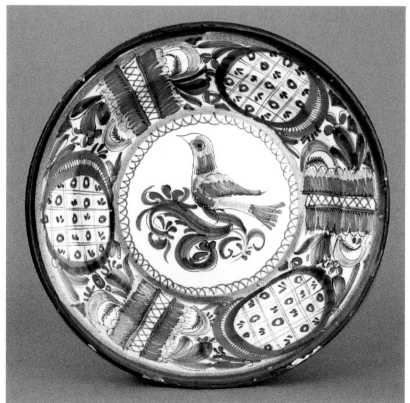

Figure 16
Plate
Manises, 19th Century
Dia. 30 cm.

Earthenware with tin glaze and cobalt, antimony, iron, copper, and manganese in-glaze decoration.

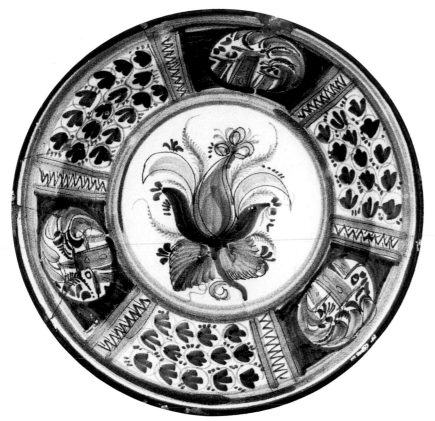

Figure 17
Plate
Manises, 19th Century
Dia. 31.5 cm.

Earthenware with tin glaze and cobalt, antimony, copper, manganese, and iron in-glaze decoration.

Figure 18
Plate
Manises, 19th Century
Dia. 31 cm.

Earthenware with tin glaze and cobalt, antimony, copper, and manganese in-glaze decoration; one of matched pair.

Although this shape seldom varied, there apparently was no effort to make table services wherein a set pattern was repeated many times. Each piece from Manises had an individual design painted either in blue or in a variety of three or four harmonious colors, including pink for the first time. Rarely pairs of similar plates were made.

Typically a broad band of decoration is placed from rim into center bottom, leaving a middle zone either undecorated or filled with an isolated single unit. A bird on a branch becomes a sort of hallmark for Manises vessels of this time, the use of that element harking back to the oldest specimen in this collection made four hundred years previously in the same town. Often the encircling band is compartmentalized into six or more segments, alternating units having matching motifs.

A high standard of potting and decorating was maintained, but unfortunately this gradually gave way to gaudier works of the twentieth century.

Aragón

An important ceramics industry emerged during the thirteenth century at Teruel and a few other towns in Aragón. That Teruel and Paterna were in communication is revealed in a sharing of certain modes of design. However, at Teruel, isolated in the interior of the country, most decoration and conventions of form remained more deeply entrenched in the Muslim past. In fact, Edwin Atlee Barber, an American student of ceramics in the early twentieth century, mistakenly considered many Teruel specimens to have come from

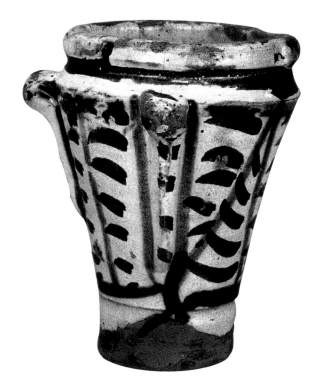

Morocco (Barber 1915b, Pl. 17–9). Darker-hued decorative pigments of copper-green and manganese-brown and deep-red clay body indicate distinctive sources from those utilized by southern shops. Although Paterna ceased being an active pottery-making center by the fifteenth century, Teruel craftsmen after that date continued making green and brown bichromes, with a few blue-on-whites added to their lines from time to time. But because cobalt was expensive and less readily available, common grades of maiolica remained the tra-

Figure 19
Mortero
Teruel, 16th (?) Century
Ht. 20 cm.
Earthenware with tin glaze and copper and manganese in-glaze decoration.

ditional green and brown. Use of glaze was curtailed so that not all surfaces were coated; cockspur scars, crawling, and crazing flaws were accepted; draftsmanship grew perfunctory.

One of the most typical household forms associated with this Aragonese pottery is a mortar, called *mamelot* there but a *mortero* in Castile, a heavy-walled, conical cylinder with a solid base for stability, two or three loop handles having an attachment extending vertically down vessel walls, and a rudimentary erect spout pinched from a thickened lip (Figure 19) (Lister and Lister 1987, 30–31, fig. 25g).

In high-class Spanish homes of the late Middle Ages through the nineteenth century bronze mortars for the grinding of salt were in every kitchen. In his famous painting of the early seventeenth century, *Christ in the House of Martha*, Velázquez made conspicuous use in the foreground of such an implement. It is suggested that these ceramic copies, for several centuries so typical of Teruel workshops, saw similar usage in less affluent establishments. They also may have been employed during the concoction of certain medicines (Frothingham 1941, 107).

The clay used at Teruel for all vessels, glazed and unglazed, was very red due to high iron content. This fact made necessary the addition of considerable tin oxide to any given glaze solution in order to conceal the red paste. Since tin always was costly, glazing was restricted to one surface or the upper walls of ordinary vessels designed for domestic service. In the case of mortars, solid basal areas remained unglazed.

As usual for mortars, the interior working surface of this example is undecorated and pitted from use. Exterior decoration consists of broad copper-green chevrons from shoulder to base, framed top and bottom, between which are wide horizontal brush swipes of irregular size and spacing, crossing the raised handle bases as well as wall space between. Because styling remained virtually unchanged for some three centuries, dating can only be suggestive, though it is believed this particular specimen may be near the beginning of the continuum. At any rate, a casual mass production for utilitarian functions is indicated.

Many features relate the *mortero* in Figure 20 to that illustrated above. It has a tapered bowl with heavy, solid foot, single handle, and rudimentary pouring spout. Its thin glaze is pinholed, crazed, and crawled. The only decoration is a few broad zigzags in copper-green and intervening horizontal strokes of manganese-brown. However, a less opaque glaze, more casual decoration, more pronounced solid foot, and an absence of applied vertical ribs associated with two side handles suggest this may be a later specimen.

A very small version of a mortar, the vessel illustrated in Figure 21, has a deep, pedestal-based bowl contour, three applied handles typically pulled down over the body to form ribs, and a tiny spout which actually was merely a nub of clay attached to the lip of the vessel. The paste, of a deep red color, is typical of all Teruel ceramics, but the glaze is whiter and glossier than the larger *morteros* in this collection. The solid base with flat bottom is unglazed.

No decoration appears on the interior of the bowl. The exterior is enlivened with random arched lines in brown, circles in green, etched encircling lines, and appliquéd clay circles.

Its petite size makes this *mortero* somewhat unusual. It is wheel-thrown, probably in a technique called "off the hump," with the basal portion left unopened and the rim untrimmed.

37

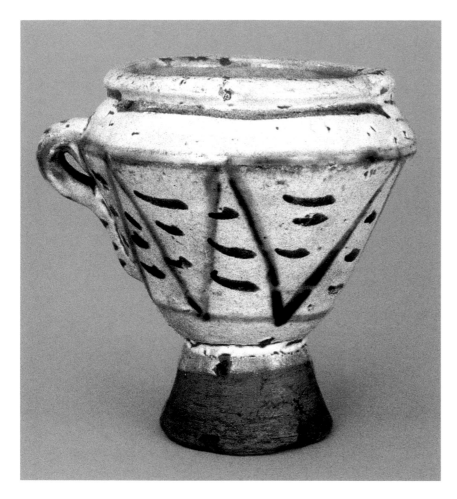

Figure 20
Mortero
Teruel, 17th (?) Century
Dia. 14 cm.; dia. orifice 6.5 cm.

Earthenware with tin glaze and copper and manganese in-glaze decoration.

OPPOSIRE PAGE
Figure 22
Cuenco
Teruel, 18th Century
Dia. at rim 32.2 cm.

Earthenware with tin glaze and copper and manganese in-glaze decoration.

Figure 21
Mortero
Teruel, 17th (?) Century
Ht. 8.4–8.9 cm.

Earthenware with tin glaze and copper and manganese in-glaze decoration and incised and appliquéd decoration.

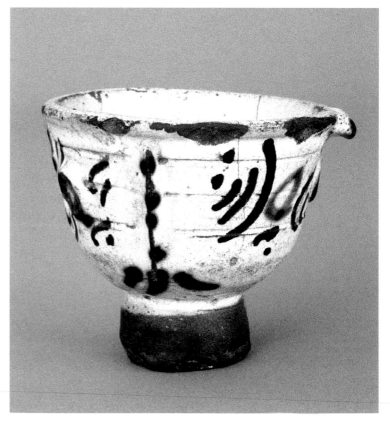

Very deep bowls, descended from the Moorish conical *cuenco*, also are typical of Teruel mass-produced popular ceramics from the late seventeenth into early nineteenth centuries. There are four examples of these bowls in this collection which probably represent eighteenth-century work (Figures 22–25). All are nearly the same size and profile, wheel-thrown using an off-the-hump method, flat-based with spiral cutting marks left unobliterated, heavy-walled, glazed on interior surfaces only. The exteriors reveal a brick-red body typically faceted by trimming tools. All specimens bear cockspur scars on crazed, pinholed, or crawled cream-colored glaze, indicating that they were nested together but separated by spurs during firing. A wave pattern formed by a broad zigzag of green with

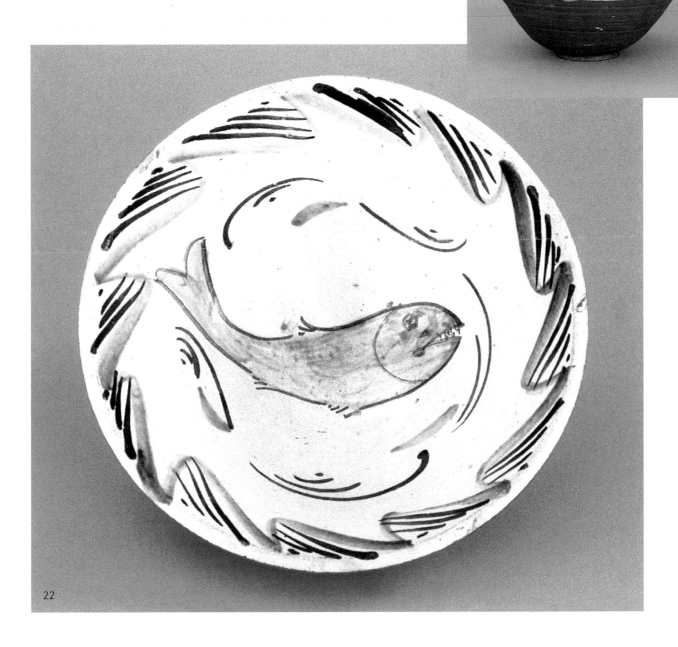

22

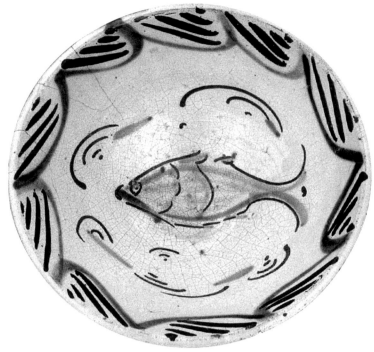

Figure 23
Cuenco
Teruel, 18th Century
Dia. at rim 31 cm.

Earthenware with tin glaze and copper and manganese in-glaze decoration.

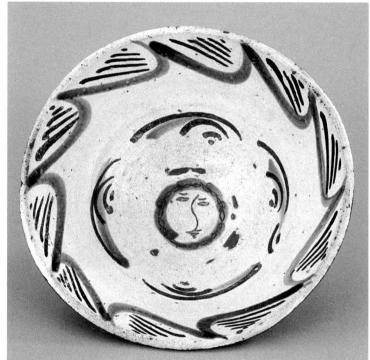

Figure 24
Cuenco
Teruel, 18th Century
Dia. at rim 31 cm.

Earthenware with tin glaze and copper and manganese in-glaze decoration.

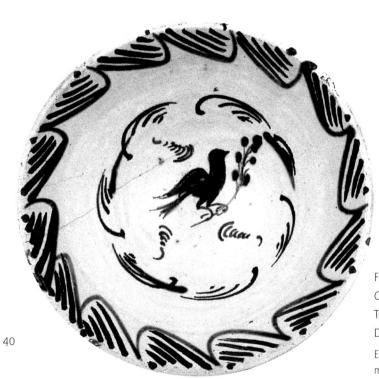

Figure 25
Cuenco
Teruel, 18th Century
Dia. at rim 32 cm.

Earthenware with tin glaze and copper and manganese in-glaze decoration.

loops filled by brown diagonal hatchure lies pendant from the rims. An isolated central element—fish, sun face, bird—is framed by random arched lines in brown and green. Two specimens provide an interesting comparison of the same motif, a fish, as interpreted by two different artisans.

Cobalt blue, which had been introduced to Muslim workshops in the south by the late thirteenth century, became the main decorative pigment on higher grade maiolicas in most areas of Spain during the sixteenth century, in part because it was a refreshing change from the archaic green and brown and in part as a response to the impact of Ming blue-on-white porcelain then being imported by Portuguese, Venetian, and other traders. In Teruel adoption of these blues was far from universal, the older green and brown being retained for popular wares. However, a pair of matched drug jars, dating from the late sixteenth or early seventeenth centuries, illustrated the finest expression of the blue vogue there (Figure 26).

Their form, called an *albarelo* and taken from typical Islamic grammar, was said to have been derived from the shape of bamboo sections

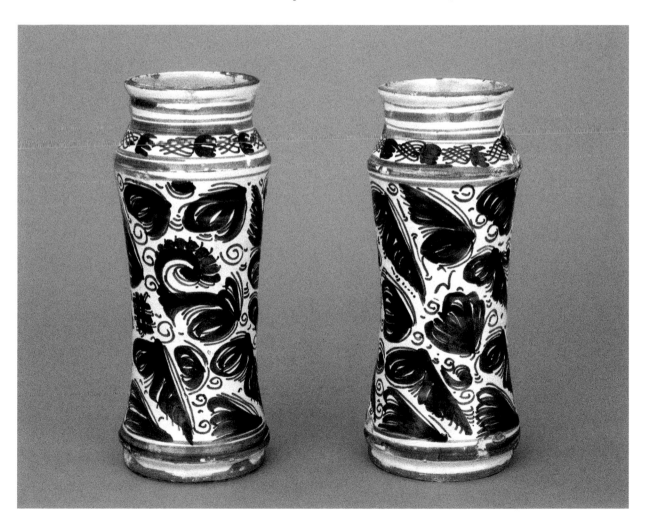

41

used in the East in which to ship medicines. The narrow waist permitted easy removal of the jars from storage shelves. The lower basal walls with a sharply angled foot also were designed to fit securely into slots in shelves. Presumably a cap of parchment or leather tied over their flat rims kept contents free of dust. For the same reason eighteenth-century Castilian jars of this form often were outfitted with ceramic lids.

The blue glaze of these particular jars is semiopaque, especially on ribbed interiors, allowing a pink paste to be faintly visible. Decoration is carried by a dark greyish-blue pigment which pooled where heavily applied. Its quality and tone suggest an early period of manufacture prior to the development of purer oxides or zaffer which promoted brighter colors. The pattern used is a boldly brushed design of what appear to be butterflies, with fluttering wings and curved tendrils, and modified *atauriques* (design of heavy scroll with lobed borders) such as enhance stucco decoration at the Alhambra. These motifs cover the entire body walls between pronounced shoulder and basal angles that are further emphasized by encircling frame lines. A running pattern of crosshatchure and petals fills the slope between body and vertical neck, the latter decorated with several broad, irregularly spaced lines.

Both specimens have flat bases scarred by concentric lines left by the tool or wire which cut them from the wheel. It is possible that the flat rim and the base never were covered with glaze, enabling a series of such forms to be stacked one on top of another for firing. One specimen appears to have suffered some running of molten glaze and to have been retouched. In a tiny area the jar also adhered during firing to a neighboring vessel.

It is fitting that the *albarelo* is introduced in a section of this study dealing with ceramics from a part of Spain that long possessed its Muslim flavor because Arab pharmaceutics underlay the establishment of the Spanish drug houses and hospitals which became numerous after the great plagues of the Middle Ages. Ceramic vessels to be used as containers for drugs, ointments, unguents, and other medicines dispensed at those places were required by the hundreds. They came in many different shapes and sizes, but the cylindrical Muslim *albarelo* remained most typical of Spain and the colonies to which she transplanted her ceramic art.

During the seventeenth and eighteenth centuries, potteries around Spain produced great quantities of maiolica tableware for both modest and rich homes and church foundations. The shops at Talavera de la Reina and Puente del Arzobispo in Castile led the way in setting styles of decoration which were widely copied. Among the most common of these patterns were escutcheons, such as appear on the pair of small plates in Figure 27.

These two plates, with their rather pronounced wells and flattened rims, are of a shape commonly made from the late sixteenth through the seventeenth centuries. Covered on both surfaces with an opaque, semimatte, white glaze characteristically pinholed and flecked, the central area is devoted to the Galve family, executed in dark blue, which consists of an ornamented shield bearing the crowned M monogram of the Virgin over the name. Differences in rendition result from two artisans working on the same order, one of whom produced a slightly deeper vessel with a not-quite-flattened brim on which he chose to draft a more modest upper insignia and to contract the A and L of the name in a customary lettering fashion, while the

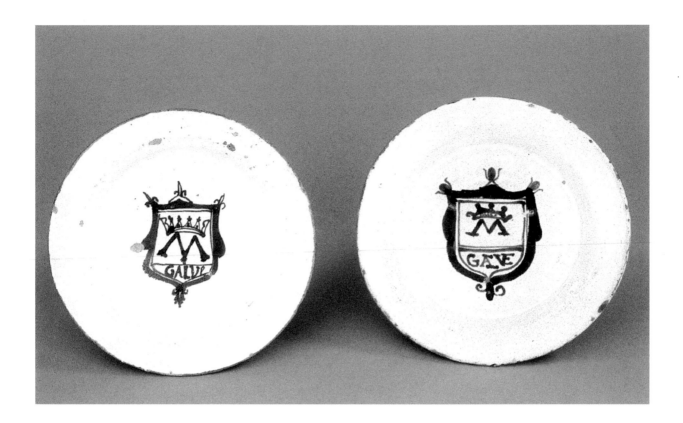

other craftsman spaced the letters more broadly. There also is minor variation in color of glaze and decorative pigments. The apparent unsure draftsmanship and the quality of glaze suggest a second-grade product meant for a religious table, probably at a Galve monastery dedicated to the Virgin Mary.

Figure 27
Pair of Plates
Teruel, Late 17th–Early 18th Century
Dia. 21.5 cm.

Earthenware with tin glaze and cobalt in-glaze decoration.

A porringer with an identical escutcheon, the A and L contracted, appears in the Museo de Arqueología in Madrid, where it is similarly considered a Teruel specimen of the seventeenth or eighteenth centuries.

Among the lesser known Aragonese pottery-making towns was Villafeliche, which became identified with a series of plates or shallow bowls exhibiting an eighteenth-century decadence of the regional wares begun a half millennium earlier. Generally they were poorly fashioned of a reddish clay, having no ring feet, flared walls and unthickened rims. Decorative work upon them typically was inferior, using few or none of past Islamic themes. The vessels illustrated in Figures 28 and 29 are thought to have come from this source. That in Figure 28 bears a mixed pattern known as *mistos* (mixed) and *alcachofas* (artichokes) of large-lobed, gridded florals having sepals drooping from broad, curving stems and laid against a ground of graduated petals and dots. The border is diapered in irregular streaked swags pendant from the rim. Design in less costly manganese, which fired to a dull slate grey, replaces cobalt. The glaze is scarred from use of cockspurs and is heavily pitted. The plate in Figure 29 displays more careful craftsmanship in both glazing and decorating.

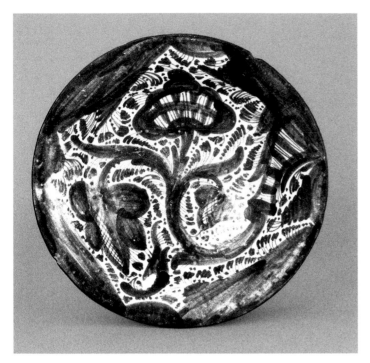 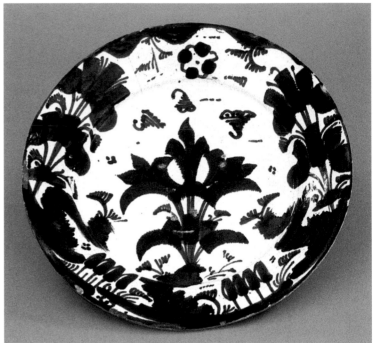

The design on this example is in cobalt rather than manganese, but the format still adheres to local ideals, demanding a central floral unit bordered by rather dense patterns on the rim having the same directional orientation as the centerpiece.

Catalonia

Catalonian potters in Barcelona, organized into an active guild long before such regimented groupings were sanctioned in Castile, for several centuries made blue-on-white styles strongly reflecting the maritime orientation of their city and its geographical proximity to southern France and northern Italy. The most direct influence of Italian decorative styles came in the first half of the seventeenth century, but whether this represented diffusion from Italy itself or an interpretation transmitted by way of Castile remains unknown. One series of such Italian Renaissance wares was polychromatic, combining blue, orange, and brown on a milky glaze. The most usual design was that of a large human or animal filling the main field of plate obverses or the interior of bowls, which was framed on either side by erect vegetal elements such as trees, flowers, or petals on curved stems. The very thick pattern on the brim of the plate illustrated in Figure 30 is typical of the approach to this style by Barcelonian maiolists. Borders were treated differently in other Spanish workshops, even though Italianate centerpieces remained similar.

Figure 28
Bowl
Villafeliche, 18th Century
Dia. 27.5 cm.
Earthenware with tin glaze and manganese in-glaze decoration.

Figure 29
Plate
Villafeliche, 18th Century
Dia. 29.5 cm.
Earthenware with tin glaze and cobalt in-glaze decoration.

44

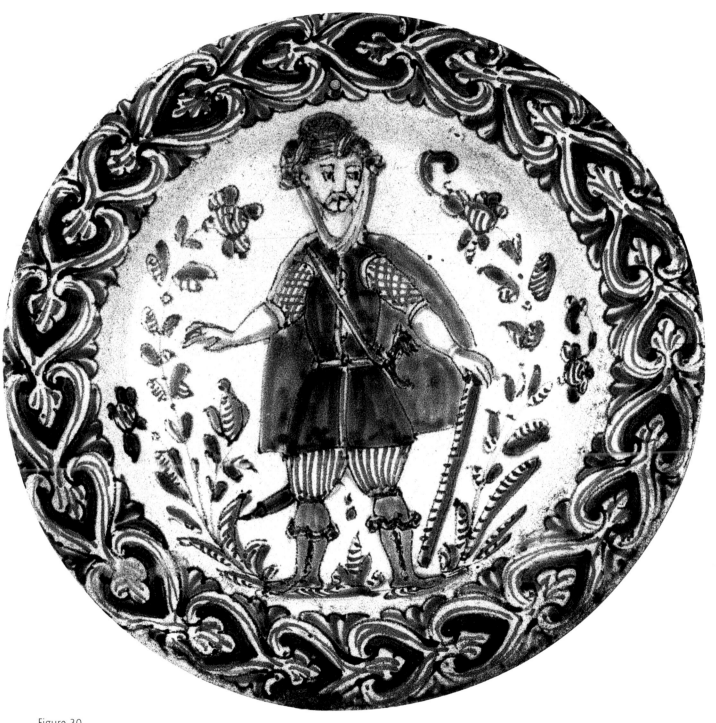

Figure 30

Plate

Barcelona, Mid-17th Century

Dia. 34 cm.

Earthenware with tin glaze and cobalt,
iron, and manganese in-glaze decoration.

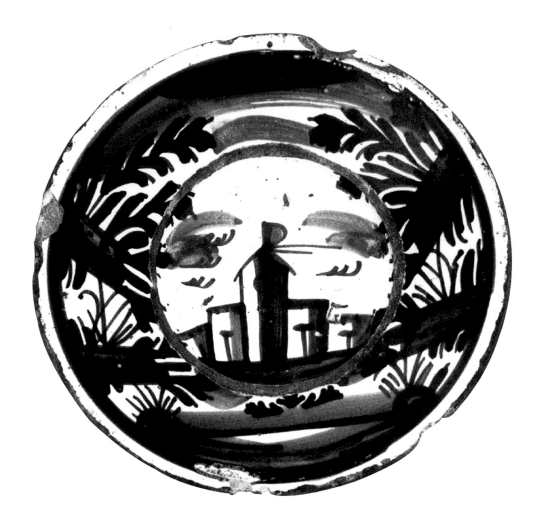

In the center of the vessel appears the erect figure of a probable soldier or seaman. His scabbard and lance, full knee breeches, blue-decorated hose and soft slippers, belted jerkin, and blue cape faithfully portray the clothing styles of the early seventeenth century. The turban headgear with an attached scarf around the chin and the mustached face appear almost Oriental and may represent one of the Barbary pirates who, after the expulsion of the *moriscos* early in the seventeenth century, caused much trouble for Catalonian shipping plying the western Mediterranean. On the other hand, scarfed headpieces were not uncommon military dress. The technique of drawing a figure in manganese outline shaded at the edge by a light-blue wash, the stance, and the use of alternating solid blue and lined, or *rayado*, orange elements are very characteristically Spanish. There is no exterior decoration.

The vessel is wheel-thrown, with a modest well, a broad horizontal marli, and a narrow ring foot. The glaze on both surfaces is slightly pebbled or of orange skin texture. Three cockspur scars indicate that neither individual saggars nor under-rim support pins were used during glaze firing. One surface blemish resulted from the vessel having been pushed too close to another object during stacking of the kiln.

Figure 31
Plate
Barcelona, 18th Century
Dia. 21 cm.

Earthenware with tin glaze and cobalt in-glaze decoration.

A shallow plate of eighteenth-century date illustrates one of the most common Barcelona styles borrowed from Savona on the Ligurian coast of Italy (Figure 31). The decoration, restricted to the obverse, is a combination of dark and light blue. On the wide brim is a depiction of trees with trunks and branches seemingly nailed to the vessel. Usually three such units were placed at each side of a central motif, but only two appear on this specimen. It is a pattern similar to but not identical with one known in Barcelona as *butifarra* (Batllori Munné and Llubiá Munné 1949, figs. 168–71, 200–1). In the depressed center of the plate is a stylized architectural element set on a ground line and backed by clouds. This building configuration of a tower framed by side elevations is an extremely common motif on Spanish vessels of the time. The plate form with a marked central well is typical of eastern Spain, particularly during the eighteenth and nineteenth centuries, probably originally taken from the Italians. As in this instance, glaze tended to wear off the sharp angle between brim and well.

The central depressed well of the two plates in Figures 32 and 33 and their quartered pattern of clusters of three dots and attached smaller dots regarded as cherries, giving rise to the name for the style of *de la cerecita*, identify the specimens as being from Barcelona factories of the first half of the nineteenth century. The groups of graduated lines pendant from rim bands are typical of Catalonia in this period, but the influence of Dutch design permeated the overall effect. The decoration is in two shades of blue cobalt on this example, but substitution of manganese is known (Batllori Munné and Llubiá Munné 1949, fig. 249E). Minor differences in size and drawing seen here may be attributed either to distinct workshops or artisans.

Figure 32
Plate
Barcelona, Early 19th Century
Dia. 20 cm.
Earthenware with tin glaze and cobalt in-glaze decoration.

Figure 33
Plate
Barcelona, Early 19th Century
Dia. 20.5 cm.
Earthenware with tin glaze and cobalt in-glaze decoration.

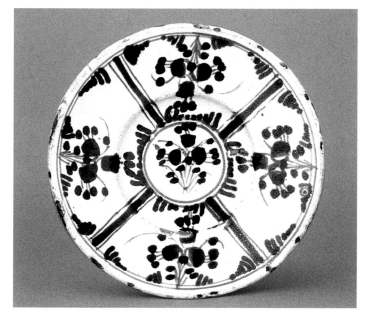

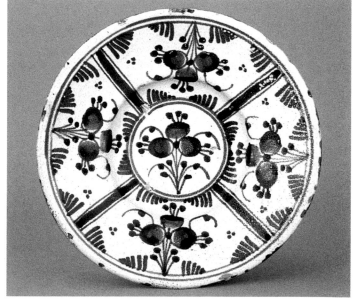

The specimen in Figure 33 was collected in Barcelona proper, but that in Figure 32 was found in Panama. Sherds and partial vessels of the same type also have been noted among excavated materials from the Caribbean island of Santo Domingo and from St. Augustine, Florida (Deagan 1987, fig. 4.34). Distribution of these ceramics so far from eastern Spain must have resulted from participation in the American trade by Catalonian ships which was not officially sanctioned until the second half of the eighteenth century.

The plate in Figure 34 probably is a later nineteenth-century interpretation of the same idea of design but with obviously less expertise. As in the earlier examples, the rim pattern flows down into the center depression but is divided into six rather than four compartments. The central zone as framed by an encircling blue line is more ample. The so-called cherries emerge as groups of dots off a central stem. Generally speaking, the line work is not as sure as that on the earlier pieces, spacing is irregular, and a cobalt contamination of the glaze imparts a faint bluish tinge to the ground. The specimen is thought to have been acquired originally in Mexico, hence suggesting Catalonian ceramic commerce to America continuing after Mexican independence.

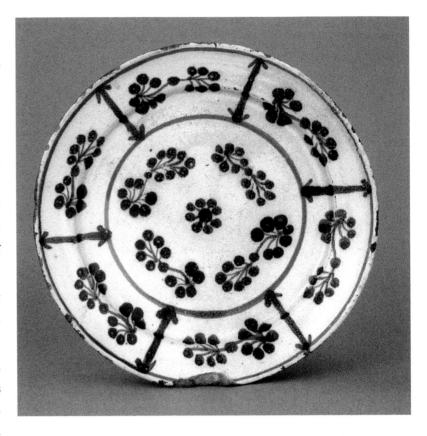

Figure 34
Plate
Barcelona, Second-half 19th Century
Dia. 9 cm.

Earthenware with tin glaze and cobalt in-glaze decoration. Houghton Sawyer Collection.

Two additional specimens at the Museum of International Folk Art, which are believed to represent nineteenth-century Barcelonian production, likewise were collected in Panama. Both were said by the vendor to have come from some rooms at Panama Viejo which were explored about 1910. However, it should not be assumed that this pottery had any connection with that old city, which served as a bastion on the west coast of the Isthmus of Panama and which, because of its rich treasure houses, was destroyed in 1672 by the English pirate Sir Henry Morgan. Off and on for years thereafter, up to the present, parts of the site were utilized by squatters who made homes of a sort amid the rubble. Apparently some of them came into possession of certain pieces of nineteenth-century Catalonian ceramics most likely traded by the merchant ships then coming sporadically to Caribbean waters.

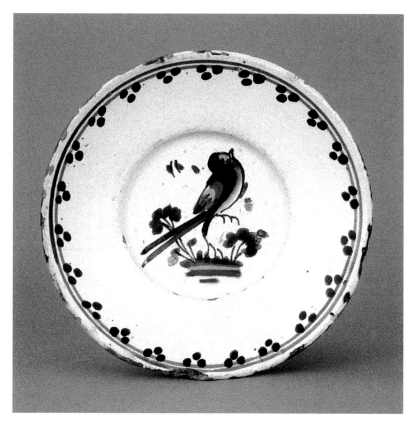

Of typical contour with central depression and a wide flaring rim, the small plate in Figure 35 bears a simple, well-executed polychrome decoration which in its restraint was characteristic of the period. Pendant from two dark-blue encircling lines at the rim is a series of three-dot clusters, an old device in Spanish ceramic decoration which enjoyed great popularity in Catalonia as rim patterns. Isolated in the plate well is a charming, long-tailed bird drawn in two shades of blue, yellow, orange, and dark green accompanied by some foliage and a ground line in yellow and orange. The identical interpretation of this bird motif is seen repeatedly on contemporary Catalonian wares (Batllori Munné and Llubiá Munné 1949, figs. 236a, b, c; 234a, b). There is no exterior decoration.

Workmanship is of good caliber, although the surfaces are marred with the usual cockspur blemishes. Crazing is minimal, but pinholing flaws the surface.

Very similar ceramics have been recovered at the ruins of a French post on Cape Breton Island in the North Atlantic Grand Banks (Fairbanks 1974, fig. 1–2). The fort was occupied during the mid-eighteenth century. Either the style of this ware was long-lived, having begun some fifty years earlier than the date suggested for this plate, or Spanish pottery was left in the North Atlantic long after the site where it was deposited was abandoned.

Figure 35
Plate
Barcelona, 19th Century
Dia. 20.5 cm.

Earthenware with tin glaze and cobalt, copper, antimony, and iron in-glaze decoration.

Several characteristics of the large plate shown in Figure 36 place its manufacture in the early to mid-nineteenth century. The use of black as a decorative pigment here illustrated was introduced at that time. It was not especially common, the Spaniards always retaining a fondness for brighter colors. Secondly, the pattern of repeated fine-lined swags separated by triads of splayed lines ending in dots, reminiscent of tassels on textiles, was inspired by work of the French engraver and designer in the court of Louis XIV, Jean Berain, which was popularized at eighteenth-century potteries such as that at Alcora located near Valencia. These designs continued to be used on lower-grade pieces into the next century. The broad but definite declivity of the plate marks this vessel as from Catalonian shops.

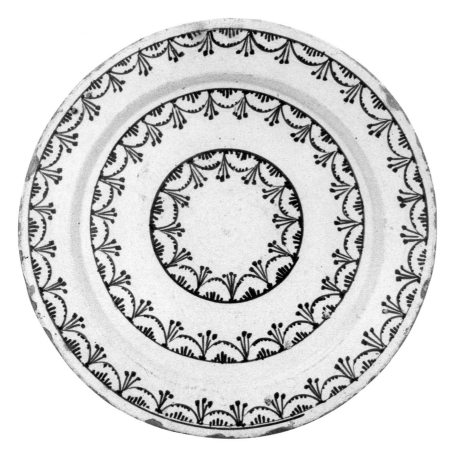

Figure 36
Plate
Barcelona, 19th Century
Dia. 39 cm.

Earthenware with tin glaze and iron in-glaze decoration.

Castile

It was in the central tableland that the manufacture of maiolica reached its zenith in Spain. First at Talavera de la Reina and then at Puente del Arzobispo, neighboring small towns located some one hundred miles southwest of Madrid, industries for the creation of such ceramics appear to have evolved early in the sixteenth century. The documents concerning first firings of Talaveran kilns are dated 1521 (Vaca González and Ruíz de la Luna Rojas 1943, 37), but there may have been such activity earlier. Elsewhere in Castile, most notably at Toledo, there was a reservoir of potting knowledge inherited from the Muslims, but at Talavera itself a fresh start had to be made. This situation worked to the advantage of the new endeavor because by this very token it was unencumbered by old lore, which was not always the best lore. An entire technology was imported wholesale from central Italy, where for a century some of the finest maiolica ever to be made had appeared. Such diffusion must have been furthered by itinerant Italian craftsmen in Spain and by Italian-influenced Flemings known to have come to Castile at this time (Frothingham 1969, 22; 1974, 5). Table-high potter's wheels; rectangular, double-chambered, vaulted-roofed updraft kilns; protective saggars and pins for supporting rims of stacks of flatware suspended in them; and a complex formulary for compounding the typically white Spanish glazes, fitting them to particular clay bodies, and creating a wider range of decorative pigments were introduced (Lister and Lister 1987, 149). Good local clays of light-burning color and high shrinkage rates were found, thus promoting a base of suitable density but which did not cause glaze coatings to craze extensively. One intangible quality of artisanship also appears to have diffused with Italian methodology, namely, a concern for finishing details which too often were not of impor-

tance to potters who drew upon Islamic resources. Most importantly, a core of decorators with a lively interest in new stylistic orientation emerged. To their credit, even while maintaining a degree of originality, they were able to assimilate design conventions which were dramatically different from those coming from the hands of the contemporary *moriscos* of Manises, and they were able to translate them with a deftness independent of the emphasis on line usual in Italy. The Italian Renaissance in new but recognizable dress had arrived in the making of Spanish hollowware more than a century after its inception in Italy.

Other factors gave Talavera an advantage in the commerce associated with pottery-making, which in turn was an integral part of the prominence achieved. At mid-century Madrid was selected as the capital of Spain, and members of the royal court there made a public show of appreciation for local crafts, including pottery. The king himself, in an effort to improve the quality of the products at Talavera, brought a master craftsman from Sevilla, to that time the best-known ceramics center in western Spain, to instruct local artisans in the compounding of better glazes and pigments. Skilled *flamencos* (Flemings) likewise set up shop, their activities obvious to regional craftsmen. Through such conscious efforts at improvement, at the end of the sixteenth century Talaveran artisans had mastered their medium, organized themselves into a flourishing guild, and were setting the pace for potters throughout Spain. In 1601, a financially desperate monarchy discouraged and even prohibited the use of metal table services in an edict which further played into the hands of the Talaveran industry. The nobility, always given to conspicuous consumption, turned to use of ceramics. Those of Talavera and Puente del Arzobispo were the closest and unquestionably the best at hand. Such patronage promoted sales throughout the realm, and because prices on pottery remained relatively low, customers ranged from the friars at the royal pharmacy of the Escorial to humble tavern keepers of roadside inns. Popular items inevitably inspire imitations. Hence, workshops around the country, among them some in Sevilla, quickly duplicated vogues introduced at Talavera. The result was that the name of the town became synonymous with Spanish maiolica, in the same way that Faenza became identified with faience.

Among the earliest styles so far associated with Talavera, and which incidentally exhibits Italian inspiration, is that shown on a small plate in Figure 37, which is believed to be of late-sixteenth- or early-seventeenth-century age. Over a buff-colored glaze, a narrow border framed by brown or black lines and containing dark-blue S-scrolls separated by orange crosshatchure encircles the vessel below the rim. The cavetto is undecorated. The framed basal pattern consists of a wheel of alternating blue and orange fronds joined at the outer circumference by arched, paired brown lines. In the very center bottom a framed hub is quartered by double blue lines, the spaces in between filled with double orange Vs. Although this pattern is very typical, frequently a monogram of the Virgin, the three keys of the Passion, or a floral arrangement are central designs. Exterior decoration is absent on this specimen. The palette and many of the components of the design and their disposition in the field differ from anything made previously in Spain.

The contour of this unelaborated plate is distinctive both from the heavy-walled, indented-base form typical of sixteenth-century Sevilla and from the plate having a sharply angled horizontal brim which would become standard at seventeenth-century Talavera.

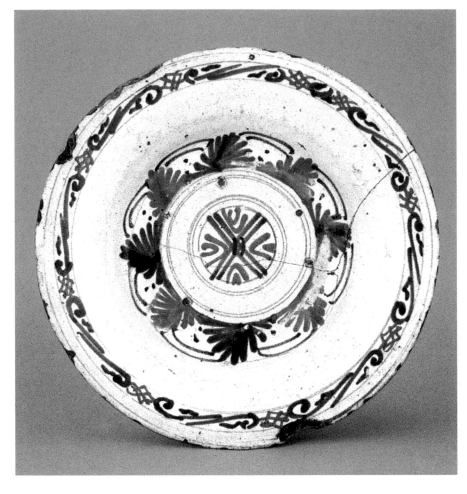

Figure 37
Plate
Talavera de la Reina, Late 16th–
Early 17th Century
Dia. 22.5 cm.
Earthenware with tin glaze and cobalt,
antimony, and iron in-glaze decoration.

The same borrowed blue, orange, and brown color scheme was used contemporaneously in Castile for another common vogue based upon naturalistic and figural elements. Gracefully curved flowers and shrubs framed animals such as the ever-popular bird, human busts either in profile or full face, standing figures, castles, or escutcheons. Delineation of motifs was made in brown, the motifs themselves being painted with solid zones of blue or hatched zones of orange.

There is one example of this decorative mode in this collection (Figure 38). It has further interest in being a moldmade form making its first appearance in Spanish ceramics. A square box with a central depressed bowl (*hueco*), this form may have served either as a salt cellar (*salero*) or an inkwell (*tintero*). The fact that no holes to accommodate quills are present in the upper surface makes the former function more probable.

Base glaze on this specimen is white. Stylized floral decoration of palmettes and leaves on the sides, placed horizontally on two sides and vertically on the other two, is outlined in brown and filled in part with solid blue and in part with parallel orange lines. The top bears a quarter-flower at each corner in the same colors, the well being undecorated.

Although formed in a mold, the sides are not of equal height nor is the depression exactly centered. The vessel is open on the bottom directly beneath the well for easy removal from the mold and to avoid cracking during firing.

Not all the design grammar at Talavera came from Italy. Some Flemish conceits are notable. But of more importance was the fact that in the late sixteenth and early seventeenth centuries Castilian potters joined others throughout western Europe in imitating, directly or indirectly, the current modes and colors of

Chinese porcelains, particularly those assignable to the Wan Li period of the Ming Dynasty (1573–1619). Most such Oriental influence appears to have filtered through Talaveran workshops as a result of Dutch copies, although actual examples of porcelain reached Castile via Sevilla and Lisbon. It should be remembered also that Portuguese, Italians, and Sevillians made their own Chinese imitations, any one of which could have served as models for the Castilians.

Figure 38
Salero
Talavera de la Reina, Late 16th–
Early 17th Century
Ht. 5.7 cm.
Earthenware with tin glaze and cobalt, antimony, and iron in-glaze decoration.

Most early Talaveran reproductions of Chinese patterns were more faithful to the original models than were later pieces. Deer, birds, foliage, and various borders such as lotus panels were meticulously rendered (Ainaud de Lasarte 1952, 271, fig. 723; 272, figs. 724, 727). The influence of Delft work on Talaveran artisans of the time seems clear.

The plate illustrated in Figure 39 is the most common local response to Eastern style —a compartmentalized cavetto in blue pattern over milky-white glaze, beaded or linear dividers between panels, and a framed centerpiece with a *golondrina*, or swallow, amid foliage. A fusion of ideas is indicated because the fern pattern on the rim, known in Spain as *helecho*, laid horizontally with a central solid flower usually called a daisy, had been used in a different arrangement by *morisco* Aragonese potters of the fifteenth and sixteenth centuries (González Martí 1944: Vol. 1, Pl. 25, fig. 672).

In 1604, a boatload of Chinese porcelain highjacked by the Dutch from the Portuguese set off a wave of reproduction which lapped through the young maiolica workshops of western Europe. Called *kraskporselein* by the Dutch, one particular pattern on many vessels in the shipment quickly took the fancy of Western imitators. That was the compartmentalization of borders such as appears on this Spanish example. Original versions made use of from eight to twelve panels, each filled with the same design, totally distinctive yet compatible designs, or alternations of designs in various combinations. Central areas, usually framed by diapered devices, contained landscapes. A comparison of some late-sixteenth-century Ming plates (Pope 1956: Pl. 100–04 with the plate shown here, which is very typical of early-seventeenth-century Talavera, will reveal how vast was the difference between the workmanship of the two peoples. At least one plate is known with an unusual merging of this Chinese mode and a typically Spanish Franciscan escutcheon (Ainaud de Lasarte 1952, 272, fig. 726).

Glaze on this specimen is whiter and the cobalt is darker or less greyed and more granular than seen at earlier periods. The pigment pooled where laid down heavily.

This plate has a smooth well sloping up to a direct rim without any sharp angle or ridge separating the two zones, very much the same contour as that in Figure 37, with which it was in part contemporaneous. There is no horizontal marli. A low ring foot was trimmed on the base of the thrown vessel. Cockspur scars appear on both surfaces. The exterior is pinholed and has some speckling from cobalt contamination.

A moldmade inkwell, or *tintero*, in the shape of an eight-pointed star, the specimen in Figure 40, has eight quill holes around a larger central opening. All surfaces except the bottom are covered with an opaque-white glaze which flowed slightly in areas that were overexposed to high drafts in the kiln. The dark-blue *helecho*, or fern, motif which graces the top and each side of the angular points is similar to that in Figure 39, considered to be a seventeenth-century fashion. Execution here is not very well done. The motif appears on the *tintero* as a partially filled ovoid floral element with lateral and vertical sprays of graduated pinnates balanced off a stem line. The four borders of each point projection and the rim of each quill hole are narrowly lined with blue.

Even though formed in a mold, the sides are irregular. In most later examples of inkwells the central opening actually was a small cup or bowl depressed into the top surfaces rather than being open to the interior as in this case.

Because the knowledge of writing was restricted to the upper social classes, the inkwell, either metal or ceramic, became part of the iconography of the portrait painters of the time when they wished to convey the impression of importance or high status to their subjects. Religious or civic figures, for example, usually appeared standing by tables on which an inkwell with quills was prominently displayed.

In Spanish workshops pharmacy jars were made in several shapes. The *albarelo* taken from Muslim grammars expectedly was most typical because most pharmaceutical knowledge also was passed to Christian Spain from Islam. Another shape which appears descended from a modified Chinese barrel contour is the *bote*, sometimes also called the *tarro* (Lister and Lister 1976, 26, 83), characterized by a bulbous body above

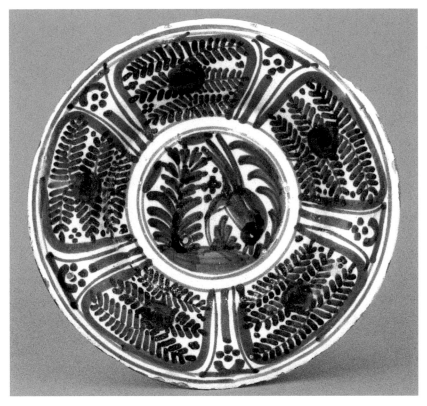

Figure 39
Plate
Talavera de la Reina, Late 16th–Early
17th Century
Dia. 22 cm.

Earthenware with tin glaze and cobalt
in-glaze decoration.

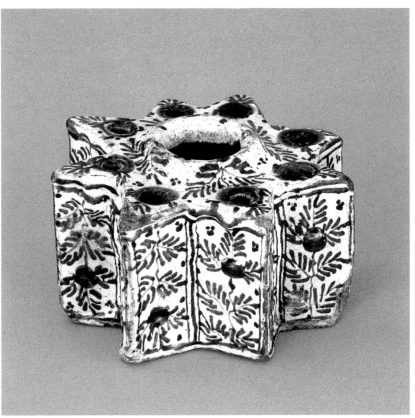

Figure 40
Tintero
Talavera de la Reina, 17th Century
Approx. dia. 14 cm.

Earthenware with tin glaze and cobalt
in-glaze decoration.

a narrow base tapering to a wide mouth only slightly narrower than the base. Generally, ribbing of clay strips was added while the vessel was at the leather-hard stage to further define borders of the principal decorated zone and the mouth. Decoration on these jars was formalized into a leafy scroll placed about the tapered neck which comprised a quarter of the total field, a broad figural scene covering approximately half the body around the midsection, and the name of the intended contents set amid a matching floral scroll in the bottom quarter-field.

The specimen in Figure 41 is typical in all respects of the Castilian *bote* series. On one side of the vessel the pictorial zone is graced by a hunter with gun and dog drawn in light blue, outlined in darker blue, placed between a palm tree on one side and a larger tree filling the vertical expanse of the area on the other. The stances of the man and animal suggest the movement characteristic of Talaveran pictorial work of the early seventeenth century, while at the same time the rather suggestive rendering of vegeta-

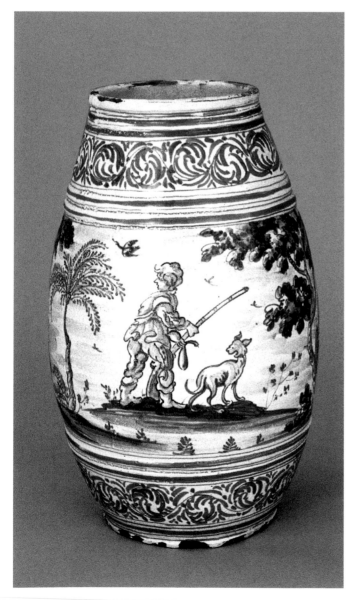

Figure 41
Bote
Talavera de la Reina, Late 17th Century
Ht. 32.5 cm.

Earthenware with tin glaze and cobalt and antimony in-glaze decoration and appliquéd decoration.

tion is indicative of a time of declining concern with realistic portrayal which is usually placed toward the end of the century. On the opposite side of the *bote* is a large escutcheon of the Escorial, a divided shield with the grid of Saint Lawrence on the left and the rampant lion of the Hieronymite Order on the right, topped by an abbot's cap, or *capela*, framed by the tiered pendant tassels of his belt. The monastery and associated pharmacy of the royal Escorial, under direction of the Hieronymites, were dedicated to Saint Lawrence, who was martyred in Rome in the year 258 by being slowly roasted on a gridiron. The background of the pictorial band is streaked with light blue in a customary Talaveran mannerism. The lower band bears the words SANGS, DRACO executed in orange with a blue floriated scroll matching that at the neck filling in the remaining space. *Sanguis draconis* is the botanical name for dragon's blood, a plant native to the Spanish Canary Islands which was used as astringent medicine to arrest bleeding.

Of all its ceramics, Talavera was most famous for its elaborate polychromes of the seventeenth century which made prominent use of greens, yellows, and browns to produce landscapes, often with animated animals or human figures engaged in such activities as hunting, fishing, or bullfighting. Some of the better scenes have been demonstrated to have been taken almost literally from engravings widely dispersed around Europe (Frothingham 1943, 96–117). Others depict more simply drawn animal, architectural, or human elements in pastoral settings. And as with all its ceramics, neighboring Puente del Arzobispo so successfully duplicated them that present attribution is open to question.

There is only one example of this polychrome vogue in the collection, and it is unique in combining green, yellow, and brown figural elements with blue escutcheons (Figure 42). Opposite sides of the jar are decorated with a naturalistically portrayed prancing horse set on a ground between pairs of erect shrubs or flowers which satisfied the Talaveran's need for framing. The crest which appears on two sides of the vessel is that of the Hieronymite Order, namely, a rampant

Figure 42
Orza
Puente del Arzobispo,
Late 17th Century
Dia. 33 cm.

Earthenware with tin glaze and cobalt, copper, iron, and antimony in-glaze decoration.

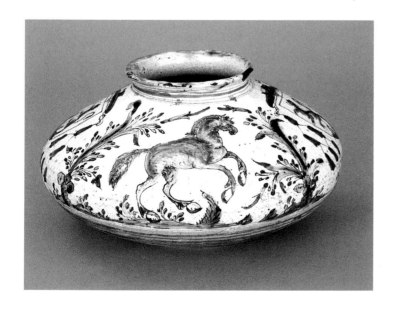

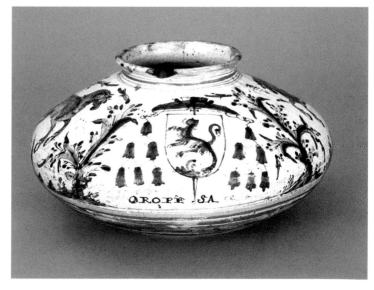

Figure 43
Especiero
Talavera de la Reina, 17th Century
Ht. 5.5 cm.

Earthenware with tin glaze and cobalt, antimony, and iron in-glaze decoration.

lion on a shield topped by an abbot's cap and bordered at each side by six tiered tassels. Although, as mentioned earlier, the Hieronymites were the controlling order at the Escorial, there is no indication that this jar was made for that vast establishment. More likely it was a piece commissioned by one of the family members residing at Oropesa, the word Oropesa appearing beneath one crest.

The castle of Oropesa caps a hill rising above the plains some twenty miles south of Talavera and eight miles west of Puente del Arzobispo. It was the palace of Don Fernando Álvarez de Toledo, who in 1475 was granted the title of Conde de Oropesa by Enrique IV of Castile. One of his more illustrious descendants, Don Francisco, born in the castle in 1515, became the governor of the Viceroyalty of Peru, a post he held for twelve years. Most of Don Francisco's properties were bequeathed to the church, very possibly the Hieronymites being included.

The flattened profile of this jar was not a common form in usual Spanish repertoires, but it did occur during the late seventeenth century. The whiteness of the background glaze suggests that this pot was made in a workshop at Puente del Arzobispo rather than at Talavera. Potters at the latter place were inclined to copper shading which tended to diffuse into the glaze during firing to produce a very green caste to the ground. Additionally, the sort of bands composed of broad, multicolored lines which demark upper and lower limits of the main field of design became a later characteristic of Puente del Arzobispo ceramics.

A triangular molded shape with three small recessed concavities bears a simple blue, ochre, and brown linear decoration on sides and top (Figure 43). Additionally on each side is a low head in relief. The white glaze has worn off the rims of the depressions, which are slightly raised above the box surface, and off the modeled heads, thereby revealing a dark paste. The bottom is merely a triangular frame open beneath the wells to permit easy removal from the mold and also to allow the steam formed during baking to escape without cracking the object.

During the seventeenth century an enrichment of life for most Spaniards entailed the increased usage of spices and condiments which were reaching Europe as a result of the East Indies trade, expanded contact with the African coast, and growing familiarity with the Americas. Specialized containers (*espieceros*) and serving dishes evolved as a result, one of which is this particular piece.

The two preceding vessels are representative of the highest grade of Castilian maiolica, although they themselves are not as elegant as many similar pieces. Contemporaneously with the evolution of their styles, another kind of decoration was used on lesser objects which generally was restricted to a coat of arms of purchasers, often a religious house, and, in the case of drug jars, a label of intended contents. Much of the white ground was thus left exposed, the design being in one or two shades of cobalt blue.

There are four vessels in the collection which exemplify this style. Among the most interesting examples is the tall drug jar in Figure 44. Its *albarelo* form originally was Islamic; the design it bears is symbolic Christian. The Pelican in Her Piety, such as comprises the major decoration on this jar, entered the vast grammar of Church iconography about the thirteenth century when it came to represent the Atonement. It was believed that the bird plucked at its breast to draw blood to nourish its young, providing a symbol of Christ's sacrifice and resurrection. For this reason the pelican often is depicted with her young. On this vessel above the bird is the Imperial Crown. Below the bird is a *cartela*, or label panel, terminating in fleur-de-lis, where the drug name was to be inscribed. It can be assumed that the vessel once was used in a royal pharmacy.

Both surfaces are glazed in a milky-white coat obscuring a rather dark paste. Design utilizes two shades of blue. The jar is ring-footed and has a rounded, thickened rim. Originally it may have had a domed ceramic lid.

A double-headed spread eagle supporting a rectangular blank shield and surmounted by a jeweled Imperial Crown decorated the small drug jar in Figure 45. It is likely that the use of the so-called Hapsburg eagle on this vessel is an example of the retention of a symbol of earlier times. The imprecise linework and the rounded contours of base

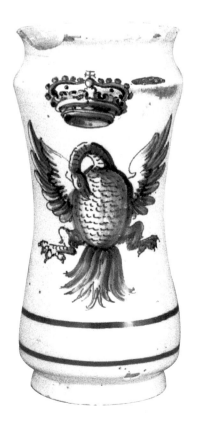

Figure 44
Albarelo
Talavera de la Reina, Second-half
17th–First-half 18th Century
Ht. 28 cm.; dia. at rim 12 cm.

Earthenware with tin glaze and cobalt
in-glaze decoration.

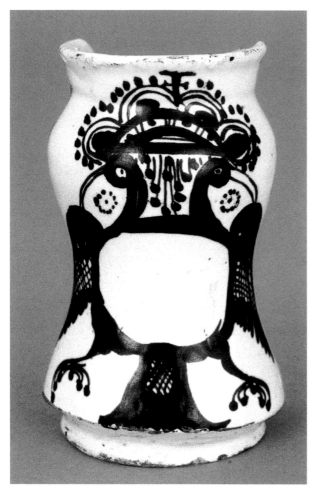

Figure 45
Albarelo
Talavera de la Reina, 18th Century
Ht. 10.8 cm.; dia. orifice 5 cm.
Earthenware with tin glaze and cobalt
in-glaze decoration.

and shoulder suggest an eighteenth-century date of manufacture, a time when the Bourbons ruled in Spain.

Glaze is very opaque blue-white. Decorative pigment is a dense blue so dark that it verges on black. The thin-walled body is concaved with a short, flared neck. No lid is present.

Figure 46 is of a small plate with flat center, outward-sloping walls, direct tapered rim, and low ring foot which bears only a medium blue rim band and a central coat of arms in two tones of blue over a semiglossy white glaze. An oval shield, with a blue diagonal band, is framed by scrollwork and surmounted by an abbot's cap and at each side a looped belt braid ending in pairs of six tiered tassels. On the

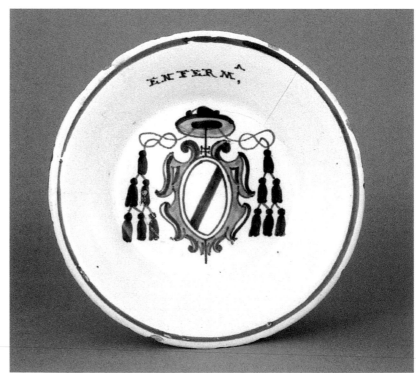

Figure 46
Plate
Talavera de la Reina,
First-half 18th Century
Dia. 23 cm.
Earthenware with tin glaze and cobalt
in-glaze decoration.

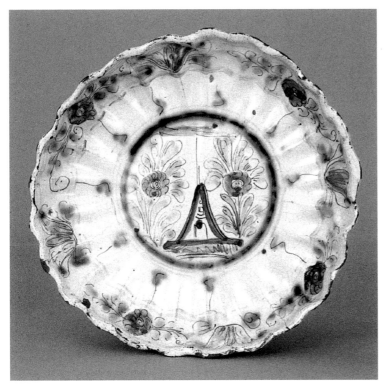

Figure 47
Salvilla
Talavera de la Reina,
First-half 18th Century
Dia. 25.5 cm.

Earthenware with tin glaze and cobalt, copper, antimony, and iron in-glaze decoration.

cavetto at the top of the escutcheon is the word ENFERMA, indicating that the vessel was used in an infirmary operated by an unidentified religious house. There is no exterior decoration.

The molded salver in Figure 47 has fluted walls with a foliated rim and rests on a pedestal foot which was attached at the leather-hard stage with enough pressure to cause a slight warping in the center of the bowl. The glaze was meant to be white but became contaminated with copper, which promoted a green tinge to the ground. The design, influenced by contemporaneous styles of the Alcora factory, consists of alternating blue, orange, green, and brown floral sprays around the rim and a central architectural element framed by erect florals on each side.

The delicate shape and decoration are typical of the French Rococo styles of the eighteenth century which were initiated at Alcora in 1727 and subsequently influenced most Spanish potteries.

The ceramic industry in Castile entered a long period of decline following its seventeenth-century bloom as a result of economic distresses which engulfed the entire nation. Also, the public began to tire of usual Talavera styles and found drawbacks to maiolica's soft paste and glaze. Religious and Renaissance themes which had been commonplace palled so that Barcelona factories quickly garnered the eighteenth-century tile market with an exceedingly popular genre series. In hollowware Alcora designers came forth with patterns and forms for maiolica, porcelain, and then creamware which had new appeal and which rapidly captured the fancy of buyers.

Nonetheless, even though markets were dwindling and the number of artisans at Talavera was diminishing, the traditional blue monochromatic armorial types continued to be made with little change from the past centuries. The green-yellow polychromes altered more obviously in being scaled down in size, simplified in design, glazed with solutions having a lower tin content, and painted with only an occasional touch of blue. The rich pictorial scenes of the preceding century, never suitable for ceramics, became standardized into one or two unvarying representational elements posed on a ground between groups of floral erections

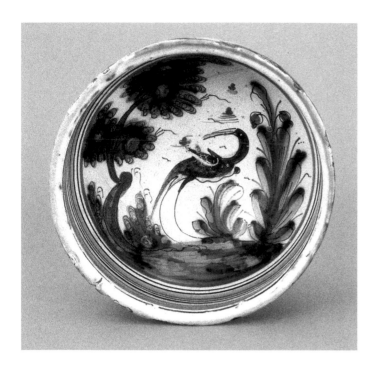

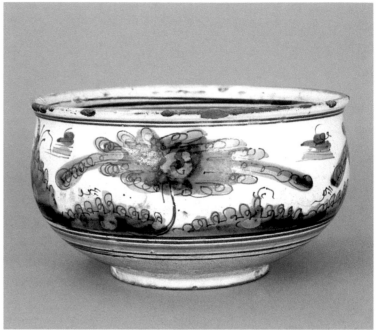

Figure 48

Bowl

Talavera de la Reina–Puente del Arzobispo, First-half 18th Century

Dia. 24.1 cm.

Earthenware with tin glaze and cobalt, copper, antimony, and iron in-glaze decoration.

and backed by a streaked sky. Exteriors of closed forms continued to carry patterns, but they too were always the same conventionalized shrubs on a wavy ground surrounded by space fillers or clouds. Both interior and exterior design panels were banded by units of parallel encircling multicolored lines. It is noteworthy that, even though the peak period of Talaveran maiolica had passed, workmanship remained of a comparatively high quality. Both form and decoration were pleasing.

The full-bodied hemispherical bowl in Figure 48 is a good example of shape and design of Castilian maiolica of the first half of the eighteenth century. Rapidly applied curved strokes form a *zancuda*, or long-legged crane, which stands in the bowl bottom. Outlined in black, the body is green and yellow. The customary tree or bush decorates the bowl's outer surface.

Another version of the polychrome style commonly employed during the declining phases of Castilian maiolica appears on the salver in Figure 49. Known as *montería*, this late vogue is characterized by use of a predominately green, yellow, and brown palette, with a rare accent of blue, on a cream ground which resulted from lower tin content of the glaze and a redder paste. As in this example, the main field of decoration covers most of the interior surface of flatware. On closed forms the field of decoration was equally as expansive, generally reaching from shoulder to foot. Within a framework of numerous encircling lines of various widths and colors, either animal or human figures are drawn on a ground between two foliage elements. Sky spaces usually contain cloud fillers made up of yellow splotches overlaid by a few brown defining lines. All brushstrokes are rapid and cursory. Obviously this was a folk style produced in large quantities for a wide market.

Figure 49
Salvilla
Talavera de la Reina–Puente del Arzobispo, First-half 18th Century
Dia. at rim 27.5 cm.

Earthenware with tin glaze and cobalt, copper, antimony, and iron in-glaze decoration.

Salvers were made in two pieces, both wheel-thrown and joined while at the leather-hard stage. Presumably they served as fruit or dessert servers.

At Talavera de la Reina and Puente del Arzobispo, further popularization of maiolica during the eighteenth and early nineteenth centuries produced simple floral and naturalistic designs, largely drawn in yellow and green outlined by brown, on forms suitable for diverse household purposes such as basins, jars, plates, and casseroles. Glaze continued to be cream-colored rather than white.

The *alcuza* (pitcher) in Figure 50 has a full body with high shoulders, a single-strap handle located from narrow neck to high shoulder, and a small pouring spout which remained erect rather than slanted downward. Decorated in typical *montería* colors is a blue bird with yellow breast flanked by large, stylized sprays of foliage shown in green, yellow, and brown. His configuration is not much different from bird motifs used three hundred years earlier. Two blue lines encircle the neck of the pitcher, balanced by a pair of yellow lines separated by a black serrated line at the base. Frondlike elements serve as space fillers. Thus the style conventions evolved early in the history of Talaveran maiolica—framed decorative panels, use of ground lines, figural motifs balanced on either side by florals, and space fillers—remained unviolated.

Erect conventionalized floral elements of ochre, yellow, and blue overlaid with fine brown-black lines encircle the upper body of a single-handled, narrow-necked jug covered with a cream glaze in Figure 51. The lower body is striped by yellow, green, blue, and ochre straight lines of varying widths and spacing and a prominent zigzag in brown-black. The flattened strap handle pulled from lower neck to upper shoulder is swiped horizontally in blue lines. Two blue lines appear at the neck base from the point of handle attach-

Figure 50
Alcuza
Talavera de la Reina–Puente del
Arzobispo, Mid-18th–Early 19th Century
Dia. orifice 7 cm.

Earthenware with tin glaze and cobalt,
iron, copper, and antimony in-glaze
decoration.

ment. Decoration, which in the late 1700s still included some cobalt blue in a palette becoming increasingly dominated by green and yellow, has a sharpness lacking in later work.

The vessel is flat-based for greater stability and outfitted with a small pouring spout which was not slanted downward.

Del pino, as the style on the plate in Figure 52 is called, because the principal motif appears to represent a lone central conifer on a ground between paired shrubs or hills, characterized Talaveran and Puente del Arzobispo work early in the nineteenth century after the kilns, which were destroyed during the Napoleonic

Figure 51
Alcuza
Talavera de la Reina–Puente del
Arzobispo, Mid 18th–
Early 19th Century
Dia. 19 cm.

Earthenware with tin glaze and cobalt,
copper, antimony, and iron in-glaze
decoration.

64

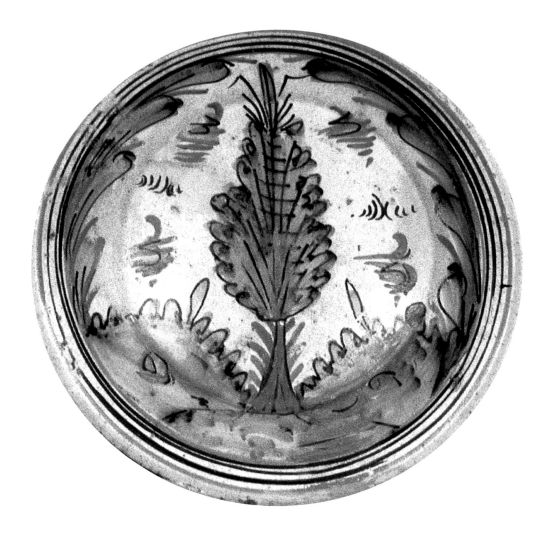

wars, were refurbished. It is interesting to note that the nineteenth-century *pino* is a faint reminder of the thirteenth-century *hom*, or Tree of Life, made at Paterna in the very beginning of Spanish maiolica production.

Typical in every way to the *del pino* mode which was mass-produced for common homes and inns, this shallow bowl or plate is glazed in a creamy coating and is decorated on the interior in the usual pine or cypress, hillocks, and traditional curved framing in green washed with yellow and defined in brown. The rim area is banded by three narrow brown lines and a broad yellow line on the rim edge. Sky fillers are graduated horizontal lines of yellow, green, and touches of brown.

In Castile the *lebrillo*, or basin, made an important appearance in the *montería* period of the late nineteenth and early twentieth centuries when it was produced in considerable quantity in sizes ranging from medium to enormous. Puente del Arzobispo seems to have been the major source for these vessels that were sold widely throughout Spain (Figures 53, 54).

Figure 52
Bowl
Talavera de la Reina–Puente del Arzobispo, Early 19th Century
Dia. 30 cm.

Earthenware with tin glaze and copper, antimony, and iron in-glaze decoration.

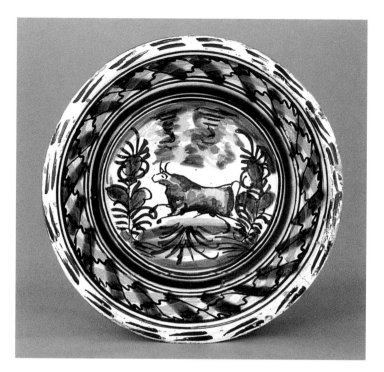

Figure 53
Lebrillo
Puente del Arzobispo, Late 19th–
Early 20th Century
Dia. 65 cm.

Earthenware with tin glaze and copper,
antimony, cobalt, and iron in-glaze
decoration.

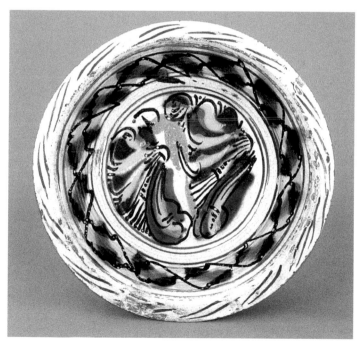

Figure 54
Lebrillo
Puente del Arzobispo, Late 19th–
Early 20th Century
Dia. 33 cm.

Earthenware with tin glaze and copper,
antimony, cobalt, and iron in-glaze
decoration.

 Except for size, the functional form did not vary and quite obviously was made on a production line. A broad, flat bottom, left rough as it was cut from the wheel head, is surrounded by steeply raised ribbed sides that terminate in a pronounced, thickened rim that slopes downward on the exterior of the vessel. The throwing ribs and heavy rim were attributes which gave body strength to vessels that were to be put to rough, everyday use. Decoration is equally standardized. On the interior a crudely crushed landscape, ani-

mal, or floral pattern fills the flat center. Yellow, green, and brown are most common colors. About the wall a framed zone swiped irregularly in green and yellow is superimposed by an interlocking diamond chain made up of black zigzag lines. The heavy, flattened rim edge is dashed with pairs of blue lines (Lister and Lister 1987, fig. 94f; Pleguexuelo Hernándex 1985, Pl. 87, 91–92). Exteriors are undecorated. At the end of the nineteenth century a ceramic tradition which once had flourished under the auspices of royalty was reduced to supplying kitchen crockery, of which these *lebrillos* are typical.

Andalusia

Sevilla probably had one of the longest experiences in the making of maiolica of any center in Spain. Craftsmen there are known to have been heir to the green-brown bichrome tradition of the Córdoban caliphate, to have made glazed tiles which covered some revetments of the twelfth-century Torre del Oro, and to have produced some blue-on-white pottery by the thirteenth century. The Repartimiento following the reconquest of the city in 1248 by Ferdinand III led to an evacuation of the Moorish population—artisans, merchants, scholars, and administrators—and their replacement by Old Christians from Castile in the north. Although the continuation of most Islamic concepts of design suggests that occasional Muslims were tolerated in the city and that others likely drifted back after the original exodus, the newcomers who moved in did not have deft potting skills bred of long familiarity with the craft. Natural disruptions of productivity must have ensued as economic recovery focused on rural agriculture rather than urban industries.

In the middle of the fourteenth century when Pedro the Cruel began to build a *mudéjar* palace in Sevilla over Roman, Visigothic, and Almohade rubble near the old mosque, he was forced to import craftsmen from Granada and Toledo to do the tile work. Sevillians learned fast, however, and in time created mosaic panels, or *alicatados*, from maiolica tile fragments which were indistinguishable from those filling the walls of the Alhambra. Then they proceeded to devise several other kinds of tin-glazed tile which were original in technique but strongly Moorish in flavor. One of these processes typified fine Sevillian work of the fifteenth century, possibly extending into the first decades of the sixteenth century.

This process was called *cuerda seca* because lines drawn in a darkened, greasy substance prevented blocks of glaze in several colors from running together while molten. The hollowware decorated by this method were mostly small plates which probably were thrown upside down over a mold attached to the head of a potter's wheel, the exterior surface being shaped by means of a revolving template or jigger. Such a method was in common use at the time in Granada. Usual designs in *cuerda seca* were identified with Islamic art, such as complex interlaced geometrics or motifs spiraled out from a central hub, but they had to remain bold due to the limitations of the method itself. A few human heads in profile hint at the arrival in Sevilla during the fifteenth century of either Italian craftsmen or artistic input. Likely it was both, a situation which contemporary sculpture, architecture and painting confirm. *Cuerda seca*, being a specialized process requiring time and skill, was limited to vessels made for an exclusive market.

It should be pointed out that there is some academic debate in Spain over the question of whether *cuerda seca* should be identified with Sevilla or with Toledo. Because both centers shared other pre-six-teenth-century ceramic styles, it is possible that *cuerda seca* likewise was made in both places. The fact that the most extensive collection of such pieces was gathered in the last century in Sevilla certainly implies a local production (Ainaud de Lasarte 1952, figs. 624–34; Martínez Caviró 1969, figs. 88–123).

The second tile process unique to Sevilla, from whence it spread to other Spanish potteries, was called *cuenca* (Pleguexuelo Hernández 1985, figs. 8–12). In this case a metal or wooden stamp was used to impress a pattern upon soft tile blanks. The ridges created kept glaze from flowing during firing. *Cuenca* obviously was not appropriate for decorating hollowware because pressure needed to achieve a pattern would have caused distortion. *Cuenca* tiles decorated by colored glazes opacified by tin oxide continued to be made in Sevilla until the middle of the sixteenth century and are the oldest Spanish tiles found in the New World (Deagan 1987, figs. 5.1a, b, 5.2).

Concurrent with the increasing importance in Sevilla of tile manufacture, there was a large output of low-grade maiolica. One of the styles, decorated in blue banding lines and debased calligraphic inscriptions or traditional Islamic *atauriques* in purple, was made in most regions of Aragón and Castile where *morisco* potters worked from the fourteenth through fifteenth centuries. Sevilla is known to have received an influx of such people as, for example, some three thousand persons transferred there after the fall of Málaga. Some of them probably were potters who joined with local *moriscos* to continue old, customary designs. The second-grade maiolica types which were made during the ensuing sixteenth and part of the seventeenth centuries forsook designs borrowed from Islamic art grammars as being part of a past no longer the background of most of the work force. If decorated at all, these vessels were elaborated only with the encircling blue lines or a combination of crudely executed geometrics or floral abstractions. Nevertheless, an interesting methodological parallel is apparent in the plate form of the earliest of the undecorated series. It is exactly that which had been used for the *cuerda seca* treatment, probably having been thrown upside down over a mold attached to a wheel head which left a characteristic ridge around the interior of the center bottom (Lister and Lister 1987, fig. 62). One can imagine that at least in the late fifteenth century the two types were made in the same shops, one batch passed on to decorators of *cuerda seca* and one merely dipped in a solution of white glaze, but both continuing a technology with direct ties back to Muslim Spain. The whites and related blue-on-whites were crudely fashioned ceramics meant for low-level consumption. They came to the Americas in the household baggage of the colonists or as inexpensive trade merchandise.

Beginning early in the sixteenth century, Italian craftsmen are known to have begun moving into Sevilla, encouraged to do so by special concessions, such as freedom from taxation, granted by the monar-chy to attract them and by the presence there already of a number of their countrymen. In steadily increas-ing numbers throughout the century other foreign traders and artisans flowed through the port, the largest, most cosmopolitan of any in Spain. Among them were Flemings, themselves under artistic influence from

Italy. In the riverside emporiums of sixteenth- and seventeenth-century Sevilla, ceramics from China, Holland, England, Italy, and Portugal were to be found. Therefore, even while lesser maiolica continued to be made in age-old ways, introduced technology and design resulting from this diversified stimulus were accepted in the local manufacture of smooth-surfaced polychrome tile, sculptured figures, and high-grade hollow ware. In ceramics, as well as other arts, the sixteenth century was the formative period at Sevilla.

Because the tile and some pieces of sculpture, in the round and in bas relief, were affixed to structures, many known examples remain in Andalusia and in European and American places to which they were exported. Unfortunately, however, urban expansion and a series of natural and man-made disasters have nearly eradicated evidence of sixteenth- and seventeenth-century Sevillian hollow ware, which, not having shared a patronage of Spain's highest nobility such as was the luck of Talaveran maiolica, appears to have been destined to be used until broken and then discarded on a trash heap. Ideas of sequence and types of all grade wares produced at Sevilla come largely from random finds made during civic projects, a few sketchy documents, and excavations carried out in some of Spain's former overseas colonies which received goods from Sevilla. Although archaeological excavation in Sevilla would do much to clarify this matter, virtually none has been conducted. Were that accomplished, many pieces now regarded as from better-known Talaveran workshops might be demonstrated to have been made in Sevilla. It is also predictable that Talaveran shops made both fine and low-grade wares, although the latter are not generally recognized. If they were, the distinctions between Sevillian and Talaveran products might not appear so great.

One possible example of late-sixteenth-century Sevillian maiolica appears in Figure 55. The potting of this large, shallow bowl is fluent but unrefined. A prominent flattened center, surrounded by a wide, sloping cavetto, provided a field for decoration. There the focal element is a formée cross embracing in its arms Renaissance-style winged angel heads, which were among the most popular motifs copied from the Italians. Their rendition on this plate is comparable to that on many Sevillian tile panels. Floral conventionalizations are scattered about the framed side wall of the bowl which, although similar to Italianate interpretations adopted at Talavera, differ in their dotted detailing and spatial use. The exterior of the bowl is undecorated. Brushwork in medium and light blue and ochre, with some outlining in black, is not equal to the example illustrated in Figure 56, though this particular combination of colors, it should be noted, came to Spain via Italian agents. On media other than ceramics the orange arm of the cross motif traditionally was red. Inasmuch as that color does not withstand the temperatures necessary to mature a maiolica glaze, ochre was used as a substitute. Not until the latter part of the eighteenth century was an overglaze method, which would allow the successful firing of red, developed at Alcora. The background of this example is heavily streaked in light blue in a manner reminiscent of that on some Talaveran examples, but with less success.

One of the most common firing mishaps damaged the specimen. A large, jagged crack spread across the flattened bottom, probably as a result of the stresses of uneven or too-high temperatures during glost firing. It is of interest that instead of being discarded as a waster, which certainly would have been the case in the better shops, this vessel was repaired on the underside with wire rivets and no doubt sold as a second. At a later date the crack traveled.

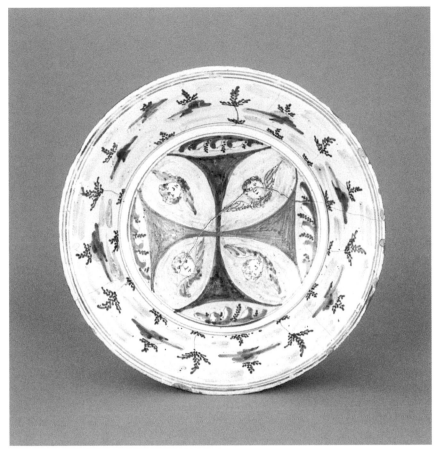

Figure 55
Bowl
Sevilla (?), Second-half 16th Century
Dia. 37.5 cm.

Earthenware with tin glaze and cobalt,
antimony, and iron in-glaze decoration.

The cross utilized on this bowl is the insignia of the Trinitarian Order, a military religious group which from its founding in Rome during the twelfth century through the sixteenth century was dedicated to freeing Christian prisoners from the Muslims. It was an especially popular order in Spain because of the long struggle between the two religions, and therefore a number of ceramic vessels bear its identifying symbol. The same cross is used as part of the arms of the Order of Our Lady of Mercy, but the element is entirely in one color and is combined with vertical bars on a shield.

During the fading decades of the sixteenth century, the Italian pottery colony of Sevilla was not only involved in extensive tile production but in the manufacture of hollowware. In both cases design ideas were transferred from their traditional but variable regional backgrounds to Spanish *fábricas* (workshops). The Ligurian coast, Venice, and central Italy—particularly the area of Montelupo—appear to have been most commonly represented in work at Sevilla and in importations of ceramics as well. Urbino is regarded as the source for some Talaveran specimens (Ainaud de Lasarte 1952, figs. 758–61; Martínez Caviró 1968, figs. 135–8). In many instances the translation of design was far more literal than use of two or three isolated motifs. The plate in Figure 56 is a case in point. A few similarly designed vessels previously have been identified with late-sixteenth-century Sevilla, although some students prefer to think of them as having been made in Talavera (Ainaud de Lasarte 1952, figs. 592–5; Martínez Caviró 1968, 146–9, 160).

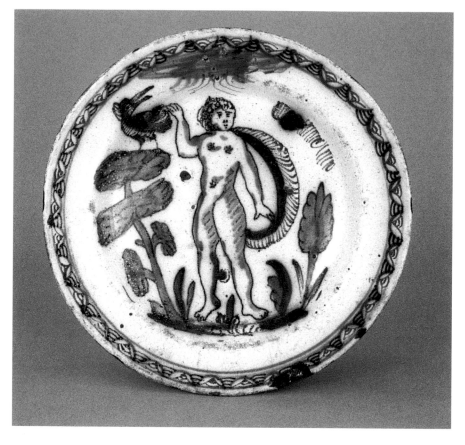

Figure 56
Plate
Sevilla or Talavera de la Reina,
Late 16th Century
Dia. 33 cm.

Earthenware with tin glaze and cobalt, copper, antimony, and iron in-glaze decoration.

The distance between Renaissance and usual Islamic themes is no more strikingly illustrated. The four traditional Italian colors of blue, orange, green, and brown are used to produce a pattern consisting of a nude, winged (?) putti standing on a ground between a topiary tree and a low shrub. On the top of the tree is a bird with an exaggerated beak. Above the putti is a rayed cloud. The narrow border band is made up of alternating blue and orange geometrics and waves in a style quite distinctive from more well-known Talaveran models. The use of outline, shading, lined fillers, a large focal motif balanced at either side by floral elements, and most dramatically the subject matter itself, shout an Italian point of view and an Italian way of expressing it. There is no decoration on the exterior.

The wheel-thrown plate form with a broad brim not delineated by a sharp angle or ridge from the cavetto and a broad well obviously designed as a field for decoration became common in Spain during the second half of the sixteenth century as part of the introduced Italian complex. Cockspur scars on obverse and reverse indicate that this specimen was fired in a stack rather than in an individual saggar. Such careless firing methods, especially for a special object such as this plate must have been, would not have been tolerated in Italy, where technical details and precision of draftsmanship had far greater importance than they ever had in Spain. Perhaps a backsliding on the part of provincials or the employment of local workers with lower standards can be inferred.

Covering most of one side of a wasp-waisted drug jar shown in Figure 57 are the arms of the Unshod Carmelites drawn in two shades of blue on a shield mantled by acanthus leaves and topped by a crude rendition of a crown. The opposite side of the vessel is undecorated. The poor brushwork and the flat base suggest that this is an eighteenth-century Sevillian copy of a seventeenth-century Talaveran type. During the

Figure 57
Albarelo
Sevilla, 18th Century
Ht. 21 cm.; dia. orifice 9 cm.
Earthenware with tin glaze and cobalt
in-glaze decoration.

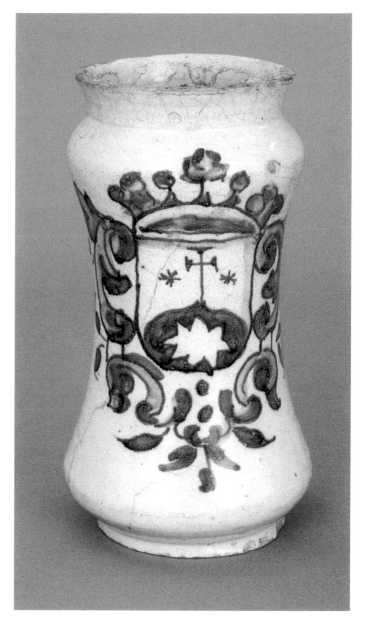

sixteenth century there were two hundred Carmelite friars residing in two Sevillian convents, though this number was reduced during the next century. Probably this drug jar saw use in a hospital or pharmacy operated by the order.

The vessel, fashioned of a buff-burning paste, has rounded rather than angular shoulders and a short, flared neck. No lid is present.

After the fall of Granada and its incorporation into the Christian sphere of Andalusia, there was an immediate cessation of the production of luxury ceramics such as had been known by the Nasrids. Squatters moved onto the slopes of the hill on which the Alhambra palace stood in ruins. There, a number of small kilns have been found which appear to date from the sixteenth century (Lister and Lister 1982, fig. 5.2). Associated with them are fragments of domestic wares which include some maiolica. This is mostly plain white, or a few pieces additionally decorated in a bit of cobalt blue (Torres Balbás 1934, 387–8). Even though *moriscos* continued to live in Granada for the entire sixteenth century, there is as yet no indication of the survival of any Nasrid ceramic decorative style. However, the basic technology inherited from the past did remain unchanged, and in fact, at one large workshop adjacent to the ancient city walls it still flourishes today. The habit of placing potter's wheels in pits in the ground, the structure of the kilns and their furniture, many primitive implements and their Arabic names, the glaze formulary and the limited use of only two or three colors—the Italian oranges and yellows not among them—and ideas concerning the hierarchy of the staff and division of labor among it seem to have been handed down with little modification from generation to generation for at least six hundred fifty years. One suspects that the final

Figure 58
Lebrillo
Granada, 18th–19th Century
Dia. 38 cm.

Earthenware with tin glaze and cobalt in-glaze decoration.

expulsion of the *moriscos* at the beginning of the seventeenth century actually caused little disruption in local production, then in the hands of Christians who had been practicing Islamic ceramic ways for the preceding century, though without doubt a market for output of the kilns must have dramatically vanished for a time.

Most of the known ceramic remains at Granada from the time following the departure of the *moriscos* until modern eras show a concentration upon blue, with an occasionally painted accent of brown or green, upon white grounds. In late phases, green and brown bichromes enjoyed some revival. The motifs were most frequently large, frondy, vegetal elements, often encircled by a dissimilar but harmonious border. The decoration obviously is hastily brushed on utilitarian pitchers, plates, and large, flat-bottomed basins such as that in Figure 58. Called a *lebrillo*, it served a number of functions in Spanish homes from a container of bread dough to a table washbasin.

This specimen is covered with an oyster-white glaze on both surfaces. Its decoration of blue, stylized, leafy sunflowers or open rosettes had a long history extending over several centuries. Dating on stylistic grounds alone therefore is uncertain. The central pattern on this example is framed by an encircling chain motif. The walls have alternating solid and lined motifs pendant from the rim. The exterior is undecorated.

Figure 59
Lebrillo
Granada, 19th Century
Dia. 37 cm.

Earthenware with tin glaze and copper and manganese in-glaze decoration.

Both obverse and reverse surfaces exhibit triads of cockspur scars, thus reaffirming their having been fired in stacks rather than in individual saggars. Saggars, it should be recalled, were an Italian introduction to Spanish ceramics which failed to be adopted in this area notable for its retention of Moorish ways.

Another typical *lebrillo* from nineteenth-century Granada is that in Figure 59. A diagonal net pattern in brown, with spaces filled with round green dots, covers the expansive flat interior of this heavily potted basin. Interior walls, which flare outward, have a repeated encircling pattern of nested half-circles of alternating green and brown loops that blurred slightly during firing. The exterior is undecorated.

Only minimal concern for flaws in glaze and decoration is evidenced by vessels such as this one which were meant for hard daily use in modest homes. Crawling, pinholing, and scarring from cockspurs mar their surfaces. Even though not up to some contemporary standards elsewhere, Granadine pottery of the nineteenth century remained attractive and entirely serviceable. Of course, it suffers from comparison with the exotic ceramics made in the same locality many centuries previously.

The crudely turned conical bowl in Figure 60 is a reminder of the old Muslim *cuenco* tradition. It bears an interior green-and-brown decoration, also a Muslim palette, on a somewhat lustrous oyster-white ground.

A central, open rosette of brown filled with lunate green petals is encircled by four waved lines in brown, the arches being filled with green dots. Draftsmanship is not precise. The lines were painted rapidly as a decorator swiveled the vessel on his knees. Pigments appear almost iridescent.

Potting is heavy, throwing ribs being left unobliterated on exterior walls. A ring base is present but is not trimmed on the exterior perimeter.

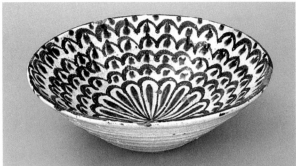

Figure 60
Cuenco
Granada, 19th Century
Dia. at rim 37 cm.

Earthenware with tin glaze and copper and manganese in-glaze decoration.

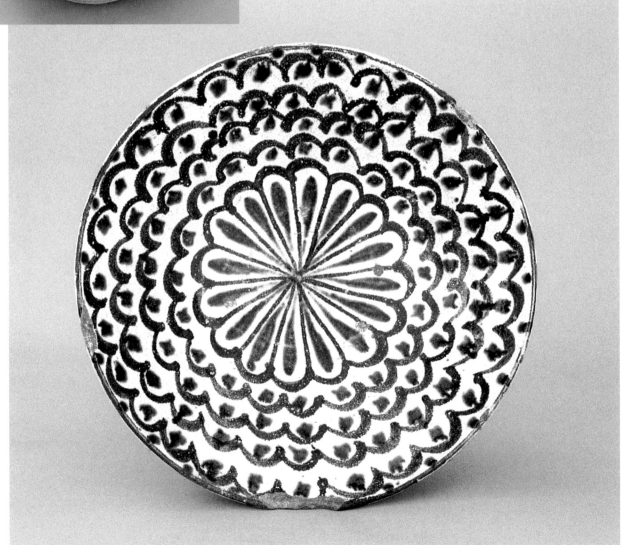

MEXICAN MAIOLICA

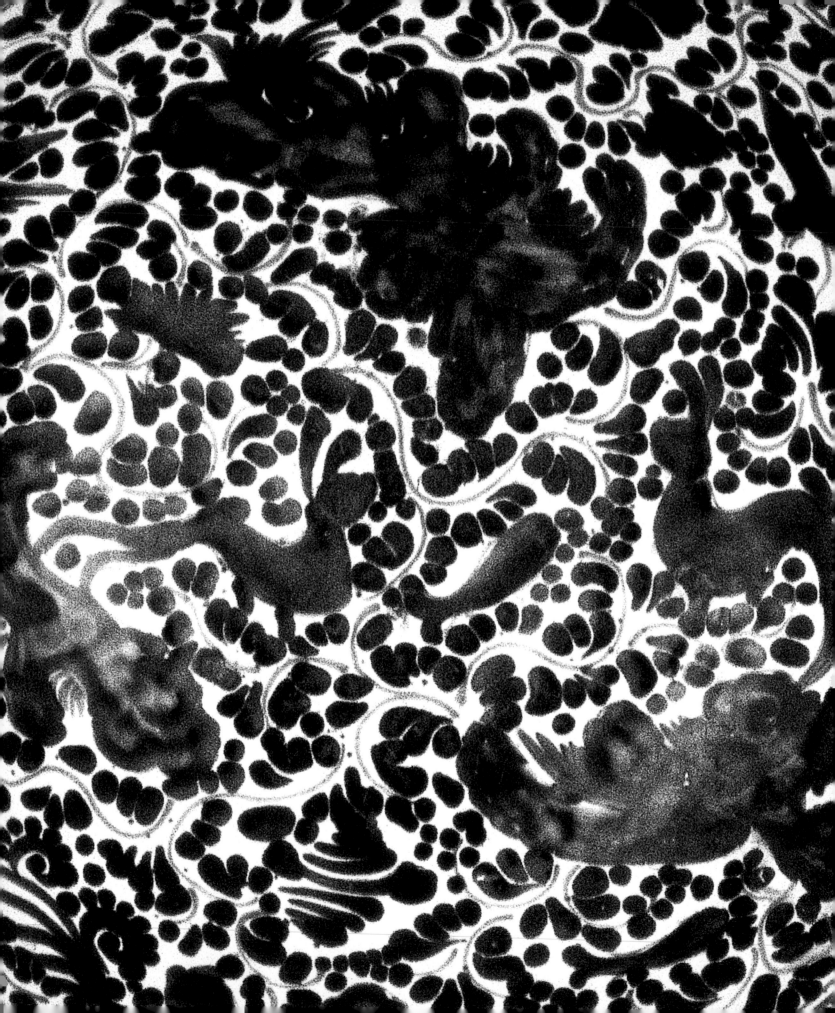

Introduction

THE HISTORY OF MEXICAN MAIOLICA appears to have begun within a few years after the Spaniards consolidated their hold on the Valley of Mexico in 1521, at which time the vessel forms and decorations of low-grade Andalusian maiolica were copied, probably by native novices under the direction of a few Iberian *maestros*. Thus, in the same way that Indians and *mestizos* were to become Renaissance stonemasons, sculptors, or jewelers, they were to become Renaissance potters. The known remains of these first Mexican maiolicas look very little like the Spanish ceramics illustrated in the earlier pages of this catalogue, but they are almost identical to types now being found in limited archaeological studies in and near Sevilla. The important consideration, however, is that a rather elaborate technology was introduced for the first time to the Americas, one which involved potter's wheels, kilns, and a glaze formulary not native to Spain but refined there over a very long period of time. It seems likely that the original Mexican center of manufacture was in the Valley of Mexico on the outskirts of the capital being erected over the ruins of the Aztec city. No kilns of this period have been uncovered as yet because they probably lie beneath the city. An educated guess is that they were the two-chambered updraft type with a roughly circular upper unit still in use in southern Spain at the beginning of the sixteenth century, the so-called *horno árabe* of the Spanish Muslims. Or they may have been the more formally rectangular Mediterranean style with a vault roof then being copied in Spain from the Italians. Not surprisingly, the few fragments of the first Mexican maiolicas from these kilns, thus far identified only from debris beneath Mexico City, are utilitarian pieces meant for daily household service. They are unrefined, unmarked, clumsily fashioned, but nevertheless coated with an impervious white stanniferous glaze (Lister and Lister 1974, 23–4; 1975, 31–2; 1982).

As styles changed in Sevilla, under the growing influence of Italian and Flemish artisans who were encouraged by the first two Hapsburgs to begin operations in Spain during the second half of the sixteenth century, so did they alter in Mexico. Potting improved; vessel shapes, which seem primarily to have been versions of a brimmed, ring-footed plate ultimately derived from the Far East, modified to conform to new

79

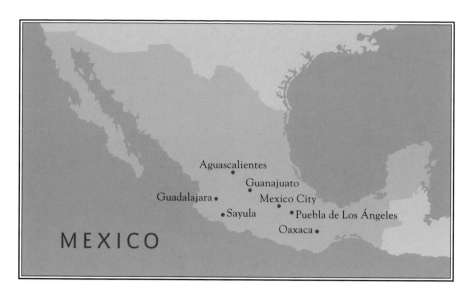

MEXICO

Aguascalientes
Guanajuato
Guadalajara
Mexico City
Sayula
Puebla de Los Ángeles
Oaxaca

Figure 61
Major Maiolica-Producing Centers
in Mexico.

vogues; firing methods were those introduced to Spain by the Italians; and decorative treatment began to be standardized into several distinct styles, both of which reflect specific European prototypes. One was a greyed blue-on-white vogue of petals and vague floral conventionalizations laid in an encircling rim band around a similar central medallion. Without doubt such treatment represents a provincial idea of Sevillian work of the second half of the sixteenth century (Ainaud de Lasarte 1952, 224, fig. 597). The other style focused on a large, single Mediterranean palmette looking suspiciously like the Granadine pomegranate isolated as a centerpiece or bordered by Italian-style wavy rays or fronds painted in murky blue accented by Italian-introduced ochre or yellow, colors current in Spain by the mid-sixteenth century although never adopted at Granada (Lister and Lister 1974, fig. 4a, b). In this style one feels the presence of Genoese, Venetians, and perhaps even *morisco* Granadine decorators functioning in contemporary Sevillian *ollerías* (pottery workshops). No examples of an occasional fusion of these two sixteenth-century modes are known as yet, a situation arising from a young offshoot industry either lacking the confidence necessary for experimentation or still being dominated by peninsular Spaniards.

There are no vessels of these types in this collection. In fact, the only evidence for this second stage of Mexican manufacture lies in shattered fragments of former tableware found in a limited number of archaeological sites in central Mexico and along the northern borderlands of New Spain (Lister and Lister 1974, 36, fig. 13). Present evidence points to a Mexico City industry under management of *sevillanos*.

The seventeenth century ushered in what on the surface appears to have been a sudden burst of activity in the making of tin-glazed ceramics in two areas of the Viceroyalty of Nueva España, though obviously the degree of proficiency and volume of production exhibited could have come about only after a long period of growth in the craft (Palacios 1917, 478). The changes in quality of workmanship which had occurred during the several decades bridging the preceding and this century only seem dramatic because the intermediary maturing phases as yet have gone unidentified. Without doubt, by the seventeenth century Puebla had become the principal pottery-making town (Cervantes 1939: Vol. 1, 17–8; Goggin 1968, 6), with Mexico City continuing to turn out lesser wares. Expansion had been so great that stratification of the ceramic industry resulted in the manufacture of at least four grades of stanniferous wares (*refino, fino, entre-*

fino, and *común*—extra-fine, fine, less fine, and common) for all levels of urban society. The increased repertoire of forms reflects a new richness and complexity of colonial life as much as it does newly acquired technical skills. Furthermore, in what often has been regarded as a cultural backwater stranded on a "new" continent, there is also evident an unusual decorative cross-fertilization from two sides of the world. Geographical isolation, strangely, created an environment in which Mexican potters were recipients of ideas, not givers. Pottery from East and West came into Mexico, located as it was midway between Orient and Occident; in exchange, few Mexican wares went back to those overseas donors of design.

At Puebla, new clay bodies which began to be used at this time for objects of medium-to-small size may or may not be an indication that an industry moved there from the Valley of Mexico or was transplanted from elsewhere, but unquestionably in physical terms the modified clay mixes permitted vessels of thinner walls which were more easily coated by a glaze relatively low in tin content. This shift from the redder pastes of the past also must have been stimulated by the popularity of Chinese porcelains, which began to flood the Mexican market after 1573. However, forms thrown during the first stages of the seventeenth century remained strongly allied to the Spanish Muslim tradition, most notable among the finer wares being the flat-bottomed, wide *lebrillo* (basin) and the tall, wasp-waisted *albarelo* (drug jar), or to the Spanish–Italian tradition of the ring-footed, wide-brimmed plate with a smooth cavetto and no deep central well.

Spanish dominance, perhaps specifically Talaveran influence, was evident in two main decorative styles which emerged with the seventeenth century, if not several decades earlier, although it should be recognized that at many periods Spanish artisans were themselves influenced by the Orient or by Chinese work as viewed through Muslim eyes. For the present, available documents appear to suggest that their production was confined to Puebla.

From the beginning, Mexican performance, facile and uncontrived, was no mere duplication of Iberian models. As Fernando Benitez, in a discussion of sixteenth-century Mexican culture, wrote, "The Indian introduced a new sensibility, a deliberate deviation from the various accepted modes, and breathed onto the stone his strong, fresh style. . . . This phenomenon was not confined to architecture, but rather marks the entire colonial culture . . ." (Benitez 1965, 71). So local workers took a gay array of five typically Italian colors—blue, yellow, orange, green, and black—which had been brought into Spain by itinerant ceramists, and used it in original depictions of a central naturalistic figure or pictorial passage outlined in black, sometimes edged with blue and filled with random, multicolored dots or zones of color, set in a banded field and bordered by flowing sprays of petals and florals composed of multicolored, encircled dots (Deagan 1987, figs. 4.42–4.43; Lister and Lister 1987, fig. 139). Such designs, simple in themselves, nevertheless were born of an entangled merging of Islamic, European, and Oriental themes. The irrepressible independent spirit of the new corps of indigenous artisans saw to it that interpretation remained Mexican—full of verve, wit, gaiety, and quite suitable for an emerging materialistic society. It should be noted further that pigments themselves were of a purity to suggest their importation from abroad, just another indication of the determination for craft improvement which underlays all the seventeenth-century developments in Puebla maiolica.

A second palette of duochrome blue and black, on oyster-white ground, was used for lace patterns such as were popular in Spain. The Mexican rendition with wide gimps was not its most typical Spanish variation but has been noted on some seventeenth-century examples from Talaveran shops which must have provided Mexican decorators with prototypes (Lister and Lister 1987, fig. 135; Martínez Caviró 1968, 136–7, fig. 180–01). They were reworked to suit local tastes, which at the time had a fondness for *mudéjar* interlacements. Confidence in the medium also led to experimental combinations of this vogue with the multicolored one discussed above. Laces sometimes framed central Italianate human figures or Hispanic animals; round balloon dots bunched on stem lines typical of the polychromes were incorporated in the duochrome lace patterns; *encaje de bolillos*, or the lace wares, occasionally displayed variations in ground color from white to yellow, the latter also having been borrowed from lesser-known Italian models used at Talavera (Cervantes 1939: Vol. 1, 105, 107; Frothingham 1944b, 33, fig. 32; Lister and Lister 1987, figs. 136–137; McQuade 1999, Pls. 6, 8; Peón Soler and Cortina Ortega 1973, fig. 2; Welty 1999, 50).

Few large *fino*-grade intact vessels bearing these two dominant seventeenth-century modes or their combinations are known outside of Mexico, and even there scarcely more than a dozen examples are thought to be preserved in various collections. There are none at the Museum of International Folk Art. Fragments of probable *entrefino*-grade or smaller vessels displaying the contemporaneous styles, however, have been recovered from archaeological zones extending from New Mexico to Florida on the north and Guatemala on the south (Lister and Lister 1974, 36, fig. 14).

Even while seventeenth-century Mexican potteries were turning out colonial manifestations of European ceramics, they, like their counterparts across the Atlantic, were falling under the spell of the Far East. A new dimension with far-reaching implications for ceramics was to be added to Mexican decorative art. Mexican trade with China and Southeast Asia via Manila, which brought luxurious Oriental goods across the Pacific and then one hundred ten leagues up the China Road from Acapulco to central Mexico, released a unique creative impulse, to issue forth in an array of opulent, spirited vessels quite unlike any produced in Spain. Thus East and West did meet, in part merged, in tiny, dreary potteries of Mexico, and, as diversified concepts were digested, the products of those shops would never be the same again. The words Balbuena wrote of seventeenth-century Mexico also apply to her pottery: "In thee Spain and China meet, Italy is linked with Japan" (Benitez 1965, 57). There is no evidence for either Chinese or Japanese natives having been active in Mexican pottery-making, although a number of Orientals are known to have been in Nueva España.

The impact of Chinese porcelain was immediate everywhere it reached in sixteenth-century Europe. The response it elicited in Mexico, situated astride its route from Manila to Madrid, must have been equally as spontaneous. Of that, there is no record, but by the 1630s a traveling priest wrote of Chinese porcelain styles being copied then at Puebla (Frothingham 1969, 78). His false claims that colonial imitations were as fine as the originals must be credited to chauvinism. In 1653, when a potters' guild was organized at Puebla, a Chinese, or *achinado*, mannerism was included as one of the three principal vogues designated to

be used for fine-grade wares, thus reaffirming its probable utilization for many years previously. A century later a *maestro* (master craftsman) of the guild claimed that he was responsible for the introduction of this style, for which he said he was widely acclaimed, but in fact he must have been preceded by several generations of Mexican maiolists fashioning both Oriental vessel shapes and motifs (Cervantes 1939: Vol. 1, 42).

Without doubt, the Chinese style did not overwhelm all other current fashions to the extent now suggested. Because it was so exotic and specialized, in the beginning it was a way of enhancing the finest pieces. Today these better ceramics are more numerous because happily they found their way into storage places where they survived. More common contemporary wares decorated either in older or less elaborate versions of similar elements were used as long as possible and then ended up broken and scattered in the city dumps, where by and large they still remain unexcavated. By the second half of the eighteenth century, Chinese patterns no longer graced the best specimens but emerged as occasional decorations for ordinary tableware.

In the past it has been argued that orientalization of ceramic style in Mexico came via Spain, which by the seventeenth century was receiving porcelain objects and/or Chinese design stimulus from two royal holdings, Portugal and the Low Countries, not to mention the older infusion of Eastern conventions into the aesthetic languages of Islam and Italy, the two traditional wellsprings of inspiration for Spanish artisans. However, Spanish maiolists never embraced the craze for Far Eastern decorative art with the same enthusiasm displayed by either European neighbors or the American colonists. When they did, copies were far more literal than those in Mexico (for example, see Ainaud de Lasarte 1952, 271, fig. 723; 230, fig. 610; 229, fig. 608; Frothingham 1944b, 56, figs. 48–49). In view of Mexico's being a direct recipient of annual cargoes of luxury items from the Orient and her rapid wholesale reflection in local pottery-making of the imprint of those imported goods, it would appear certain that the most obvious aspects of this stylistic diffusion were firsthand and not diluted through Spanish workshops, which at this very time were increasingly cut off from Mexican markets. In fact, porcelain, and perhaps as well a few Mexican versions of Chinese styles, reached Spain from Nueva España, making possible a reverse direction of at least some diffusion (for example, see Barber 1915b, Pl. 26[57] and Frothingham 1944b, fig. 130, for specimens identified as Spanish which the authors consider to be Mexican).

The interest aroused in Mexico by Chinese ceramics had a parallel in the contemporary adoption in architecture of the Churrigueresque. In both instances, simple, basic items were enriched with elegant surface decoration. A superficial similarity to porcelain was achieved by potters through outright copying of some forms, some motifs, and a palette of several shades of "heaped and piled" blues on a lustrous white group to imitate similar impasto Ming blue-on-white types, especially those of the Wan Li period (1573–1619). Later Transition-period types (1620–62) and those of the Yung Cheng rule (1723–35) within the Ch'ing Dynasty had their own effect upon Mexican maiolica, and thus one can trace changes occurring within the Mexican sequence which reflect new styles arising in the East. The difference in raw materials, decorative techniques, and firing conditions and temperatures utilized in the two distinct industries precluded identical results. But there were other underlying factors which made for vast distinctions between

these wares, even though the porcelain reaching Mexico was already in a state of decline, which it might be thought would have brought the two ceramics closer together. In the seventeenth-century emergence of a new half-breed American culture, Mexican attitudes and aptitudes were coalescing into a national idiom in the arts.

For basic production, Mexicans closely followed Spanish methods, themselves a manifestation of Moorish and/or Italian tradition, but they made little successful effort to upgrade their products even to the level of those typical of Spain, let alone those of China. Although at Puebla they did adopt a buff-firing paste, they never purposefully sought out the kind of marly clay body most desirable for maiolica because of its high rate of shrinkage nor did they experiment with a different balance of massicot and glaze ingredients which might have reduced the excessive crazing, pinholing, and crawling which characterized their ceramics. Once they had mastered the introduced technology to their own satisfaction, they seemed uninterested in correcting these and other surface blemishes, the elimination of which obviously would have greatly enhanced the quality of the finished product. When soft green vessels were bumped and slightly deformed, they were not thrown out nor were pots rejected even though they had adhered to each other while the glaze was molten. If separation was possible, they were processed. In addition to indifferences to such defects, they owed some of the flaws seen in their ceramics to their Spanish models. In glost firings for instance, at the end of the sixteenth century they followed the Spaniards in abandoning the use of supporting pins which left only insignificant marks beneath rims. After the sixteenth century cockspurs were used universally to separate stacks of vessels. These stilts scarred both obverses and reverses of glazed ceramics. During the periods of best workmanship in the second half of the seventeenth century individual saggars appear to have been used for *refino-* and *fino*-grade pieces, but in the early eighteenth century potters protested and succeeded in eliminating the guild ordinance requiring them, thus accepting the marring of even their finest pieces (Cervantes 1939: Vol. 1, 33). Most frequently, Mexican craftsmen of these times did not bother to rub down or retouch cockspur blemishes, which to them apparently did not negate the overall pleasing effect of their wares. It must be assumed either that faults of this nature simply were not regarded as important or that prevailing standards of workmanship were not sufficiently high or rigid to promote greater physical perfection. The *mestizo* artisan then, as later, seemed more interested in the drama of size, color, brilliance, and a superficial display of virtuosity than what were to him unimportant minutiae of production. He was, and has remained, strongly individualistic, unwilling to be bound by fixed patterns and the numbing monotony of precise details or mechanical reproduction.

A notable lack of interest in technical experimentation also is apparent, in part perhaps attributable to Spanish character and in part to complacent provincialism. In decorating there was no effort to duplicate the icy bluish-white caste of porcelain through the addition of a slight bit of cobalt to glaze solutions, nor was there any application of a finish coat of transparent lead glaze. Both techniques were devised in various parts of Europe but not in Spain or in her colonies. There was no painting of designs directly on green or bisqued ware which in firing might penetrate the glaze coat from below to impart depth to ornamentation

similar to that on porcelain. The Chinese fired their pieces one time only, the cobalt patterns drawn upon leather-hard, unfired bodies which were then dipped in glaze. Actually, at thirteenth-century Nasrid and Paterna factories in Spain, Muslim or *morisco* maiolists had decorated bisqued vessels prior to glazing, the strong colorants rising under heat up through the glaze (Gaiger-Smith 1973, 55; González Martí 1944: Vol. I, 193). This method had passed into limbo and no doubt been forgotten long prior to the conquest of Mexico, though, if revised, it might have led to a floating quality of painted design so admired on porcelain.

The most obvious adopted Chinese decorative mannerisms were the banded and compartmentalized subdivisions of field and balanced areas of reserve white emphasized by many variations of dark frames, their acceptance being eased by similar traditional concepts in Spanish Muslim art. Because *poblano* artistic grammar had an appreciation for the figural, this aspect of the imported styling was quickly adopted. Many *achinado* (Chinese-style) vessels displayed a charmingly naive melange of stylized landscapes which included pagodas, phoenixes, rocks, waves, and other assorted chinoiserie, most imitative at the outset of the sequence but at all periods revealing a disregard for scale and an obvious lack of appetite for tight reproduction. Mindful of the foreign quality of the decoration and wishing to underscore it, Chinese human figures, regardless of sex intended, were marked as non-Mexican by symbols such as queues and umbrellas. Without them the simply garbed coolies could have passed for Mexican *campesinos* (peasants). Patterns which were so uniquely Oriental as to have no appeal for the Mexicans—dragons and flying horses, for example—were not copied. Other elements which were equally as Oriental, particularly certain architectural devices, were utilized but grossly misunderstood. Hence Taoist temples and teahouses emerged from Mexican brushes as Catholic cathedrals. Steadily the gap between the two artistic expressions widened as Mexican decorators increasingly relished ambiguity rather than specificity in design to the point where derivation of individual motifs became obscured (Figure 62).

Among the most beautiful Mexican interpretations of the Chinese style was one which featured a thick foliage resembling a veritable briar patch through which scampered small animals or birds. The same theme was used in contemporary Spanish potteries but with a different emphasis (Ainaud de Lasarte 1952, 284, fig. 762–8; Frothingham 1944b, 56, fig. 48). An *emborronada* (embroidered, packed) style, characterized by foliage depicted through extensive dotting, appeared in Mexico coincident with this more refined, lighter rendition. Presently it is uncertain whether one evolved from the other, though both drew upon the same representations. The dotted manifestation, used on traditional Chinese shapes, also appeared more indiscriminately on forms taken from the Spanish background. These two Chinese vogues, plus another which featured paneling filled with phoenixes on the wing, typified the second half of the seventeenth century and probably overlapped into the eighteenth century.

The Puebla manufacture of tiles during the seventeenth century exhibits the same exuberance as shown in the production of fine hollowware. Mexican colonials took a Spanish idea—originally inherited from Muslims and perfected by Italians—made it theirs, and then outdid their teachers in its application as in its patterns. Where *sevillanos* most usually mounted tiles as house or church wainscotings and altar frontals, the

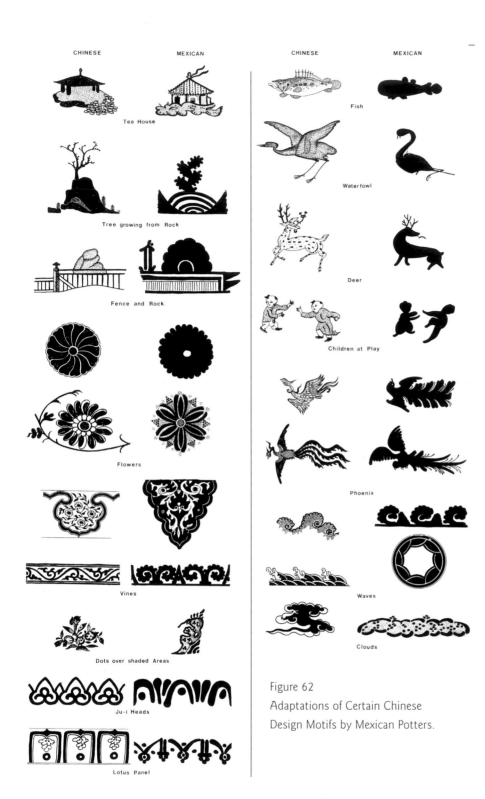

Figure 62

Adaptations of Certain Chinese Design Motifs by Mexican Potters.

Mexicans added them also to sweeps of church cupolas and domes, facades, columns, plaques, and all manner of outdoor furnishings. In their hands there was an astounding amalgamation of motifs absorbed from every source of inspiration available to them. With joyful abandonment, *mudéjar* tracery, Renaissance conceits, Christian symbolism, Oriental whimsies, and subsequently European genre came into juxtaposition in a riot of strong colors flashing in the brilliant highland sun. Available records do not affirm that maiolica tilers were distinguished from makers of maiolica hollowware, though such dichotomy might be presumed from usual Spanish specialization. It may be noteworthy that presently tiles and vessels are made in the same Mexican *fábricas* (workshops), painted by the same decorators. Because sixteenth- and seventeenth-century Sevillian tiles were more widely known and of higher aesthetic importance than Sevillian vessels, tilers there appear to have gained added social status and economic rewards. Those advantages may not have accrued to Mexican tilers, who competed with a more versatile, productive body of potters. Archival references found in Mexico are strangely quiet about the makers of tiles, although today more of their efforts remain on view.

By 1693, some forty-six potteries were open in Puebla (Lopez Rosado 1965, 97), probably half of which were dedicated to making maiolica objects. Mexico City likewise supported a flourishing industry in cheaper

tableware (Lister and Lister 1974, 33, fig. 10). In the face of a burgeoning colonial population within central Mexico and outward along all frontiers, the need for mass-produced ceramics inevitably brought about an abandonment of individuality and a concentration upon less elaborate stereotypes. Smaller vessels for individual use—cups, plates, bowls—were made by the thousands (Lister and Lister 1982, 24–30). These generally do not appear in museum collections nor are they present in any number at the Museum of International Folk Art. The blue-on-white color combination remained dominant, but polychromes occasionally were inserted into these schemes. For the first half of the eighteenth century Chinese patterns continued to be popular, particularly for the larger items. Abstracted florals, flying phoenixes, and various scrolls placed within framing, which most often was diagonally segmented, replaced the former elaborations. Gradually these, too, gave way to new ideas closer in step with European styles.

Despite the geographical isolation of the American colonies, there was a continual renewal of artistic influences coming from the motherland. As Bourbon Rococo evolved in the Iberian peninsula during the second half of the eighteenth century, Mexican potters soon imitated Spanish potters in adopting widespread use of molds to create flat-bottomed, scallop-edged, fluted-walled, or noncircular vessels, forms which suggested themselves through metal services, as well as Oriental ceramics. The heroic products of the Baroque gave way to ones of diminished scale. At the same time, the thrown shapes of the past taken from European and Asiatic grammars continued. As was appropriate for smaller objects, decorators strove for tiny, refined, floral, or geometric patterns set against expanses of undecorated ground, but they also continued to display considerable eclecticism in combinations of Eastern and Western ideas. Made popular anew by eighteenth-century Spanish and Chinese fashions, polychromes reasserted themselves as the eighteenth century waned.

The potting industry in Mexico at this time must have found itself in severe competition with English industrialized ceramics, which were cheaper, more serviceable, more uniform, and had new colors and shapes. Such pottery is known to have begun appearing in Mexico, imported there through Spain along traditional channels and directly from Great Britain in the wake of eased trade restrictions on the part of the House of Bourbon. At the same time there were fewer Mexican factories in operation than a century previously. The shops at Mexico City apparently had dwindled into small *fábricas* making only ordinary culinary pots or sets of inexpensive tableware. Those at Puebla had worn themselves out in dispirited repetitions of old forms and decorations which were losing their appeal to prospective buyers. The guild was ineffectual in stimulating the sagging craft, although a surprisingly high level of workmanship was maintained. In this situation of a bored clientele and steady decline in numbers of craftsmen and profits possible, during the last several decades of the eighteenth century there are indications of sudden revitalization.

The appearance of a greatly expanded range of functional shapes, such as lidded casseroles and tureens, pitchers, cups with and without handles and saucers, sugar bowls, condiment trays, and a number of gadrooned and fluted plates, added to the introduction of new colors for glazing and decorating, point to serious efforts being made to regain the average household market. Thus rejuvenated, the Mexican maiolica industry continued to function throughout the nineteenth century.

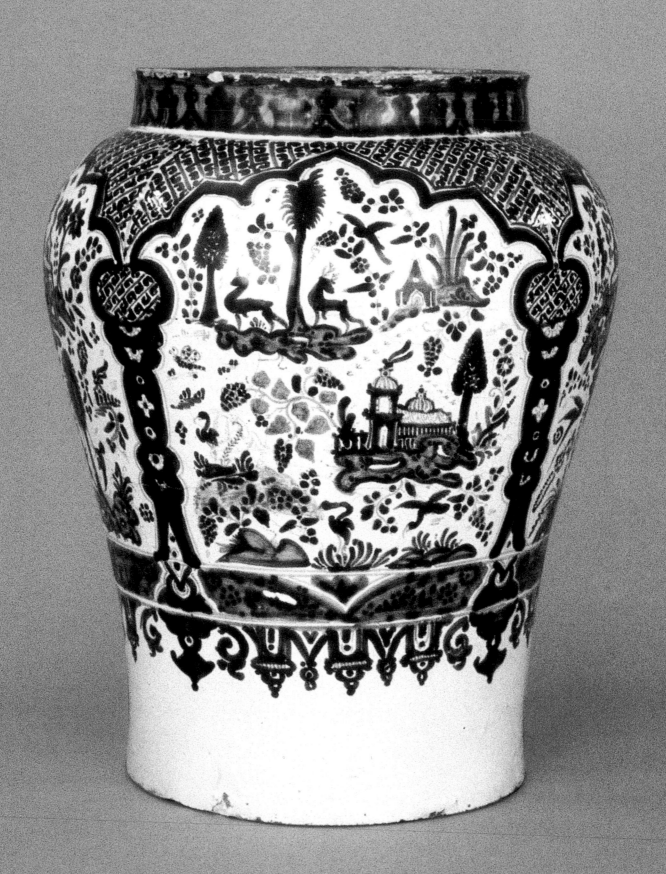

The Mexican Collection

PUEBLA

Seventeenth and Eighteenth Centuries

THE MASTERPIECE OF THE SAWYER COLLECTION of large maiolica jars from Mexico is illustrated in Figure 63. It is in the category of wares copied rather faithfully from Chinese models. Its immense size, contour, and detailed, well-executed design also suggest that it probably is one of the oldest pieces of this series of vessels, perhaps having been made by the middle of the seventeenth century. More exact translation of borrowed art conventions was practiced at this period than later when careful draftsmanship and imitative drawing gave way to repetitious, hastily applied, more suggestive patterning. The fact that such a spectacular vessel was not signed by the *maestro* also may be a sign of its having been made prior to the establishment of the guild in 1653, although admittedly enforcement of the marking regulation was exceedingly lax.

Often utilized as a storage receptacle for wine, the form is not quite a true *tibor* as it subsequently evolved, but the wider base extending upward cylindrically rather than rounding outward to a high shoulder must have been considered essential for stability in a jar of this height and weight. Its origin may have been in the Chinese *mei'ping*, which was more slender with a narrow mouth. Although some Mexican potters were capable of sufficient dexterity, strength, and control to throw a vessel as large as this, most likely it grew from two sections luted together while at the leather-hard stage. If so, all clues of juncture were carefully obliterated, and the exterior profile was trimmed with a template. The short, broad neck was of a suitable height for receiving some sort of a lid which would have nestled down on the upper shoulder in a typical Chinese profile (McQuade 1999, Pl. 12). It was wide enough to allow entrance of a dipper. Bisque firing occurred before the body was thoroughly dry, a process which even in arid Mexico would have required many days in the case of so large an object. The evidence for this is a crack which developed along the inside of the ring foot as a result of escaping steam. It was later sealed as molten glaze ran into the fissure, but to complete the vessel with such time-consuming decoration was a calculated gamble. The pressures of preliminary firing also caused the base to bulge downward, making it necessary to wipe glaze from this area prior to glost firing in order to prevent the vessel from fusing to the kiln shelf. In this cleaning process some dirt must have adhered to the jar bottom, which caused extensive crawling of the glaze.

The jar was lowered into a vat of liquid glaze of sufficient thickness and opacity to conceal the dark paste beneath. All surfaces were cov-

Figure 63
Tibor
Puebla de los Angeles,
Mid-17th Century
Ht. 46 cm.; dia. orifice 2.5 cm.
Earthenware with tin glaze and cobalt in-glaze decoration. Houghton Sawyer Collection.

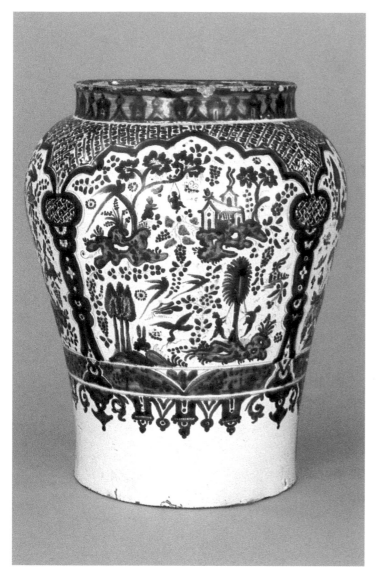

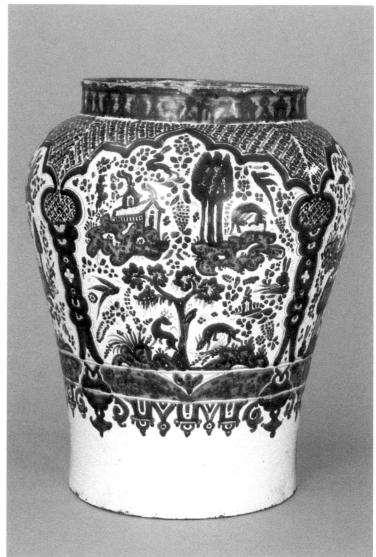

Figure 63b

Figure 63c

ered. Presently this coating is finely mazed with hairline cracks, but perhaps this circumstance has resulted from later exposure and was not its original condition. Notwithstanding, the crazing, pinholing, and flaking flaws to which all Mexican maiolica has been subject are present on this vessel, which must have been superlative even at the time of its manufacture.

The design on this virtuoso piece is an intriguing blend of many introduced ideas, but the rendition is purely Mexican. The layout consists of four bands, the principal one divided vertically into four panels. A Chinese approach to division of field, it was also one widely used by Muslim artisans. Background devices acting as a foil for the pictorial panels likewise are Oriental, but they, too, were adapted by the Muslims. The individual pictorial motifs are primarily Chinese. Some, such as the bounding or sitting long-eared hares and antlered deer, had seen much use in Spanish Muslim ceramic art. In Christian symbolism, the rabbit represented the hope of Salvation in Christ and also was a sign of fecundity in both East and West. The deer was an emblem of immortality in Taoist beliefs. As a result of strong identification of Mexican potters with their Iberian past, the rendition here of these two motifs is virtually the same as that seen on Spanish Muslim or *morisco* vessels. On the other hand, interpretations of most Chinese-derived themes lost a great deal in Mexican adaptation.

At the neck of the large jar is a row of repeated erect devices which may have been borrowed from a variation of the lotus panel. In this case the row is painted over a ground washed with medium-blue stain. This dark band is balanced by a similar one below the pictorial zone wherein random dotting is substituted for the lotus panel, which instead lies pendant in a second zone below. The basal band consists of five motifs between each tassel, one of parallel lines barred at the top, the other of nested Vs, and both capped with a dot-filled circle and a second, smaller, solid dot. A compatible but slightly different motif between hooked scrolls hangs below the tassel end. Of more elaborated treatment than the neck band, the base band neatly balances the total arrangement by repeating the pattern but with a reverse orientation. The bottom 7.5 cm. of the jar remains undecorated in accord with the fashion of this particular time.

The focal decoration located in a zone 28 cm. wide is displayed in four compartments, each framed by a foliate, diapered netting of alternating dark-blue upright and inverted U's separated by fine light-blue lines. This netting is carried down into tassels serving as panel dividers, the ends of which are filled solid with dark blue except for dots or flowers left in reserve white. The tassels at each side, the netting at the top, and the washed band at the bottom create a dark frame for each white-grounded figural unit.

Content of each pictorial frame differs, although there are elements repeated in all which, together with similarity in quality of painting and scale of motifs, help to unify the total composition. Close inspection reveals a square (a, c) or triangular (b, d) placement of most important motifs within seeming disarray, but there is no single landscape scene. Pictorial vignettes combined on one vessel with an economy of illustration were not uncommon on contemporary Ming vessels (Pope 1956, fig. 94 [29.207, 29.208]). Proper relative proportions are lacking generally, as, for example, birds and animals being the same size as human figures (d) or a man standing taller than a nearby building (c). The desire for a ground line is expressed in

an individual Mexican way through assimilation of several Chinese methods. For example, a washed, convoluted pattern overlaid with dotting, which may have been inspired by Chinese cloud scrolls, constituted a sort of floating baseline. Furthermore, after the fifteenth century it was usual Chinese practice to outline elements and then fill the spaces with a blue wash (Pope 1956, 121). The overlay of darker dots was most common in Yung Cheng times (1723–35), but the practice can be assumed to have begun much earlier, perhaps in the fifteenth century, because much work in this period was a revival of earlier ideas.

Most of the leading elements which were to typify Mexican maiolica work for the next one hundred fifty years already had evolved by the time this jar was fashioned. Turning to a brief review of them, it is noted that although birds were frequent on earlier Spanish pottery, they seldom were shown in flight or sitting in trees (see Figure 2). These were Chinese conventions which the Mexicans copied. Long tails of phoenixes, spread wings of other unidentified birds, and exaggerated, curved necks of cranes appearing in these panels help convey a feeling of movement. The portrayal of human figures had been associated with Spanish ceramic design since the thirteenth-century work at Paterna. Until the sixteenth-century introduction of the Italian Renaissance, they remained stiff and frontal. Then they relaxed into attitudes of motion. Mexican artisans working under comparable stimuli easily adopted Chinese figural elements, but their renditions were uniquely their own. For instance, the decorator of this vessel drew human figures in two ways. Both were local adaptations which were used often but seldom together. An obvious Chinese man, identified with a queue, strides across an upper scene in panel c. His physical features are indicated in faint lines of light blue, the reverse of usual Oriental and Spanish dark outlining. There is nothing particularly Mongoloid about them. Inasmuch as the Mexican *mestizo* also had much Mongoloid blood in his veins because of the absorption of the native Indians, perhaps Chinese facial characteristics did not strike him as unusual. The coiffure, however, did. Clothing, which was also similar to that worn by certain classes of the colonial populace, consists of pants of medium-blue wash over which dark linework implies a pattern such as brocade, topped with a belted jacket having loose sleeves. This latter garment is dotted in a mode also used contemporaneously on Mexican polychromes. Other humans of far smaller scale and almost lost amid foliage (a, d), shown swinging or playing, are painted in rapid strokes as solid, dark-blue silhouette figures without any added detailing. Children at play were favorite Chinese subjects for pottery decoration, carefully indicated with attributes of costume and bodily features clearly portrayed.

Five variations of architecture are shown on this jar. One rendition on two panels (a, d) appears to be a gable-roofed church with bell tower, but since streamers instead of crosses top the combs, this interpretation is uncertain. Slightly hooked eaves suggest that it could be a debased representation of a Chinese temple. However, the structure shown in the lower right of unit b surely must be a Catholic cathedral with a two-story bell tower and ribbed dome with lantern over the crossing. No cross appears on this building either. The peak-roofed edifice beneath a tall, branched tree at the top of panel c seems most like an Oriental teahouse. Another very simplified depiction of what probably was a straight-on view of a gable-roofed building was repeatedly used by subsequent craftsmen. It appears at the top of panel b, right middle

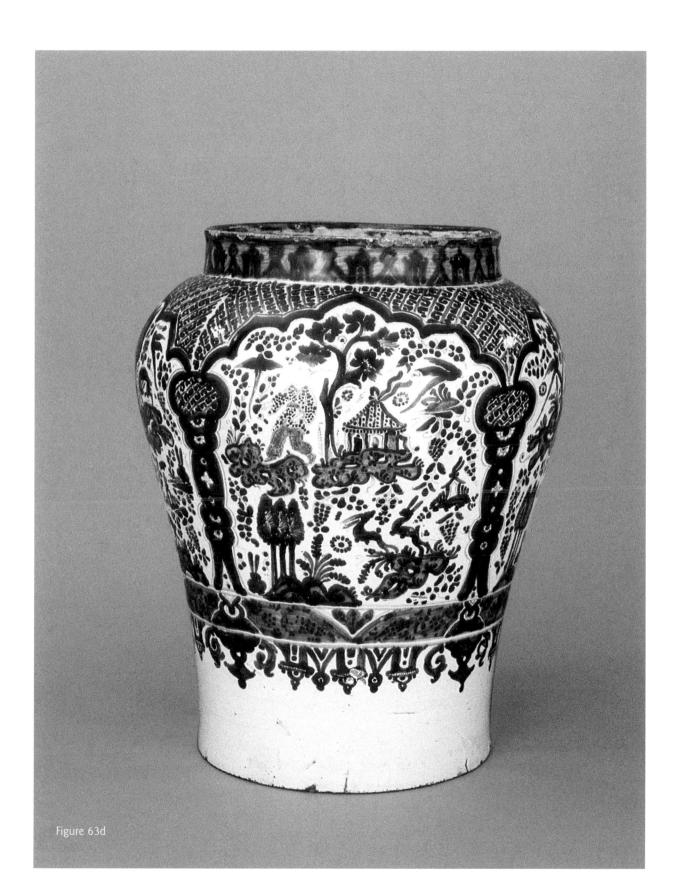

Figure 63d

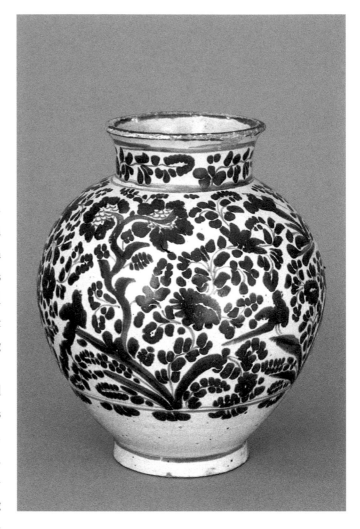

Figure 64
Orza
Puebla de los Angeles, Second-half
17th Century
Ht. 22.5 cm.

Earthenware with tin glaze and cobalt
in-glaze decoration. Houghton Sawyer
Collection.

side of panel c, and lower right side of panel d. Later practice also followed an invariable plan of a dissimilar tree element at each side of a building to serve as a frame. Such treatment is introduced in the cathedral depiction on panel b where a branch of grapes and leaves in light and dark pigments at the left of the building counterbalances a cypress at the right.

Trees on this jar are of four generalized configurations. The Oriental weeping willow is reproduced as a ceiba hung with Spanish moss. A frondy tree probably is meant to be a palm, certainly not unfamiliar to Mexican decorators. The cypress, single or in clumps, had long usage on medieval Spanish ceramics as a symbolic Tree of Life, and during the eighteenth century it emerged as a main element used in the centers of Talaveran plates and bowls (Figure 52). Sprays of flowers, grape bunches, dots off stem lines, open rosettes, clumps of grasses, and butterflies with dotted wings and body randomly fill background spaces which are decorated also with light, isolated dots of several sizes and parallel lines.

In spite of the large number of elements used in these panels, their small size left enough ground exposed to allow a lightness of design to contrast with the surrounding density of framing devices. Animation is imparted by stances of human figures, animals, and the curved pennants from structures which seem to be flying in the breeze.

A well-proportioned globular jar drawn to a narrow base and opened with a vertical, flared neck in Figure 64 is characteristic of the best reproduction of the Chinese mode of which Mexican craftsmen were capable. The decoration is of the same high quality, but copying of Oriental patterns was not exact.

The *orza* is covered with a lustrous white glaze showing only minimal defects. Although the neck area is defined by light encircling lines at top and bottom, the dark pattern within that band is made up of three

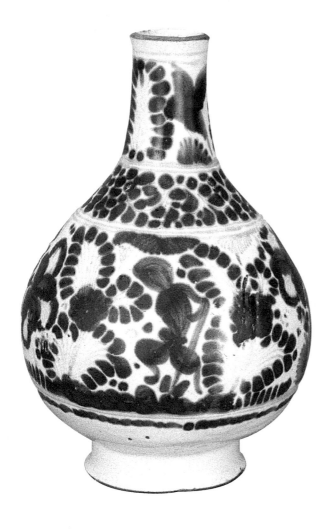

Figure 65
Bottle
Puebla de los Ángeles, Second-half
17th Century
Ht. 20.5 cm.; dia. orifice 3.5 cm.

Earthenware with tin glaze and cobalt
in-glaze decoration. Houghton Sawyer
Collection.

groups of petals like those appearing on the upper two-thirds of the body. There wavy trunks, fanned stalks, and floral elements having graceful sprays off their crests curve around and almost hide a few birds sitting on branches. The origin of the vegetal patterning probably lay in lotus scrolls. The design—compact, balanced, dainty, and surely drafted—is carried by a clear blue pigment lacking relief. Groups of graduated, elongated dots pendant from the bottom frame neatly finish off the pattern. In typical Chinese manner, a light-blue line encircles the jar at the point where the ring foot projects from the swelling body.

Even though this represents one of the most handsome vessels in the Sawyer collection, its graceful contour matched by a pleasing decoration in beautiful tones over a good ground, the motifs utilized totally lack the realistic detailing which Chinese craftsmen would have supplied. None of the individual parts of the composition—flowers, leaves, or birds—can be specifically identified. Likely such suggestive decoration added to a tightly spaced background coarsened into the vogue exhibited on the specimens illustrated in Figures 66, 67, 68, and 69.

In the seventeenth century Talaveran decorators also drew upon this style for their own uses. Their treatment remained closer to the originals than did Mexican copies (see Martínez Caviró 1969, figs. 19b, 22a).

A companion piece to the *orza* above is the exquisite bottle in Figure 65. The exceptionally white lustrous glaze, the bright blue cobalt applied without any attempt at impasto effect, and the high quality of potting and decorating place this specimen among the finest of the Chinese vogue. However, most Chinese versions had flared rather than straight mouths.

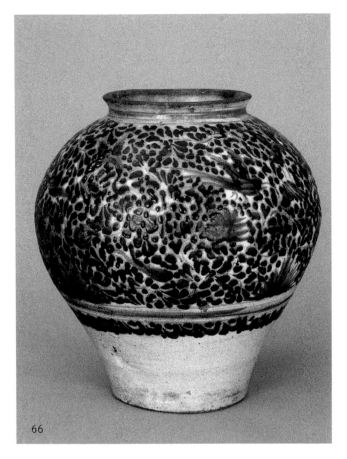

66

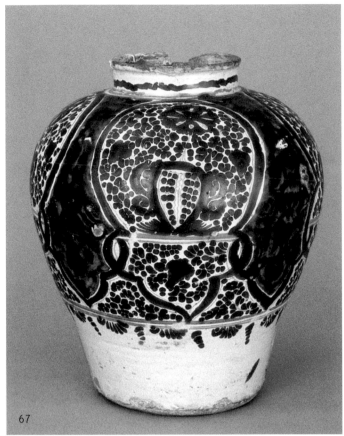

67

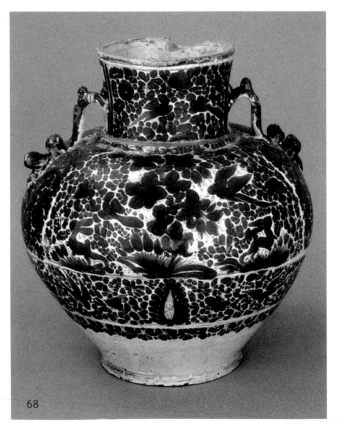

68

Figure 66
Modified *Tibor*
Puebla de los Angeles,
Second-half 17th Century
Ht. 28 cm.; dia. orifice 13 cm.

Earthenware with tin glaze and cobalt
in-glaze decoration. Houghton Sawyer
Collection.

Figure 68
Handled Jar
Puebla de los Angeles,
Second-half 17th Century
Ht. 42 cm.; dia. orifice 17.5 cm.

Earthenware with tin glaze and cobalt
in-glaze decoration. Houghton Sawyer
Collection.

Figure 67
Tibor
Puebla de los Angeles,
Second-half 17th Century
Ht. 34 cm.

Earthenware with tin glaze and cobalt
in-glaze decoration. Houghton Sawyer
Collection.

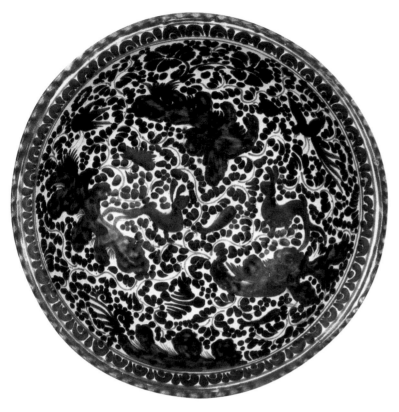

Figure 69
Bowl
Puebla de los Angeles,
Second-half 17th Century
Dia. 36.5 cm.

Earthenware with tin glaze and cobalt
in-glaze decoration. Houghton Sawyer
Collection.

Three encircling bands comprise its decoration. Around the tall neck appear two deep loops of graduated dark dots and light stem lines. Two birds of solid dark blue fly over a bush of graded vertical lines ending in small dots. The shoulder panel, set apart by a light encircling line, is filled with floral abstractions closely spaced so as to create a dark passage between two lighter zones. The 8-cm.-wide body band contains loops of tapered petals, rosettes, and a silhouette human figure above a dark ground line of continuous dots. Heavy beading closes the pattern, balanced above by a dark line on the bottle lip. Similar execution, as well as some repeated motifs, pulls the bands into harmony even though actual subject matter differs.

Strongly motivated in this style by Chinese concepts, Mexican decorators nevertheless were inclined to add small-scaled light ground fillers of a purely Muslim flavor. The pyramidal constructions of arched lines, two-dot clusters, and six-dot rosettes appearing on this vessel can be seen on a continuous succession of Spanish wares dating from the thirteenth century onward.

Mexican potters produced a few known examples of a shape the Chinese called *yu-hu-ch'un-p'ing*, all of which faithfully duplicate the form with its pear-shaped body set on a rather high foot. Perhaps this kind of vessel was a container for wine. Divisions of field and generalized designs used upon them are those assimilated from the East. Nevertheless, the way in which the motifs are presented remains indigenous. Floral depictions are usually composed of round or tapered dots in dark pigment with connecting lines in light pigment. Sometimes they are bunched, as in the intermediate band on this bottle. Other times they are arranged in loops to suggest larger units, as in the first and third bands. Often they are placed in a circle around a central dot to form a stylized flower. Almost never do they illustrate identifiable plants. This is in direct contradiction to Chinese portrayal, which was so precise that dozens of definite plant species can be noted. The same ambiguous presentation of animal or human forms is characteristic of Mexican work,

although when they are large size some detailing of features or clothing makes for more specificity. Again, Chinese artisans left no doubt about what kinds of animals or people were intended, although they also drew imaginary beasts such as dragons and phoenixes. The man on the Mexican bottle in Figure 65 could be any nationality. He could be using a garden tool or be engaged in a number of other activities. His stance, however, is in the sprightly Chinese manner. The suggestive nature of the motif is further heightened by its breezy brushwork and by almost hiding it in the midst of a welter of what appears to be foliage.

Several unusual features are immediately obvious in observing the jar in Figure 66. First, it differs from the usual *tibor* in having the largest body bulge at the equator rather than at the shoulder. That contour is characteristic of the *orza* form, but the wide mouth is not. Secondly, the brief neck is everted rather than straight. The design is laid on in three bands, but only the central one is of particular importance. The upper band at the neck is merely an irregularly drawn light line. At the base of the pattern is an encircling motif frequently used by the Mexicans which may be schematized *ju-i* heads, though so extenuated as to be virtually unrecognizable. Such a motif is composed of rounded or ovoid hooked scrolls separated by pendant, elongated lines either inspired by or parent to classical egg-and-dart.

The main zone dominating the patterning is not segmented in any way. Instead, a very dense construction of petals and dots in impasto blue connected by tendrils in light flat blue mass the surface, concealing in its tangle a few silhouette bird figures executed with the same flowing strokes. The style of decoration and quality of pigment, in Mexico called an *emborronada* mode, suggest this jar dates in the middle to late seventeenth century.

Often such a style has been considered *mudéjar*. The animal figures are those seen in Muslim Spain, but their placement half-obscured in lush, leafy foliage was a Chinese idea reused in Italy, Spain, and Mexico (Frothingham 1944b, 56, fig. 48). The Mexicans simplified the pattern, as shown in Figures 66 and 69, but went on to compact the design and add another dimension in relief paint as this and three other specimens in the collection demonstrate (Figures 67–69). In neither Mexican adaptation was the band itself segmented.

An unusual feature of this jar is the evidence that some sort of decoration once had been painted over the fired vessel. Faint traces of impermanent pigment reveal that a circular crest in white, black, and red was applied to one shoulder opposite a rectangular label panel on the other side. Either the pattern wore off through use or was purposefully but incompletely removed. The lower quarter of the exterior body wall is undecorated.

The framers encircling the neck and the bottom of the decorative area have been reduced on the specimen illustrated in Figure 67 to an irregular dark line bordered below by a fine light line and a pendant row of alternating, graduated petals and vertically placed dots. The main zone of pattern covers the upper three-fourths of the body, leaving a wide basal surface unelaborated. Such coverage became typical of the Mexican *achinada*, or styling based on Chinese models, even though contemporary Oriental jars usually were decorated from rim to foot. Pendant lappet panels washed with medium-blue and overlaid with clusters of dark dots quarter the field. Intervening spaces left in white ground are plastered with floral abstractions ultimately based upon lotus scrolls and spiky leaves but rendered in dark round and elliptical dots spaced off

light stem lines. Broad foliate lines at the base of the reserve panel interlock the unit with the dark lappets and repeat their terminal configurations. Near the vessel equator is a pattern resembling a shield-shaped crest filled with dots and mantled at each side by Muslim *ataurique* or Chinese fungus scrolls. The escutcheon, incongruously resting on paired tufts of grass, is connected by a light line to an open rosette slightly off center at the top of the panel.

All basic characteristics of the design exhibited on this *tibor*, a form assimilated from the Orient, are Chinese, with the exception of the crest. Armorial motifs, often purely ornamental with no specific family or organizational connections intended, appear on Spanish ceramics dating from the thirteenth through eighteenth centuries. It should be pointed out also that the dot as an element of design had an equally long record on Spanish Muslim pottery. It was, however, of minor importance as a ground filler, not a substitute for graphic painting.

A date of manufacture in the second half of the seventeenth century is suggested by the pattern, the impasto quality of the very dark cobalt, the unsteady craftsmanship, and the prominent use of wash-and-dot panels. The jar served secondarily as a planter as is evidenced by a large hole drilled in its base some time after initial firing.

Contemporary Spanish versions of this *tibor* form almost invariably had heavy rolled rims over which a ceramic lid would not have fit (Frothingham 1943, fig. 15). The straight neck and rim of this Mexican jar could have received a metal cap or a domed ceramic lid.

Italian Renaissance maiolists had a fondness for spectacular handles on large, closed forms, some of which dominated the pot beneath them. Talaveran artisans adopted the fashion but reduced their elaborate modeling and exaggerated size (Martínez Caviró 1969, figs. 34a, 35b). The most common Mexican response was that seen on the large-handled jar in Figure 68 which is one of the few forms seen in this seventeenth-century Sawyer material that appears to be more Spanish than Chinese. Pulled handles, 3 cm. in width and having wide double grooves down their lengths, were pushed up into two folds or loops while being attached to a leather-hard body. Small loops of clay were added at the top of the handle arch and between the point of upper attachment and the neck wall. The base of each handle was pinched off between the potter's fingers into a V shape. The custom of looping handles continued through the nineteenth century, at which time it assumed greater decorative importance.

On this specimen a tall, straight, wide-mouthed neck, possibly thrown separately to be attached at the leather-hard stage, fits with a pronounced ridge onto a globular body. Unlike the *tibor*, which had no line of foot visible in profile, a prominent support appears at the base to provide a needed appearance of stability for a jar so wide of girth.

Four decorative units occupy the upper three-fourths of the body wall. Segmented into two panels between handles and one unit on the sides of each handle, the neck is covered with a matted vegetation of closely spaced elongated dots, flowers, petals, and several silhouette long-tailed flying birds. The pattern on each side of the neck is essentially the same, but at one place on the rim edge the glaze ran during firing, which caused the design to flow slightly.

99

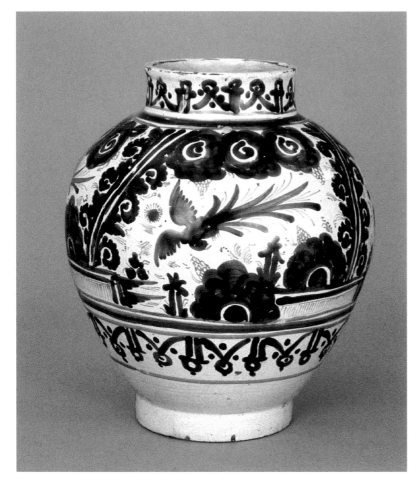

Figure 70
Jarrón
Puebla de los Angeles, Late 17th–Early 18th Century
Ht. 34 cm.; dia. orifice 14 cm.
Earthenware with tin glaze and cobalt in-glaze decoration. Houghton Sawyer Collection.

As usual in Mexican jar decoration, the main zone of some 19 cm. width covers the upper shoulder and extends down to a line well below the equator. Comparable to the neck panel, it is subdivided into four parts, two to correspond to the main frontal view of each side and two to encompass handle attachments. No linear elements were used to mark these units. Instead, a space .5 cm. or less in width left in reserve white stands out clearly against the massed dark blue of the patterning. The same technique also is used to set off the third and fourth horizontal bands. Caught in a maze of dotted foliage, long-eared rabbits cavort among bushes as long-tailed swallows swoop around large, open flowers overhead. The animals show an adept sweep of the brush exemplary of the fluency attained by seventeenth- century Mexican decorators. It is noteworthy that animals always were painted positively on Mexican vessels, never indicated in reserve white as was the case with some Chinese deer figures.

Typical of this style, the third encircling band is not compartmentalized. It is punctuated at the center of each side and under handles by an ovoid, open-center floral abstraction reminiscent of that on the bottle in Figure 65 and flying birds which are almost hidden from quick detection by the densely dotted ground. A heavy, narrow *ju-i* (?) chain composes the fourth band, below which the body wall is left undecorated.

Dense, bright-blue pigment on this exceedingly handsome vessel is not raised above the vessel surface but appears slightly faceted where it was sucked into the glaze solution while molten. The fact that it was not so heavily laid down may account for its luminosity in comparison to contemporary *emborronadas*.

Large bowls dating from the earlier periods of Mexican maiolica are not common in the collection, but a particularly fine specimen of the late seventeenth century appears in Figure 69. The massively built vessel has gently curved rather than vertical walls typical of *lebrillos*, a slightly flattened rim which was pinched,

piecrust fashion, in a manner to become more popular and vulgarized in the nineteenth century, and a thick, heavy ring foot for support. The height of the walls has led to its designation as a bowl, although the openness of the form placing the interior surface into primary importance also suggests a deep plate. Like many seventeenth-century bowls decorated in the Chinese manner, some attention was given to the reverse surface but certainly with none of the Oriental elaborateness. Seven blue, casually applied linear motifs, which are reminiscent of contemporary examples of Chinese-inspired designs recently excavated near Sevilla, are placed irregularly about the wall. In part they are comparable to a similar exterior decoration seen in Figure 71 and probably were coeval.

On the obverse can be seen the same style as on the closed forms illustrated in Figures 66–68 applied to a flat surface meant to be viewed from above rather than from the side. The same minor banding used to establish a firm limit on the pattern binds the central decorative zone. It travels a circle because of the round form itself, but the elements used are identical to those on the closed counterparts, that is, line and a *ju-i* or egg-and-dart debasement. Within that constriction is an unsegmented spread of motifs similar to those on the jars painted in the same impasto dark blue interlaced by light, flat tendrils. Because of the thick patterning required by this vogue, an interesting point of view concerning orientation for decoration on an open form earlier was overlooked, as, for example, when publishers of Enrique A. Cervantes's classical work on Puebla pottery mounted illustrations upside down (Cervantes 1939: Vol. 1, 185). On upright vessels, the

figural motifs such as birds and hares always appear erect or in correct alignment with a ground. For decoration conceived as a natural scene, on this round, flat object the figures had to be provided with a base line, above which they could appear oriented properly. Three contiguous waves or rocks, ending in hooked scrolls which the Chinese customarily used to indicate waves, placed at one edge of the pat-

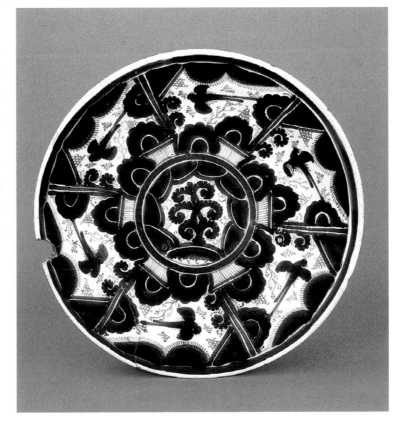

Figure 71
Plate
Puebla de los Ángeles,
Second-half 17th Century
Dia. 37 cm.

Earthenware with tin glaze and cobalt in-glaze decoration. Houghton Sawyer Collection.

101

tern serve this purpose. Above them three large, convoluted cloud or wave scrolls, outlined and filled with lighter-blue wash, form a triangular framework across the bowl interior. Within that stand two hares, a crane, and a bird in flight, each typically executed with exaggeration of some characteristic part. The presence of two fishes suggests this is an aquatic view, the hares standing at water's edge. All the figures are in correct orientation in relation to the waves at the center-bottom edge of the scene. They are rendered in dark solid blue with faint detailing in very finely applied darker pigment. Movement is implied in their attitudes. They are not in proper relative scale nor are they identifiable as to species.

Everything about this expression and the basic way in which it is treated is Chinese. As noted elsewhere in this study, this kind of massing of pattern in what deceptively appears to be an unstructured, unplanned way often has been called *mudéjar*. That approach surely came to Islamic art from Eastern prototypes and was not a concept likely to have been reached by artisans accustomed to flat, mathematically ordered relationships. The use of relief blue, the practice of filling zones with blue wash and superimposing heavy dotting, the hazy definition lines of darker color, the harmony of dark and light, the fine sense of balance and symmetry without resorting to a geometrically plotted field—all were Oriental contributions. The hare (?) figures with their preposterous hind legs bound through centuries of Spanish Muslim ceramic art (Lister and Lister 1987, figs. 32c, 35b), but they, too, probably were adopted. The modest exterior design compares to usual European limited acknowledgment of the Chinese tradition.

The shape of the bowl—broad and relatively shallow with curved cavetto—and the style of enrichment place its period of manufacture in the late seventeenth century. The fact that no stilt scars are present on either surface corroborates this dating because it will be remembered that between 1653 and 1720 guild ordinances required saggars for fine pieces.

Slightly more round-bodied than the usual *tibor* and further distinguished by its prominent foot, the specimen in Figure 70 more adequately fits into the category known in Mexico as *jarrón*. Possibly it was used as a container for wine, cacao, or spices, or it may have been solely a display object.

The decorative mode on this jar in a rich dark blue lightened by fine, light-blue details was a favorite of the eras bridging the seventeenth and eighteenth centuries, and as necessary it was altered to fit a variety of shapes. Using the vessel as a model, one can understand the processes by which the design was built. The decorator first marked off the bands needed to regulate the composition. This he may have accomplished by use of a banding wheel or a simple tow made from a container filled with soft materials to support the piece as it was slowly revolved. Waviness apparent on examples such as this suggests the latter, the painting hand not being steadied against any sort of prop. Then, working rapidly without instruments such as calipers or rule, he segmented the principal decoration field, which extended from the neck to well below the equator, depending upon the particular form being painted. Dark lines were drawn first, later paralleled by lighter ones to each side. Dividers in the focal unit are made up of three broad lines, from which spring three lobed scrolls hooking downward that were derived from Oriental fungus scrolls. They are laid diagonally across the space to create four panels. The use of dots along outlines of elements, such as are shown

on these scrolls, was common Chinese practice during the Yung Cheng period early in the eighteenth century and probably inspired this Mexican copy (Ayers 1969, 48–49). As a further clue to the artisan's rough draftsmanship, none of the compartments so created on this jar is the same size. They range from 25 to 18 cm. at their bases and 13.5 to 11 cm. at their upper limits. Within their limits two half-circles with convoluted perimeters and a smaller central circle are placed at the lower right corner of each. One rests on the framing line, the other on a rectangular, boxlike device filled with narrow parallel hatchure, perhaps derived from a fence motif appearing in many Chinese landscapes. Between the half-circles and at the left side are motifs of two vertical parallel lines topped by an inverted, crossed V. This grouping of motifs may have been the Mexican conception (or misconception) of Oriental rocks, waves, and garden houses. At the upper left of the panel, three heavily drawn circles with a central scroll and the same scalloped edges visually balance the massing of bulky elements at the bottom of the zone, at the same time completing a dark frame for a central light area. Across this latter passage, at the point of maximum vessel girth, swoops a long-tailed phoenix in full flight surrounded by diverse ground fillers such as fine crosshatchure, pyramids of arched lines, graduated parallel lines, or scrolls.

To complete the overall pattern, matching bands of modified lotus scrolls are drawn upright at the neck and inverted at the lower edge of the zone. The final touch is a narrow light line to split the remaining undecorated area at the bottom of the jar, a treatment which became very common in the eighteenth century. The diagonal thrust of the panel dividers, the diagonal opposing balance of heavy units at top left and bottom right, and the angled position of the bird and its upturned tail feathers impart excitement and motion to an otherwise static image.

The phoenix was a symbol which seems to have come into Oriental iconography from the Middle East. Supposedly, it was a long-lived creature with a lifespan of five hundred or more years, ultimately was consumed by fire, and later rose from its own ashes. It widely became an emblem of immortality, or of the Resurrection to Christians. Chinese decorators endowed their phoenixes with fanciful trailing plumage so abundant that flight might have been difficult. Mexican imitations expectedly avoided the details but advantageously used the long curvature of tail feathers to energize their depictions. It is doubtful that the phoenix had any symbolic significance to them. Probably they merely were copying a bird figure which they found appealing and "Chinese."

Although some of the elements, such as those applied as fillers and the lobed scrolls which possibly can be considered to be *atauriques*, passed to Mexican craftsmen from an old Spanish Muslim background, the fundamental appearance of the decoration is soundly Oriental. The lack of specificity in Mexican execution does not obviate that conclusion.

Inasmuch as most of the large, open forms that have survived from the early eras of Mexican maiolica are *lebrillos*, or basins having a flat central area surrounded by almost perpendicular walls, the plate in Figure 71 is a rare specimen. Its smooth contour from center to rim, due to absence of a sharp angle between cavetto and brim, and the low height are notable. Because of the latter characteristic, it is here called a plate rather

than bowl. That the two categories tended to merge is obvious. Nearly the same diameter as the other seventeenth-century example of flatware in this collection, it is almost half as high and weighs considerably less.

Exemplary of the layered cultural environment of colonial Nueva España, the design is Chinese, wrought by a Mexican, with Muslim trivia in the background. The center well is defined by a circle, overlapping solid half-circles around the inner border, in the middle of which is an erection of six symmetrical, hooked scrolls with dotted edges. In both these motifs the painter possibly was mindful of a Chinese tree or wave-from-rock motif. The paneling across the cavetto to a heavy rim line, shaped to fit the vessel contour by being 17 cm. in width at the outer edge and 10 cm. at the base, is yet another interpretation of the scene on the *tibor* in Figure 70, except that the bird is more likely a swallow than a phoenix. Compartmentalization of open forms, which typified seventeenth-century copies of Chinese styling, received a new variation in the Mexican adaptation. A comparison with the contemporary Talaveran plate in Figure 39 offers dramatic proof of the vitality and originality present in colonial work. The scallop-edged, solid half-circles, their placement, and the rectangular platform reappear at the bottom frame. At the top of the scene the half-circles have become misshapen and rayed or fringed, those fine lines subtly complementing the vertical hatchure in the platform below. The offset balance between these two groupings, the series of six birds in flight, and the splayed panel dividing lines create a rotational symmetry and a burst of vigor unusual in Mexican ceramics. For further contrast and drama, Oriental designers would have left the background undecorated, but Mexican maiolists working before the middle of the eighteenth century almost invariably demonstrated a *horror vacui* transmitted to them via Muslim Spain. In addition to the more common offset parallel lines, fringe lines, and pyramids of arched lines which Muslim artisans typically used as inconspicuous ground fillers, the decorator of this vessel also made use of a light, many-branched bush emerging from a dark half-circle. Such a vegetal motif was a frequent, prominent component of Chinese naturalistic settings, in that culture not a secondary addition.

In a somewhat casual recognition of Chinese methods, the exterior of this plate was decorated with six groups of light-blue motifs in two variations spaced around the wall. One of these patterns is strikingly similar to that on the plate reverse in Figure 69, underscoring their contemporaneity and possibly their origin in the same workshop.

The blue pigment on this specimen is exceptionally dark in color. Where applied with a heavily charged brush, it stands in low relief above the vessel surface. Even though this was a *fino*-grade vessel, its glaze is flawed with pinholing and crawling. Triads of cockspur scars on both surfaces and some unintentional speckling of cobalt, or *salpicadura* (salted), resulted from careless processing.

The strong Chinese flavor of the vessel in Figure 72 stems from form and decoration. The small, thin-walled, high-shouldered jar with short, flared neck and flanged, domed, knobbed lid with everted lower edge exactly matching the jar lip represents a two-piece shape commonly seen in Chinese porcelain, often called a rose jar in the Western world. The banded format; the triad of lobed medallions in reserve white filled either with a flying bird or bounding hare both almost obscured by thick, leafy foliage; and the ground

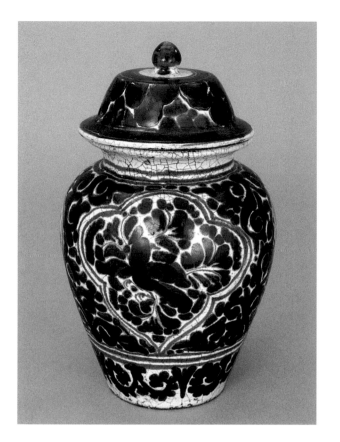

Figure 72
Covered Jar
Puebla de los Angeles,
First-half 18th Century
Ht. (inc. lid) 17.8 cm.;
dia. orifice 10.2 cm.
Earthenware with tin glaze and cobalt
in-glaze decoration.

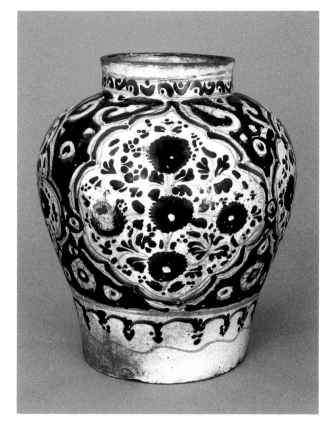

Figure 73
Tibor
Puebla de los Angeles,
First-half 18th Century
Ht. 30 cm.; dia. orifice 12.5 cm.
Earthenware with tin glaze and cobalt
in-glaze decoration. Houghton Sawyer
Collection.

between medallions darkened by dense pattern were outright imitations of the Chinese manner. They were accomplished, however, within the framework of usual Mexican interpretation as witnessed on earlier examples in this collection. The fact that the pigment was not laid in impasto and that dotting was replaced by heavy scrollwork suggest that this piece was a later echo of the *emborronada*.

Between a neck band of dark, alternating, erect, and inverted U's over dots edged by light frame lines and a basal band of pendant, stylized leaves is the main zone of decoration on the *tibor* illustrated in Figure 73. Covering the usual three-fourths of the upper body, the decoration band is divided by four foliated medallions in reserve white but outlined in dark blue framed by light-blue lines. Large enough to reach from

Figure 74
Bacín
Puebla de los Angeles,
First-half 18th Century
Ht. 27.5 cm.; dia. orifice 32 cm.
Earthenware with tin glaze and cobalt in-glaze decoration. Houghton Sawyer Collection.

top to bottom of the panel, these medallions are filled with a more or less symmetrical arrangement of five chrysanthemum-type flowers in dark impasto blue, centers left in reserve white. Around them are sprays of petals and dot clusters off light stem lines. The spaces between the medallions, which touch at midpoint, are covered with comparable dark cobalt crudely brushed so as to leave negative circles and scrolls. In usual Chinese technique, such dark passages needed to create a foil for reserve white units were achieved through close reticulation rather than patches of solid color. Below the pendant band of conventionalized leaves at the lower edge of the decoration, a wavy light line encircles the jar, thus dividing the undecorated bottom area in a customary eighteenth-century Mexican way.

The workmanship exhibited on this jar is not as good as that seen on earlier examples, although the design itself is strong and bold. Line work is careless, particularly in the concentrations of dark blue which tended to flux, and draftsmanship is hurried or perfunctory. In this there is a hint that not only was the Oriental fad becoming tired, but standards were tumbling. Further signs of decline are the physical defects all too characteristic of Mexican maiolica at all periods but which generally had been held to a minimum during most of the seventeenth century. The glaze is marred in two small spots, which indicates that the pot was shoved against others during firing. A strip across both interior and exterior of the bottom of the jar did not take the glaze. Such crawling results usually from dust or foreign materials clinging to vessel surfaces. Also, besides crazing and pinholing of the glassy coating, it is matte and honeycombed in several areas. Whatever the causes of these defects were, they did not affect the cobalt used for decoration.

Known chamber pots of colonial Mexico are tall, straight-sided cylinders with attached, paired handles for convenience and wide, almost horizontal brims for comfort. Such a vessel is shown in Figure 74. In the vocabulary of Mexican ceramics there are more names for chamber pots or urinals than for any other ceramic object, which must arise from their importance in homes without modern plumbing. *Bacín* is the word most commonly used, though coy references to *vasos de noche* (vases of the night) occur frequently, as do a number of other terms.

Among collections of Spanish ceramics can be found vessels of similar profile, though often more squat and equipped with four handles. Whether they were made for the same function as the Mexican *bacín* is not made explicit in the descriptive literature. At any rate, because at least one such vessel has been recovered near Sevilla in sixteenth-century context, one can postulate that the form diffused to the Americas along with other traditional Hispanic shapes (Lister and Lister 1982, fig. 4.15).

Be that as it may, the decoration of the cylinder in Figure 74 is the stereotyped Chinese mode of the first half of the eighteenth century. It is a banded format, the zone of greatest decoration lying in line with top and bottom handle attachment. Below a dark, beaded line is a framed, compacted arrangement of open flowers, bushes or clumps of grass made up of graduated vertical lines, and foliage of dots and lozenges. A second narrow band of double *ju-i* or egg-and-dart motifs lies below, from which groups of tapered feather or petal lines are pendant. This latter motif became increasingly common throughout the eighteenth century, particularly for plate decoration. In accord with a new taste for lessening of pattern, only the upper half of the cylinder is decorated. A wavy, light-blue line divides the undecorated lower body. Four fern units grace the interior surface of the flared rim. Handles, which have a single loop of clay pushed up at the bottom attachment, carry a heavy vertical beading. These appendages form vertical dividers in the major band of decoration.

During the nineteenth century, chamber pots of the same shape continued to be made in Mexico. At that period they were decorated in polychromes, sometimes of a pictorial nature. Usually lids were made to fit over the cylinder. However, under the influence of English creamware, the contour of Mexican chamber pots altered into a low, round-bodied profile, generally coated with white, undecorated glaze.

Synthesis of decorative styles is exhibited by the large-handled jar illustrated in Figure 75. The wide-based, globular form with paired ribbon handles and raised ribbing is from the Spanish tradition. The painted decoration is a Mexicanization of Chinese concepts.

The vertical neck of the jar, heavily restored with a rolled rim modeled after known Spanish examples, bears a pattern of four lobed half-medallions or cloud collar points in reserve white erect from the lower border and surrounded by unrelieved dark areas. These cloud collar points encompass sprays of dark petals and dots branching off light stems. A raised rib covered with dark blue separated neck from shoulder. It probably was a trimmed rather than appliquéd feature. A zone 17 cm. wide from the neck to below the equator is separated into eight panels by raised, vertical ribs of added clay which splay out from upper to lower scalloped framing. On each side of the jar, two central panels are decorated with a very stylized urn holding stiffly formal arrangements of five dark, radiating branches alternating with stalks of dot clusters connected by narrow stems, the two central sprays further elaborated with pairs of open flowers. Two panels on either side of the handles are filled with a complex, foliated scroll reminiscent of both Chinese fungus scrolls and Muslim *atauriques* which flow downward from a cloud scroll. The use of a washed blue ground overlaid with random dark dots, as in the urn and cloud, was an Oriental idea frequently copied by Mexican artisans. Particularly in the Yung Chen period (1723–35) of the Ch'ing Dynasty, a time when a new interest was evi-

107

Figure 75
Handled Jar
Puebla de los Angeles,
First-half 18th Century
Ht. 36 cm.; dia. orifice 15 cm.

Earthenware with tin glaze
and cobalt in-glaze decoration.
Houghton Sawyer Collection.

dent in reviving former techniques, was such a method employed on objects which may have reached a Mexican market (Ayers 1969, figs. 75–76).

A third decorative band covering the lower body to within 2.5 cm. of the base is similarly divided into eight units, four wide ones containing floral branches in urns and four narrow ones encompassing floral elements in reserve white. These panels are offset in relation to the principal band above. A dark, waved line forms a basal frame. The flattened upper surface of the handles bears a decoration of petals and stems. The handles themselves were pinched to a point at basal attachment, but their line carries on to the appliqued rib positioned below them.

The balancing of light and dark tones, the playing off of unaligned panels, the pattern coverage of almost all available space, and the basic motifs themselves are typically Chinese approaches to design. As with other Mexican examples in this collection, their imprecise, casual rendition, the extensive use of suggestive dotting in place of more exact delineation, and many brush marks in dark areas make the final product quite distinctive from original prototypes.

The handled jar in Figure 76 is essentially a high-shouldered *tibor* form. A tall neck was finished with a horizontally flattened rim. A pair of grooved ribbon handles was attached with three loops of pulled clay pressed against the wall in a mode that carried into the nineteenth century and converted the form into one with Spanish flavor. Design, however, in four bands repeats many often-used Chinese patterns.

Figure 76
Handled Jar
Puebla de los Angeles,
First-half 18th Century
Ht. 29 cm.

Earthenware with tin glaze
and cobalt in-glaze decoration.
Houghton Sawyer Collection.

About the straight neck are wide, unevenly drawn lines in dark blue separated by light lines, their verticality contrasting with the curvilinear elements below. As usual, the zone of most prominent decoration extends from neck juncture to well below the equator, a space of 15.5 cm. width. A large lappet medallion reaching from top to bottom frame lines hangs pendant on each side between the dark-blue handles. One of these lappets is evenly placed in the intervening space, but the other is off center at 17 cm. from one handle base and 14.5 cm. from the other. Smaller lappets lie at each side between the large lappets, the handles stretching over them. Symmetrical floral scrolls in reserve white appear within the large medallions, light line and dot fillers crowding in upon them. Similar reserve scrolls fill the body wall between all medallions. The third decorative panel, framed in narrow light lines, is an unsegmented band of dark petals and dots leading off light stem lines whose curves complement the curve of the medallion outline above. On occasion, similar decoration, frequently with freely brushed animal or human figures, was used as principal patterning (see Figure 64). A debased *ju-i* or egg-and-dart chain pendant from the bottom frame line closes the pattern at the lower edge to balance the upper finish band on the rim.

Some basic changes in format apparent on the *tibor* in Figure 77 herald a drift toward more static design, though whether an emergence of indigenous attitude was responsible is not clear. The vessel itself was deftly thrown with graceful *tibor* shape and sturdy walls brought down to a foot not visible on the exterior profile.

It is covered on all surfaces with a thick, lustrous white glaze. On the exterior the entire space typically is divided into five horizontal bands, each indicated by narrow light lines laid on the body wall while a banding wheel or tow slowly revolved. Chinese jars often were banded by narrow strips of scroll work, but in Mexican simplifications unelaborated banding lines were the rule. Within these zones, major decoration is carried by heavy, dark-blue cobalt so thickly applied as to stand in some relief above the glossy vessel surface. Minor detailing, framing of elements, and background fillers are light and apparent only with close scrutiny.

About a short neck with rim flattened to receive a metal or ceramic cap is a casually brushed, erect *ju-i* or egg-and-dart band formed of heavy, irregular U figures embracing a central dot and separated by a vertical petal narrow at its upper limits but widening as the brush moved downward. Neither placement nor size of these elements is uniform. A netted or diapered band, punctuated by four dark quatrefoils filled with a scroll in reserve white, covers 5 cm. of the upper shoulder. Reticulated patterns played off against a mass of dark medallions were used by both Chinese and Muslim artisans, from either of whom Mexicans could have drawn inspiration.

Beneath a 1-cm.-wide undecorated strip which focuses attention below it is the major design panel extending downward over 16 cm. of the body. This zone is compartmentalized into four units by groups of five bold, vertical pilasters, separated by fine lines, which terminate in half-trefoils. Such field dividers were typical eighteenth-century Mexican devices, the vertical lines lending equilibrium to the pattern. These pilasters are intersected at the middle by lobed medallions containing central scrolls in reserve white. All units of the band are similar but with different specific content. Two bear a freely brushed depiction of a long-legged crane, or *zancuda*, standing above a nopal cactus rising out of a set of four arched lines of graduated size. The *zancuda*, Chinese symbol for vigilance, loyalty, and the good life, was extensively copied from

Oriental design grammar for Spanish or Mexican wares. Although present on seventeenth-century vessels in Spain, the figure was more closely associated with the eighteenth century in Mexico when it commonly decorated simple tableware. The vegetal motif might be considered a rare Mexicanization (nopal cactus) of the traditional Ming pattern described as a tree emerging from a rock or spray curling up from a wave. The alternating panels on opposite sides of the *tibor* bear a central tree with curved branches ending in symmetrical clusters of dotted, conventionalized flowers. The botanical affiliations of neither tree nor flowers can be specifically identified. At the sides of each of the four panels rises a three-lobed pattern which may be a kind of Chinese wave. Mexican decorators followed Eastern custom in filling them with a medium-blue wash, leaving several lozenges in reserve white, and superimposing three-dot clusters over them, but those latter groupings were an old Muslim convention illustrated in Spanish examples in this collection. The same method was used to darken the nopal. Such blue-wash ground topped by darker-blue design carried on into the second half of the century to inspire a new class of ware. Thus a concentration of dark motifs contrasted with light ground neatly balances the pattern and provides basal stability. Vertical arrangement of components furthered this sense of order and calm. Vaguely portrayed floral sprays consisting of light stem lines and dark dots in clusters provide space fillers around the birds.

A suggestion of an architectural element can be seen at the crest of left wave frames, each one somewhat distinctive. One is composed of two parallel vertical lines topped by an inverted V which has a small dot on each slope and at the ridge. Another is a pair of vertical lines with a triad of dots forming a roof over them. The third is similar, though the lines are of unequal length and a shorter line stands between them. A fourth idea is two vertical lines with a slanted line to indicate a shed roof across their tops. From these small variations of a minor motif one senses a remembered but rapidly applied style. It might also be a misinterpretation of a Chinese motif which originally was intended as an outcropping in the foreground of a landscape.

Along the top of each panel is a horizontal heavy branch of S-scrolls and dotted flowers to provide an enclosing frame at the upper edge of the scene. All units have a number of faint, light-colored background fillers which, as noted elsewhere, had been a common Spanish Muslim practice that endured into Renaissance-influenced Christian work. Mexican versions represented on this vessel are three-dot clusters, offset graduated parallel lines, and C-hooks. These randomly placed motifs, as well as detailing or outlining of major elements, probably were the finishing touches of the decorating process.

An example of the typical lack of precision in drafting a design is shown in the variations of sizes in the panels composing the principal zone of decoration. Each widens at midsection to better fit the body bulge and narrows at top and bottom, but none of the spacing is identical. For example, the width dimensions of the two bird units are: 7.5 cm. and 9 cm. top; 8.5 cm. and 10.5 cm. bottom; 15 cm. and 16.5 cm. middle. The width dimensions of the two tree units are: 8 cm. and 11 cm. top; 10 cm. and 13 cm. bottom; 16 cm. and 20 cm. middle. Such differences in spacing apparently did not concern the Mexican maiolist, who obviously worked freehand by sight, because comparisons between units are not immediate inasmuch as only one

unit can be seen in a side view at any given time. Also, these discrepancies of spacing were minimized by the alignment of shoulder medallions with the vertical dividers of the principal panels.

The fourth and fifth decorative zones at the base of the jar are of a width to balance the shoulder panel. One has a design of heavy, half-circle inverted scrolls over center dots alternating with what might be debased cloud scrolls. The other is a typical Mexican rendition of a pendant Chinese lotus panel. A comparison of this band with that on the great jar illustrated in Figure 63 shows the degree of abstraction reached by the time this *tibor* was decorated.

The vessel form, palette, horizontal banding using dissimilar motifs, density of patterning which covers most of the available field, balanced and symmetrical placement of motifs, as well as subject content itself, all suggest a Chinese model from which Mexican decorators greatly strayed. The specimen probably dates within the first half of the eighteenth century. A small hole drilled somewhat off center in its base indicates a secondary use as a container for a plant.

Two similar bands of about the same width framed by wide, dark lines outlined in narrow light lines cover the entire surface of the squat *barril* (barrel) in Figure 78. Six elliptically shaped dark chrysanthemums with open centers lightly filled with hatchure are the focal elements. The chrysanthemum was a motif adopted early in the continuum of Chinese styling (see Figures 73, 79, 80, 81), and it continues to be reproduced to the present time. These elements are separated by elongated leaves and round dots placed in groups next to light stem lines. Vertical alignment of motifs in each band is inexact.

The vessel was made to be a planter, as shown by the drainage hole punched in the bottom while the greenware was at the leather-hard stage.

A specimen comparable to the barrel above exhibiting an eighteenth-century modification of the seventeenth-century lotus scroll and leaf design is the shallow, flared

Figure 78
Barril
Puebla de los Angeles, Mid-18th Century
Ht. 18.5 cm.; dia. orifice 15.5–16 cm.
Earthenware with tin glaze and cobalt in-glaze decoration. Houghton Sawyer Collection.

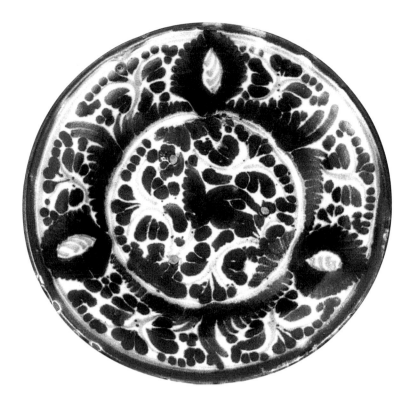

Figure 79
Bowl
Puebla de los Angeles, Mid-18th
Century
Dia. 21 cm.

Earthenware with tin glaze and cobalt in-glaze decoration. Houghton Sawyer Collection.

bowl or plate in Figure 79. The obverse is banded in the usual way, light, encircling lines setting the center off from the walls, the edge finished in a bold, dark line directly on the rim. Three elliptical chrysanthemums are spaced about the wall so as to form a triangular pattern within the circular form. A similar technique of altering a normally round motif to fit a prescribed space also is seen on the contemporary barrel, but its precedent interpretation was that on the bottle in Figure 65. Curved sprays of exceptionally dark, dotted foliage, connected by light tendrils, which originate at the bottom of the wall panel, complement a compatible pattern in the flat central zone of the bowl through which flies a barely discernible dark bird silhouette. Nothing much has radically changed from earlier rendition of the style except for the cobalt used in painting. It is rich and deep, not impasto but broadly applied.

Prior to the eighteenth century, Mexican serving needs were satisfied by the Spanish *lebrillo*. But at that time, bowls of moderate size and hemispherical contour began to appear with some frequency in collections of Mexican maiolica. Undoubtedly they imitated the so-called Chinese "export" form sent to the Western world by the thousands. Its deep, round body, set on a foot which was relatively tall and small in diameter as compared to that of the mouth, gained height and a touch of elegance by this simple feature. Realistically viewed, it was not needed for stability, but it made the vessel aesthetically more pleasing than the traditional chunky Spanish bowl. A thickened rim at the top of the vessel, important for increased durability, also visually balanced the prominent foot at its base.

In Figure 80, a specimen typical of the Chinese "export" bowl form also is graced on its exterior by a remodeled Chinese decoration which might be considered a later manifestation of the style on the two pre-

Figure 80
Bowl
Puebla de los Angeles, Mid-18th Century
Dia. 20.5 cm.
Earthenware with tin glaze and cobalt
in-glaze decoration. Houghton Sawyer
Collection.

Figure 81
Bowl
Puebla de los Angeles, First-half 18th Century
Dia. 30 cm.
Earthenware with tin glaze and cobalt
in-glaze decoration.

ceding examples. A dark-blue band directly on the rim with two narrow blue lines below leads into the main design area covering all of the visible surface down to a ring encircling the foot. Within this panel, six compartments drawn wider at top (9 cm.) than bottom (5.5 cm.) to fit the bowl curvature are separated by narrow, vertical divider panels washed with blue and overlaid by a vertical row of dark circles. The interaction of light against dark thus is preserved. The reserve compartments created each contain a very dark, open chrysanthemum flower which can be found on the earliest Chinese-styled vessels down to those made today. Matching elements at top, bottom, and middle of the zone make for a totally balanced, serene pattern. It will be noted further that Muslim-derived space fillers have been abandoned to leave exposed greater areas of ground, thus foreshadowing a trend which would dominate the last half of the eighteenth century.

The interior of most Mexican bowls remains plain, the local artisans not taking up the Chinese habit of some pattern added to that space. This specimen exhibits just two narrow light lines below the rim, two light lines near the bottom of the wall, and a sprinkling of cobalt at center. To judge from some archaeological findings in the Mexico City subway excavations, the latter appears to have been a more common mode of decoration for ordinary eighteenth-century pieces than has been generally recognized.

A large, hemispherical footed bowl in Figure 81 is decorated on the exterior in a Chinese style which had become mechanical by the mid-eighteenth century. Two shades of blue carry the design, confined to the upper two-thirds of the wall. Six upright, lobed medallions or cloud collar points in reserve white contain a central open chrysanthemum surrounded by carefully arranged petals. Spaces between the medallions are filled with a diapered netting of light blue, dark blue dots at line intersections, and an added chrysanthe-

mum placed in the center of the zone. The band of medallions is framed top and bottom by light-blue encircling lines. Below the lower one is a dark-blue *ju-i* or egg-and-dart band. No interior decoration is present.

Architecture provided both Spaniard and Chinaman with many decorative motifs. The Spaniards in particular were fond of such minute rendition that specific edifices such as the Escorial can be identified (Frothingham 1944b, 39, fig. 33). Chinese artists more frequently portrayed buildings as part of an imagined landscape. During the seventeenth and eighteenth centuries, the Mexican penchant for suggestive rather than literal interpretation precluded positive treatment, but structural doodlings in the background are observed from time to time, generally as another variety of ground filler. When the Chinese manner was first imitated, buildings appear as definite entities, sometimes seemingly Oriental, other times more like Mediterranean construction (Figure 63). Later, their rendition deteriorated into two vertical lines capped by an inverted V or diagonal line (Figure 77).

During the second half of the eighteenth century, one particular architectural representation suddenly appeared on a large number of bowls, plates, and platters. No known preliminary developmental stages for this motif can be verified in the Mexican continuum nor are explicit prototypes which might have inspired it known. That suggests that the pattern was the original creation of a single craftsman or workshop. In a craft of such anonymity of workers, it is intriguing to speculate upon the possibility of associating this pattern with a specific person.

The most likely decorator capable of that creation may have been Don Diego Santa Cruz Oyanguren y Espínola, who filed his last will and testament at Puebla de los Angeles in 1777, leaving his heirs considerable property, which included three houses, another under construction, and two fully outfitted pottery workshops (Cervantes 1939: Vol. 2, 303–4). This worldly fortune must have come from his position of status as a master ceramic decorator which led to at least five terms as a guild official. In a legal petition Santa Cruz Oyungueren claimed to have originated the Chinese mode, which he said brought a demand throughout the viceroyalty for his products (Cervantes 1939: Vol. 1, 42).

Regardless of who should be given credit for the pattern, it came as a refreshing change to a long stylistic sequence which had grown stale and tiresome from repetition and eroding craftsmanship. Not forsaking either Eastern or Western tradition, it appeared as a unique fusion of the two which somehow remained individual. The most usual atmosphere conveyed by this particular motif is Oriental, three examples of which appear on the exterior wall of the medium-sized hemispherical bowl shown in Figure 82. Calling to mind the Mexican vagueness in rendition, it is not surprising that its identification with a known Chinese structure cannot be made. The main clue to its foreign identity is the obvious hooked scroll at the right edge of the roof corner, the painter in this way employing a symbol in architecture such as those used in some Mexican depictions of Oriental human figures. The elongated, ribbed dome with a standard and banner at center crest also seems non-Mexican, as do the paired flagpoles by the entrance facade. A large pennant streams from this element in other versions (Cervantes 1939: Vol. 1, 221, 223), and still others use the heavy parallel lines with knobbed ends as a tree motif. Dots on the diagonal across a pitched roof hint at tiling. Small rectangles along the lower wall indicate windows. The building rests on a dark ground which

Figure 82
Bowl
Puebla de los Angeles, Second-half 18th Century
Dia. 21.5 cm.

Earthenware with tin glaze and cobalt
in-glaze decoration. Houghton Sawyer Collection.

Figure 83
Bowl
Puebla de los Angeles, Second-half 18th Century
Dia. 23 cm.

Earthenware with tin glaze and cobalt
in-glaze decoration. Houghton Sawyer Collection.

is shown as the washed and dotted cloud motif assimilated from Chinese examples into Mexican design language at least a century earlier. An interesting adaptation from Spanish grammar is expressed by the opposing vertical motifs stationed as framers at each side of the structure. The configuration of these verticals is vaguely Oriental, their dark dot enrichment Spanish. Space fillers of light offset parallel lines, and light dot clusters also came from Spain via the Muslim heritage.

On occasion, a few changes in the basic architectural pattern produced a different building and through that a distinctive cultural implication. The front pennant standard was converted to a gabled bell tower, sometimes with two stories; the central domed roof compressed into half-orange shape looming high above a gabled tile roof; and the corner pagoda hooks disappeared. Occasionally a secondary tower was added at the opposite end of the building from the entrance. The result was a depiction of what most Mexicans would have regarded as a church, though typically expressed in this style without crosses. A few faint lines in some versions might have been so intended. Similar generalized orientation of a tower with a lower gabled roof off to one side can be found on many Spanish vessels, from which it is assumed Mexicans derived their inspiration (for example, see Figure 31).

In accord with usual Mexican custom, there is no design on the interior of the bowl in Figure 82. From use, the glaze there is heavily crazed.

The bowl form was taken from the Chinese repertoire of shapes. It should be noted, however, that the same architectural pattern was used on contemporary pieces molded according to shapes made popular through Spanish imports.

A second footed bowl of identical form and decorative style as that in Figure 82 exhibits enough minor variations in execution and pattern to suggest that it came from the brushes of a different craftsman. It was usual in most shops to have the basic model, which was provided by the *maestro*, be followed by other workers in the production line who were given freedom to fill in detailing according to their own tastes. Those tastes inevitably conformed to the fashions of the day. Thus some small variations can be witnessed on individual examples bearing the same focal pattern. Obviously, some painters were more skilled than others. Therefore, no time differential in period of manufacture is necessarily implied in the minor decorative variances seen on these two pieces.

The exterior pattern on the bowl in Figure 83 consists of the same building, but it is painted with a slightly lighter hand. The greatest difference between the two bowls is seen in the framers at each end of the scenes. On this bowl, the tree with undulating trunk and branches at the viewer's left is the same as that at the opposite side of the panel on the bowl in Figure 82. The plant with bunched foliage resembling some kind of conifer used on the previous specimen is replaced here by a symmetrical, stylized floral arrangement at the viewer's right. All these lesser motifs were in common use during the second half of the eighteenth century.

As with the other bowl above, no interior decoration appears. Both specimens are well-potted, with thin, even walls and finely proportioned ring foot and thickened rim.

A comparison of the phoenix-in-flight scene on the *tibor* in Figure 70 and the depiction filling one of two quatrefoils on the *albarelo* in Figure 84 demonstrates important changes which evolved in the Mexican artisan's decorative attitude in the years between the late seventeenth century and the middle of the

Figure 84
Albarelo
Puebla de los Angeles, Mid-18th Century
Ht. 25 cm.; dia. orifice 10 cm.

Earthenware with tin glaze and cobalt
in-glaze decoration.

117

Figure 85
Albarelo
Puebla de los Angeles, Mid-18th Century
Ht. 26 cm.; dia. orifice 10 cm.
Earthenware with tin glaze and cobalt,
antimony, and iron in-glaze decoration.
Houghton Sawyer Collection.

eighteenth century while at the same time pointing to a remarkable artistic continuity. The hold of Chinese ideas on Mexican work concerning balance, harmony of light and dark values, layout, and content will be seen to have diminished somewhat but nevertheless to have remained effective.

For example, fields of decoration continued to be segmented in some way. On closed forms such as this *albarelo*, this usually was by bands which in zones of least importance were only defined horizontally. The *ju-i* or egg-and-dart chain at the top of the drug jar and the wider, erect lotus panel at the base are such units. In focal areas the bands frequently also were cut vertically. The vertical dividing device on the *albarelo* was a pair of large reserve quatrefoils set against a ground of dark, hooked scrolls, by this means reaffirming concern with contrast of tonal values. On the *albarelo* the pattern expanded to cover most of the available wall space, a distribution not unusual on most closed forms of the seventeenth century nor to be continued consistently later.

The most noticeable changes appear within the principal compartment of the decorative band. It should be noted that by the time the *albarelo* was made, one scene had assumed more importance than the other, whereas previously all units were of more or less equal interest. The way in which this main scene is presented exemplifies the movement toward overtly pictorial themes on the one hand and an interest in lightness of pattern on the other. A facilely drawn dark crane, or *zancuda*, with faintly indicated beak and limbs, stands slightly off center toward the lower left of the space within the quatrefoil frame. An imaginary diagonal line running from it through a bush element at upper right corresponds to the diagonal of the phoenix body and tail on the *tibor*. Similarly, a grouping of modified rock, wave, and floral motifs at lower right cross-balances a light, rayed cloud at upper left. The motifs in the same position on the phoenix panel were heavier but served the same visual function. A ground of five parallel lines and a nopal anchored the *albarelo* scene at the lower left corner. These elements were foreshadowed by the

pair of horizontally projecting lines and a three-dot pyramid in the same part of the phoenix panel. Though still present, fillers are fewer, thus leaving more ground exposed. In summary, the configuration of the motifs differed, but the identical basic structure of composition remained.

The quatrefoil on the opposite side of the vessel is filled with a pattern of three dotted flowers, stems, and smaller florals. Scallops and pendant rays were drawn from the top and sides of the medallion.

The *albarelo* shape with sharply angled base and shoulder and constricted waist came to Mexican maiolica from Spain. In the late colonial period it appears to have been used more often as a flower vase than a drug container and is among the most frequently encountered vessel shapes.

The *albarelo* in Figure 85 imitated seventeenth- and eighteenth-century Spanish drug jar design in displaying a pattern of a single large escutcheon on one face of the vessel. Decorative workmanship is of a lower caliber, however, than on most contemporary Iberian jars.

On an oval shield located at the center of the vessel body is a polychromed coat of arms, thought to be that of the Juaninos or Carmelites, which appears to be a pomegranate topped by a cross. Apparently the cross was retouched in iron oxide. The vessel must have been refired to set the pigment but not sufficiently to flux the underlying glaze. The retouched cross remained matte. Hooked scrolls around the oval shield are complicated by unrelated pyramids of arched lines and splayed, graduated lines which fill space but do little to strengthen the design. An S-scroll chain encircles the jar shoulder. Line work was freehand and unsteady, the hue of the cobalt pigment varying with pressure of the brush.

In form and decorative style this *albarelo* clearly shows the abandonment of much of the Orientalism which had characterized Mexican maiolica for more than a century. The form itself was becoming more like that used later in the century by being more straight-sided and in having a flared neck.

Few Mexican vessels with decoration having religious connotation are present in this collection nor are they as common as among Spanish ceramics. The reason must be that fewer religious organizations placed large orders for maiolica pieces marked with their emblems. However, a possible example bearing such enrichment is the bulbous jar in Figure 86. The

Figure 86
Orza
Puebla de los Angeles, Mid-18th Century
Ht. 25.2 cm.; dia. orifice 11 cm.
Earthenware with tin glaze and cobalt
in-glaze decoration. Houghton Sawyer
Collection.

119

Figure 87
Barril
Puebla de los Angeles,
Second-half 18th Century
Ht. 32.5 cm.; dia. orifice 21.5 cm.

Earthenware with tin glaze and cobalt in-glaze decoration. Houghton Sawyer Collection.

Figure 88
Barril
Puebla de los Angeles,
Second-half 18th Century
Ht. 25.5 cm.

Earthenware with tin glaze and cobalt in-glaze decoration. Houghton Sawyer Collection.

main design covering the full height of the globular body from vertical neck to vertical foot is a flattened trefoil or shield in whose interior are seen three crowns and an eight-pointed star. This is a possible allusion to the Holy Trinity and Holy Birth. Four hooked scrolls with dotted edges, either an *ataurique* or fungus scroll variation, point toward the center of the shield from the inside outline of the medallion, four others of varying sizes are placed at top and bottom of the outer edge of the same medallion, and about the neck are still four more. None of these scrolls are known to have iconographic importance.

The full, balloon-body contour mounted on a prominent foot with a brief, straight neck seems more Chinese than Spanish, but exact prototypes in either idiom are uncommon.

A probable time of manufacture toward the middle of the eighteenth century is suggested by styling which has lost any semblance to chinoiserie. Lack of concentric banding and restricted amount of decoration repeat a growing shift away from Eastern models.

Barrel-shaped jars, having greatest circumference at midsection and sloping slightly in to broad base and mouth, were made by Chinese potters to be used as stools if large, as jardinieres if small. During the eighteenth century they were produced by Mexican potters for the latter purpose. Figure 87 shows a specimen which on many fronts displays a marked decline of technique.

Not only was the vessel thick-walled, but it warped out of shape during firing. It was covered with a glaze low in tin content, which resulted in a cream rather than white ground. The cobalt likewise was not top quality because it bubbled and became speckled when fired. The most obvious sign of poor work was the decoration, an uninspired rephrasing of an old idea borrowed from the Chinese coupled, as in the past, with filler detail taken from the Muslims.

Against a checkerboard of solid dark rectangles alternating with reserve white rectangles containing four-dot clusters appears a degraded version of the flying phoenix scene such as in Figure 70. The underlying vigor of the pattern has been reduced because of lack of understanding of basic structural concepts and because of bungling execution of motifs. The diagonal slant of dividers approaches the vertical, thus losing their potential for adding excitement of line. The large, hooked scroll at the upper left corner, merely ungainly, does not provide strong counterthrust to the elements lower and opposite. An especially awkward angle is created by the backward tilt of the bird head. And as if that were not enough to destroy the effect, space fillers were applied with too heavy a hand.

Another barrel planter shown in Figure 88 is further elaborated with three applied clay bands. These additions were not needed for body reinforcement but on this jar serve to emphasize band pattern borders. In other instances they were not utilized as a factor in design. Each rib, framed by light, encircling lines, is further decorated with a vine motif which became exceedingly popular into the nineteenth century. On the upper shoulder is a band unit of repeated rosettes and branches in reserve white. The widest band covering the expanse from above midsection to lower body is decorated with a diapered diamond pattern, the centers filled with dotted rosettes and the intersections accented with five-dot clusters.

Figure 89
Tibor
Puebla de los Angeles,
Second-half 18th Century
Ht. 23.5 cm.; dia. orifice 12.5 cm.

Earthenware with tin glaze and cobalt
in-glaze decoration. Houghton Sawyer
Collection.

Layout of decoration on the smaller version of a wide-mouthed *tibor* in Figure 89 followed the long-established custom. A narrow band of inverted *ju-i* or egg-and-dart around the base of the neck matches an opposing, encircling band at the bottom of the field. Four large Oriental lappet medallions are spaced around the body, thereby quartering the zone in the usual way. These medallions, filled with dark-blue pigment painted to leave a flower and petals in reserve white, provide the dark part of the composition. The spaces between them carry one type of stylized flower at the top and another at the bottom set upon a beaded line, the latter being more a European than Oriental pattern which found great favor in the last half of the eighteenth century. Major pattern is dark; outlining is light. A wavy, light line divides the undecorated basal portion of the jar. All design work suffered because the glaze became unduly fluxed. As it began to flow downward, it caused decoration to slump and blur. Such a mishap seems not to have been sufficient to cause the vessel to be discarded as a waster.

A merging of styles similar to that on the *tibor* in Figure 89 is apparent on that in Figure 90. Three bands compose the design, the neck remaining undecorated except for a bright green stripe at the rim. On the upper shoulder is an encircling pattern of contiguous leaves outlined in light, feathered lines. Dark, elliptical dots appear at each side and base of the leaf, and smaller four-dot clusters are above and below the leaf centers. Around the bottom of decoration is an egg-and-dart or *ju-i* border which varies from more usual renditions in having two petals between the loops. Central decoration between broad, dark framers with light outliners consists of four foliated, dark, Oriental lappets containing reserve white scrolls. Erect floral abstractions which fill the white spaces between lappets resemble those popularized in Bourbon Spain and often duplicated in the late eighteenth century by Mexican decorators. A wavy, light-blue line divides the blank basal area.

Several attributes of the jar point to its having been made during the second half of the eighteenth century. The use of green on a style generally restricted to blue on white became more common as guild control and the industry itself declined. In this case the glaze has a faint greenish tinge due to contamination

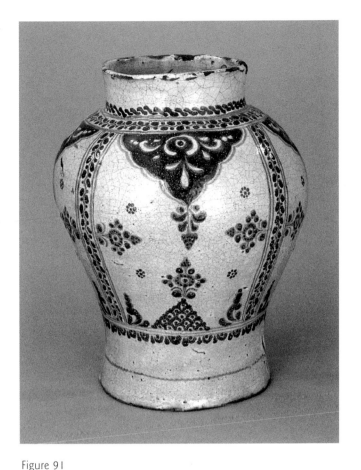

Figure 90
Tibor
Puebla de los Angeles, Second-half 18th Century
Ht. 23 cm.; dia. orifice 9 cm.

Earthenware with tin glaze and cobalt and copper
in-glaze decoration. Houghton Sawyer Collection.

Figure 91
Tibor
Puebla de los Angeles,
Second-half 18th Century
Ht. 45 cm.; dia. orifice 8 cm.

Earthenware with tin glaze and cobalt
in-glaze decoration. Houghton Sawyer
Collection.

from the copper decoration at the rim. The jar is also unusual in having had a hole punched in the bottom at time of manufacture, verified by the flow of glaze into the cut, this in spite of a mouth considerably more restricted than that on the preceding vessel. Evidently it was designed as a planter right from the beginning, unlike earlier *tibores* which assumed that role secondarily. The use of patterns taken from Spanish sources emphasizes the abandonment of Chinese modes which occurred in the late eighteenth century.

This *tibor* was shattered during the 1906 San Francisco earthquake. Perhaps it was not as sturdy as the companion pieces in this collection because its comparatively thin walls were fashioned from light-burning clays which have less strength.

Figure 91 illustrates a very thick, large, oviform jar of the *tibor* series that was either thrown off center or warped badly during firing. The upper shoulder slumped, causing an irregular profile. In spite of its ample

size, there is no clue that the jar was thrown in two sections. The base spreads more than that of most *tibores*, making it closer to the Chinese *potiche*. An extensively crazed glaze may have resulted from the same stresses which promoted wall distortion.

Four encircling bands, with the main zone of decoration segmented vertically into four units, continue the Chinese format introduced early in the seventeenth century. S-scroll, vine, and egg-and-dart patterns making up minor bands have Mediterranean pedigrees going back to Classical times. The first two came into frequent usage by Mexican maiolists in the late eighteenth century and remained prominent on Puebla ceramics of the next century. Egg-and-dart borders appear to have been assimilated earlier. The same vine, formed by dark round or lozenge-shaped dots alternating with smaller round dots off an undulating light stem, appear on this *tibor* as panel dividers, in contrast to the more usual unelaborated lines of various widths. Attached horizontally to these ordering devices are matched, stylized floral sprays duplicating another spray held vertically by a pyramid of arched lines. Stiff floral arrangements of this type, made up of a dark, dotted rosette over or encircled by light lines with balanced petals or dots at each side and top, became a stock-in-trade motif in the second half of the eighteenth century. The pyramidal group, first evolved in Spanish lusterware of the fifteenth century, was common on the lace-patterned work in seventeenth-century Mexico and subsequently as a light background accent. Pendant from the top border line is a cloud collar point filled with reserve white scrolls and petals. The element suspended from it is reminiscent of those on other contemporary vessels in this collection. Background fillers are four symmetrically placed rosettes, likewise repeatedly used. A light, irregular line divides the undecorated area at the base of the jar in a manner typifying eighteenth-century Mexican ceramic decoration.

Draftsmanship is fairly exact. Each compartment of the main band is 16 cm. in width at top and bottom, swelling to 22 cm. at center to fit body curvature. Line work and details of pattern are sure-handed. The dark pigment used in decoration contains many white speckles owing to improper or incomplete grinding. A local cobalt, such as that used after Mexico became politically independent of Spain, is suggested.

On the large, deep bowl in Figure 92, a lingering Chinese mannerism to establish contrasting passages of light and dark appears to create a diapered pattern favored by ceramic decorators working under the stimulus of the Spanish Rococo. Four dark cloud collar points tasseled with petals and dots are suspended into the bowl interior from a narrow (2.5 cm.), everted rim. These are lightened by hooked scrolls and circles in reserve white. They are placed in such a way as to frame a four-pointed white field across the entire bowl interior. In each point on the bowl wall are duplicate stylized floral groupings of two chrysanthemums in vertical position surrounded by completely balanced, tapered leaves and round dots. In the bowl bottom is another floral conventionalization, also totally symmetrical. Major parts of the pattern are drawn in thick, dark blue, lesser outlining and line work in light blue. All the florals used and the way in which they are combined were typical of the mid-eighteenth century. Small-scaled, six-dot rosettes and four-dot clusters in dark blue serve as ground fillers. On the rim is a row of modified egg-and-dart between light framing lines, a heavier dark line being directly on the rim edge which had been lightly indented with a tool rather than

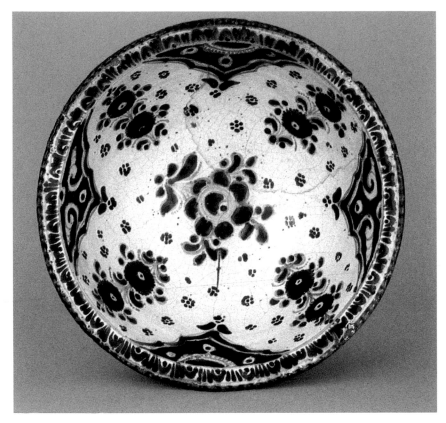

Figure 92
Bowl
Puebla de los Angeles,
Mid-18th Century
Dia. 40 cm.

Earthenware with tin glaze and cobalt in-glaze decoration. Houghton Sawyer Collection.

Figure 93
Tibor
Puebla de los Angeles,
Mid-18th Century
Ht. 20 cm.

Earthenware with tin glaze and cobalt in-glaze decoration. Houghton Sawyer Collection.

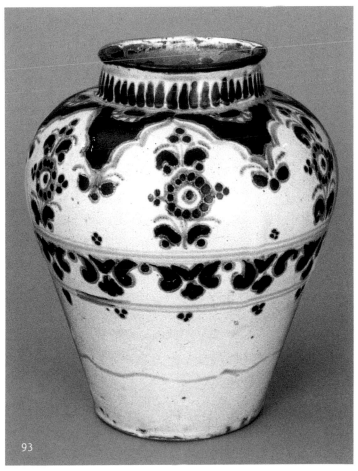

being pinched by the potter's fingers. There is no exterior decoration.

A comparison between this bowl and the *tibor* in Figure 91 will show the same point of view in structuring field of design, the same play of light and dark values, the same symmetry and balance, the same motifs. They both also demonstrate the growing taste for uncluttered backgrounds.

Medium-sized jars of the high-shouldered, narrow-based contour illustrated in Figure 93 sometimes have been called spice jars. Such a function is problematical inasmuch as capacity of most vessels in this category is considerably more than that necessary to store substances used sparingly and subject to deterioration from air, light, and dust. The interior of this particular pot is heavily crazed due to prolonged moisture, leading to the conclusion that at some time it served as a vase. That might have been a secondary function.

Three zones of decoration typically confined to the upper two-thirds of the jar are defined by light framers,

93

such layout and lining an automatic decorative technique by the middle of the eighteenth century. Below that, about a vertical neck of a height suitable to engage a lid, is a band of dark, contiguous lozenges. The wide shoulder band of principal interest is divided with six dark cloud collar scrolls tipped by three suspended dots pendant from the top band line. In more usual Chinese work, these would have been lightened by greater use of negative pattern. The cloud collar points are separated by six dark-blue, upright rosettes and their balanced comma-and-dot associations, stem lines and outlines in dark blue. Four-dot clusters appear near the base frame line as space fillers. The lower band is made up of groups of dark pendant commas in opposing directions separated by fleur-de-lis. Three-dot clusters are suspended from the paired lower framing lines. A light, wavy line divides the remaining undecorated space on the basal third of the body wall.

The large, molded plate with foliated rim and no ring foot in Figure 94 is typical of the second half of the eighteenth century when the influence of European Rococo was at its height. Its broad, flattened rim, separated from the expansive center by a sharp angle typical of metal services, invited decoration, which was used to focus the viewer's eye inward toward the important field. Contiguous, dark horseshoe scrolls embracing a round dot and separated by a fleur-de-lis are painted below a light frame which undulates to conform to the curved plate edge. Four-dot clusters suspend from the band to thicken its appearance and so dramatize the focal pattern. That is another rendition of the architectural theme used on the bowls in Figures 82 and 83.

There are a number of aspects to this interpretation which point to its being a later imitation, perhaps even made in the shop of Santa Cruz Oyanguren after the old master had died. The left side shadowed, the perspective has been modified so that the long axis of the building appears as the front rather than side, with the flagpole at one corner. Its facade has become probable stonemasonry. What was formerly an elongated dome rounds into the typical Mexican drum dome but rises above a gabled roof seemingly of the same width and having no visible back slope. A lantern topping the construction converts its appearance into a possible church. The effect of balance through vertical side framers of equal strength has been shifted to interaction between the flagpole and a vertical vegetal unit to the viewer's right, the left floral having shrunk in size and importance. Dots arranged pyramidally and suspended by threadlike lines below the washed ground make the structure appear to be floating. Dark, dotted rosettes are added to graduated and crossed light lines as space breakers which clutter the background. The outlining of elements by light lines of blue has assumed increased importance.

The cobalt pigment was heavily applied to this decoration, but some postfiring of pennants and roof was necessary, leaving patches of matte pigment visible. Many individual pins or a single device with up to eight fingers supported this broad vessel during glost firing to keep it from fusing to the kiln shelf yet not buckle under heat.

The shallow, fluted bowl in Figure 95 illustrates the generalized Meissen style which infiltrated Mexican work after the middle eighteenth century. The border is a large-scale, carefully drawn elaboration of horse-

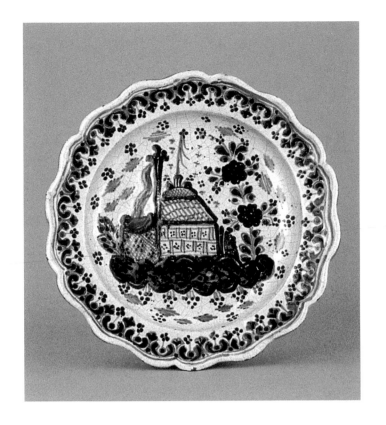

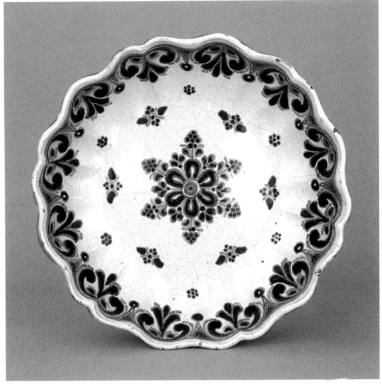

Figure 94
Plate
Puebla de los Angeles,
Second-half 18th Century
Dia. 38 cm.
Earthenware with tin glaze and cobalt
in-glaze decoration. Houghton Sawyer
Collection.

Figure 95
Bowl
Puebla de los Angeles,
Second-half 18th Century
Dia. 38 cm.
Earthenware with tin glaze and cobalt
in-glaze decoration. Houghton Sawyer
Collection.

shoe scrolls and pendant fleur-de-lis current on Mexican maiolica from at least the early seventeenth century. In the bowl center is a prominent, formally structured flower which was repeated many times on vessels of the late eighteenth century. It is surrounded by other smaller floral units and rosettes. All these motifs are composed of the same dark, broad lines, tapered petals, and dots which characterized Mexican ceramic design work almost from its inception. However, they have gained added interest with more concentration of light blue, which unifies the carefully planned and executed pattern. Close inspection shows the absence of some feathering lines in the outer band, as though the painter forgot to add them.

As was customary for most open forms of this period, this flat-bottomed bowl was moldmade. Its rim remained unthickened or rolled. Similar fluted bowls in Spain were called *crespina* because of their resemblance to a hair cap.

127

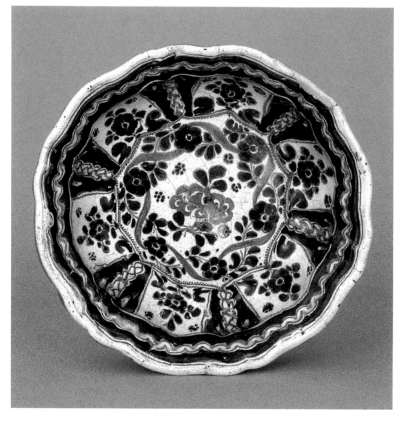

Figure 96
Bowl
Puebla de los Angeles,
Second-half 18th Century
Dia. 28 cm.

Earthenware with tin glaze and cobalt
in-glaze decoration. Houghton Sawyer
Collection.

The same careful, segmented decoration on a fluted bowl is exhibited on the specimen in Figure 96. Beneath a banded, wavy line, the cavetto is divided by dark verticals enhanced by a light-blue chain into six reserve white units filled with balanced floral elements. The basal zone is bordered by six flowers on a twisted ribbon line and a center flower. Fillers are dot clusters. The use of light blue in the balanced pattern is important. There is no exterior decoration.

The massive bowl in Figure 97 represents a late version of the old Spanish *lebrillo*. Instead of being vertically pulled from a broad, flat center, its walls sloped gently outward to a thickened rim which was pinched between the potter's fingers. Ten groups of four indentations each were formed in this fashion and were spaced around the bowl edge.

A synthesis of Eastern and Western traditions decorates the bowl's interior surface. Below a banded eighteenth-century vine motif, dark cloud collar points suspend down the cavetto to form a six-point star in reserve white. Each point of the star is further defined by groups of four vertical,

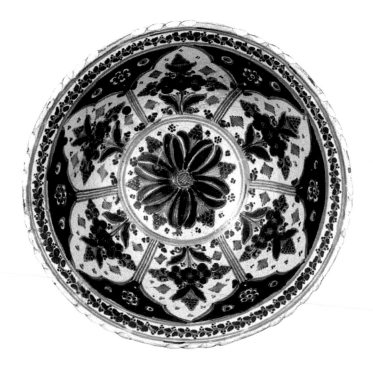

Figure 97
Bowl
Puebla de los Angeles,
Second-half 18th Century
Dia. 38 cm.

Earthenware with tin glaze and cobalt
in-glaze decoration. Houghton Sawyer
Collection.

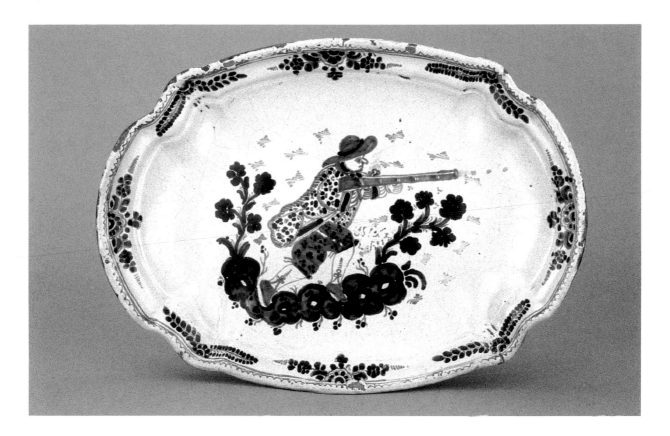

light lines leading to a central encircled zone, making sections 11 cm. in width at the outer edge tapered to 7.5 cm. in width at the inner edge. It is noteworthy that spacing on open forms of the second half of the eighteenth century is more exact than it had been on earlier closed examples, partly because on the former fields gross inaccuracies would have been immediately observable. Furthermore, there is evident a growing concern with rigidly balanced patterns which demanded strictly controlled layout. The symmetrical, stylized, vertical florals in

the star compartments and a large, open flower in the bowl bottom are good examples of this kind of decoration. The usual three-dot cluster and graduated parallel lines serve as ground fillers for the cavetto; rosettes and four-dot clusters are fillers for the center. All these groupings also are laid on symmetrically. Dark-blue pigment carrying the principal pattern is heavy and raised, producing a strong contrast with the areas left in white. Some extra detailing is added in a black pigment. There is important use of light blue as an integral part of the pattern, not merely supplemental outlining, in a trend which would evolve at the end of the century into comparable patterns in polychromes of many colors rather than being confined to two shades of blue plus a minor accent of black.

The oval platter with thick, foliated rim in Figure 98 has a hybrid decoration typical of the late eighteenth century. The flattened rim is painted on the interior with eight units of two alternating floral and

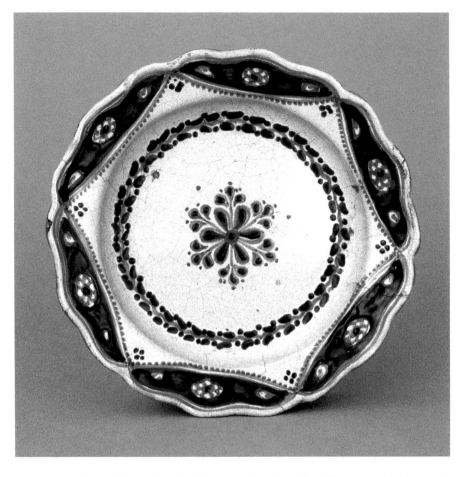

Figure 99
Plate
Puebla de los Angeles,
Second-half 18th Century
Dia. 22.5 cm.

Earthenware with tin glaze and cobalt in-glaze decoration. Houghton Sawyer Collection.

fern motifs. The central pattern is a naively painted hunter with harquebus, long a favorite theme on Spanish maiolica. The figure is obviously Western, probably a *vecino* (citizen) of some Mexican town out to enjoy a common pastime. The way in which he is defined in light blue is a typical Mexican method of figure-painting on ceramics. Especially interesting is his clothing of full breeches tied below the knees, waistcoat with sleeves short enough to reveal ruffled shirt sleeves beneath it, soft-soled shoes and embroidered hose, and a large, slouched hat. The identical hat style also has been noted on a figure decorating a fragment of late-eighteenth-century Mexican polychrome recovered at Santa Rosa Pensacola, Florida (Smith 1972, fig. 6). The custom of indicating pattern within the figure through wash and dotting had counterparts in seventeenth-century Mexican decoration, but here dotting is more carefully grouped into the traditional threes. The ground is the same Chinese wave cloud, washed and dotted, as appears beneath the contemporary architectural patterns. The concept of vertical framers for the scene is Spanish; their specific design is Chinese. Ground fillers of dot clusters and graduated parallel lines are those seen in this collection from earliest Spanish Muslim work, but in the late-eighteenth-century piece they are confined to an area immediately around the principal figure, thus leaving the cavetto blank in Rococo fashion. As if in a cartoon, three groupings of fine lines represent shots from the gun.

Although wares found in archaeological contexts of the late eighteenth century frequently have exterior decoration of overlapping arcaded lines, there are no comparable examples in this collection. The rare exterior decoration appearing on this platter is two long floral bands on the sides and two shorter ones across the ends, all in light blue.

Obviously molded in imitation of a metal tray, the exterior surface is scarred where it adhered to the kiln shelf during glost firing. Its bottom surface bulged slightly during drying or firing.

Diapered patterns such as were popular in Europe during the eighteenth century usually were interpreted by the Mexicans in the way illustrated on the delicate plate in Figure 99. Beneath foliated rim edges dark zones alleviated by reserve flowers leave a sixpointed star white field across the interior expanse. The idea of this contrast and structure, basically Chinese, probably diffused to Mexico through Spain. Dotted lines accented at points by four-dot clusters framed the white zone, which contained a very typical late-eighteenth-century vine pattern of dark dots of several sizes and configurations opposed along a light, curved thread making a circle within the angled field. In the middle of the plate is a schematic, symmetrical floral element of dark petals and dots unified by light outlines which repeats the circularity of the frame. Large amounts of undecorated vessel surface are typical for the period. There is no exterior decoration.

It is no accident that bits and pieces of patterns very similar or identical to that on this plate are those most commonly found in archaeological sites along the northern borderlands from California through Texas, because during the second half of the eighteenth century the influence of Nueva España expanded to its greatest geographical dimensions. Eastern Florida, however, passed from Spanish control about the time the Rococo style was firmed. Much tin-glazed tableware of the common market was decorated in some variation of this style, so that soldiers in far-flung northern *presidios* ate from comparable dishes; parish priests, supplied by annual mission caravans, had a few similar vessels on their altars as plates beneath cruets of sacramental wines; and isolated settlers hoarded some such dishes in a *comedor* cupboard.

The same kind of visual impact between border and center of a flat, open form is provided by the molded plate in Figure 100. The banded border, rather than being diapered, is made of alternating dark and light passages conforming to the scalloped plate edge, the light areas filled with alternating dark

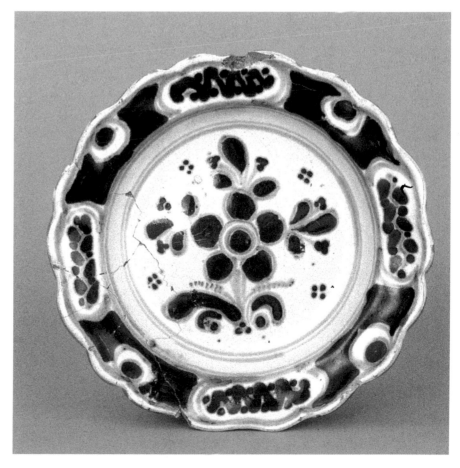

Figure 100
Plate
Puebla de los Angeles,
Second-half 18th Century
Dia. 21.5 cm.

Earthenware with tin glaze and cobalt in-glaze decoration. Houghton Sawyer Collection

vines and zigzags. Central pattern is an erect, dark floral laid down symmetrically in which use of light blue is restricted to outlining. Dark, four-dot clusters serve as space fillers. The overall aspect of the piece is a Europeanization of colonial taste, yet the bold, dark areas and the foliated form itself ultimately came from a Chinese idea long lost in the complexities of artistic diffusion. The undecorated cavetto was a hallmark of the times.

As with the former specimen and for the same reasons, fragments bearing designs reminiscent of this style occur frequently in archaeological materials of the Spanish occupation of the American Southwest.

The small plate in Figure 101 exhibits another late simplification of a decorative style which was exported to all frontiers. The diapered treatment has been replaced by banding and alternating motifs of dot clusters and floral abstractions. The entire center field has been left blank except for a highly convention-alized motif of petals and dots. Dark-blue pigment remains of primary importance. One suspects this is an example of hastily decorated, hastily processed maiolica made to meet the needs of a common market, but it was also a style of decoration which survived into the polychrome period of the first half of the nineteenth century. Three prominent cockspur scars on obverse and reverse emphasize mass production, when there was no interest in or time for niceties of surface finishing.

Most Spanish vessels having lids were pharmacy jars. In Mexico they appear to have been large storage receptacles. Probably many more lids were made there than now are known, such additions having been eas-ily broken and discarded. There are three large lids in the collection, none fashioned for vessels on hand but all of a late-eighteenth-century style. They are illustrated in Figure 102. All are domed, probably thrown upside down as bowls with a raised flange formed around the inner circumference to fit into the orifice of a jar, thus securing the lid in position. At the leather-hard stage they were topped with a rounded knob.

102a

102b

Figure 101
Plate
Puebla de los Angeles,
Second-half 18th Century
Dia. 18.5 cm.
Earthenware with tin glaze and cobalt in-glaze decoration. Houghton Sawyer Collection.

102c

Figure 102
Three Lids
Puebla de los Angeles,
Second-half 18th Century

(a) Dia. 14.5 cm.
Earthenware with tin glaze and cobalt in-glaze decoration. Houghton Sawyer Collection.

(b) Dia. 24 cm.
Earthenware with tin glaze and cobalt in-glaze decoration. Houghton Sawyer Collection.

(c) Dia. 20 cm.
Earthenware with tin glaze and cobalt in-glaze decoration. Houghton Sawyer Collection.

133

Such rounded lids were a typically Chinese covering copied by the Westerners. Among Mexican examples, their usual size indicates use on *tibores*. Nevertheless, smaller lids suitable for sugar bowls, ointment jars, and the like are known archaeologically. In the nineteenth century, lids of similar contour covered casseroles, tureens, chamber pots, and decorative jars.

All the present examples of lids are decorated to be viewed from above, the knob handle providing a pivotal axis for design. One knob, Figure 102a, is painted in a dark, compacted, floral or petal pattern surrounded at flange position with a dark, flowing petal border. In style it matches the *tibor* in Figure 104 but its size is too small to have permitted its use with that pot. Another lid, Figure 102b, makes the dark knob the center of a dark-petaled flower surrounded by a dark, six-pointed star inlaid in a larger six-pointed star reserve field in white. It is bordered at the very outer edge by a three- or four-dot cluster and petal chain, making for the same complex relationship of light and dark seen on contemporary pieces in the collection. The third lid, Figure 102c, has the restored knob, decorated in a dark circle outlined by dots, in the center of an encircling vine to which are attached six small loops that project into six dark zones separating six lobed medallions in reserve white. The same vertical floral conventionalization seen on contemporary vessels appears in these medallions beneath a beading around the outer lid edge.

Even though the main wave of Chinese influence on Mexican maiolica was receding by the middle of the eighteenth century, Mexican potters found the *tibor* form a useful one for many purposes, such as the storage of wine or cacao beans. However, the profiles of these vessels lost much of the earlier elegance of proportion and articulation of parts, as in the jar illustrated in Figure 103, which had become notably wider at its base and more ample at its waist, causing a chunkiness in appearance.

Figure 103
Tibor
Puebla de los Angeles,
Second-half 18th Century
Ht. 32 cm.; dia. orifice 11.5 cm.
Earthenware with tin glaze and cobalt in glaze decoration. Houghton Sawyer Collection.

Decorators chose to decorate these late pieces in accord with their own artistic language rather than attempting duplication of Oriental modes. Hispanic layout and themes are indicated on this late jar in two wide units at the top and bottom of the vessel, leaving a wide midriff bare. This was a disposition of pattern which became increasingly common as decorators pulled farther away from Chinese models, which most typically bore decoration over their total exterior surfaces. On this jar, each zone has carelessly drafted egg-and-dart bands bordering a zone 6 cm. in width filled with lobed spirals separated by splayed petal groups. Although original derivation may have been Oriental, the minor egg-and-dart band perhaps came to Mexico from classical sources; the dark central scrolls formed of short, contiguous strokes from a heavily charged brush rather than a continuously curved line were descended from Moorish *atauriques*, themselves modifications of Eastern scrolls. Inferior rendition of both patterns as compared to original versions expresses a nonchalant but typically Mexican attitude toward measured draftsmanship.

Also representative of the style evolved in the second half of the eighteenth century is the *tibor* in Figure 104. Because of a slightly flared foot and a constriction up the body, its profile is not as thickset as some contemporary vessels. Its decoration, executed only in heavy, dark cobalt, is confined to two neatly drawn, matching, unframed bands top and bottom consisting of curved fern scrolls and commalike elements in opposing directions.

The poor quality of the glaze detracts from the well-formed and well-decorated jar. It is deeply pitted from pinholes and is marred by patches to which glaze did not adhere. Interior crazing may have resulted from the vessel having served as a planter, although no drainage hole is present.

The late-eighteenth-century bottle in Figure 105 has the same pear shape taken from Chinese examples as that in Figure 65 but lacks the elevated foot. The center of its base was slightly depressed inwardly to create a foot. Design is greatly simplified over earlier works. Some 9 cm. below a sharply everted lip, an encircling band of heavy horseshoe scrolls separated by fleur-de-lis hangs pendant from a light frame line. A large, round dot is in the scroll enclosures, four-dot clusters lying below their openings. Nine six-dot rosettes divide the area between the above band and a narrow light line near the vessel bottom. Although rather frequently seen on Spanish ceramics, the horseshoe scroll originally may have been taken by Italians or other Europeans from the Chinese *ju-i* head motif. Likely it infiltrated Mexican repertoires as part of a European complex of design ideas which spread to that colonial province in Bourbon times.

As the late eighteenth century witnessed a growing appreciation for restricted design, ground areas assumed new importance. Many specimens of the time exhibit improved coatings from which one might infer a conscious effort on the part of potters to improve their glaze compositions. The stanniferous glaze on this bottle gleams, inviting a viewer to pass his hands across the surface. Notwithstanding, there still remained at that late date, some two and a half centuries after the introduction of the maiolica technology, an indifference to surface blemishes of a sort which would have caused great anguish to Spanish or Chinese potters. As a result of improper fit or comparative rates of shrinkage of clay and glaze, crazing is very extensive. Pinholes, resulting from imbalance of certain mineral additives to the glaze, crater the surface.

Figure 104
Tibor
Puebla de los Angeles,
Second-half 18th Century
Ht. 34 cm.; dia. orifice 15 cm.

Earthenware with tin glaze and cobalt
in-glaze decoration. Houghton Sawyer
Collection.

Figure 105
Bottle
Puebla de los Angeles,
Second-half 18th Century
Ht. 28 cm.; dia. 58 cm.

Earthenware with tin glaze and cobalt
in-glaze decoration. Houghton Sawyer
Collection.

Crawling occurred in many areas about the vessel bottom. This was a mishap which usually developed because of dust particles remaining on the bisqued body and resulted in bare patches of the paste being left exposed.

The verticality of the cylindrical *albarelo* form is emphasized in the example in Figure 106. This erect composition was not common, but other specimens bearing identical decoration inspired by Alcoran designers (Martínez Caviró 1968, figs. 251–54) are known.

Four panels, 4 cm. in width, of foliage groups placed in opposing directions are separated by four narrower vines of dots and wavy connecting lines. The fern pattern has definite similarities of brushwork to the pattern on the *tibor* in Figure 104. Light frame lines close top and base of the pattern, which extends the

Figure 106
Albarelo
Puebla de los Angeles,
Second-half 18th Century
Ht. 24.5 cm.; dia. orifice 11 cm.

Earthenware with tin glaze and cobalt in-glaze decoration. Houghton Sawyer Collection.

Figure 107
Albarelo
Puebla de los Angeles,
Second-half 18th Century
Ht. 27.5 cm.; dia. orifice 10 cm.

Earthenware with tin glaze and cobalt in-glaze decoration. Houghton Sawyer Collection.

full height of the jar. All elements are outlined in light blue. There is a marked restraint of pattern to permit some of the lustrous background to be visible.

Both potting and decorating craftsmanship on this *albarelo* are good.

One of the manifestations of simplification of ceramic decoration which took place in the second half of the eighteenth century was the restriction of pattern to shoulder and lower walls of *albarelos*. Usually such designs were narrow bands of repeated motifs, though band-framing lines on occasion were omitted. Some vertical connecting elements continued in use.

The *albarelo* in Figure 107 has two identical dark-blue framed bands incorporating scrolls in reserve white at its upper and lower field. Between them appear a pair of lines composed of three casually drawn long-legged birds of the eighteenth-century repertoire placed one above the other. There is an obvious lack of excitement in these lines of design as compared with the design on the specimen below.

On the *albarelo* in Figure 108, the unframed bands are foliated scrolls made up of a wavy line over which petals and hooks are drawn in much the same treatment as appears on the *tibor* in Figure 104 and the lid in Figure 102a. Accent dots were added within the loops to fill in the blank spaces so that a more solid band would emerge. On one side a lone bird with an exaggerated tail is used to form a downward-angled movement across the vessel wall (Figure 108a). A bounding hare raised up on hind legs and a bird pointed in

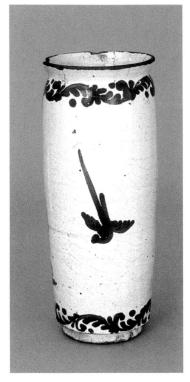

flight lead the viewer's eye upward across the pot on the other side (Figure 108b). These lines add interest to the pattern. As noted elsewhere, all the motifs on this vessel may originally have been Chinese, but by the late eighteenth century they were thoroughly integrated into Mexican style.

The shape of both these vessels differs from earlier examples in having more rounded shoulders, little or no central constriction, and short, flared necks.

Four *albarelos* with virtually identical decoration are shown in Figure 109. Each has a double upper band of a vine composed of a light, undulating line and large and small dark, alternating dots on each side, and beneath that a dark zigzag with alternating three-dot clusters. The same vine band is repeated around lower-body walls. All bands are framed with light lines. Such an orderly, limited decoration, contrasting well with large areas of undecorated white glaze, was in accord with late-eighteenth-century tastes. So popular was the vine pattern that it continued into the nineteenth-century polychrome production.

The four jars exhibit variable forms. Two have short, flared necks above angled shoulders. The remaining two were finished with tall, straight necks constricted above more rounded shoulders. All are wasp-waisted, a characteristic heightened in several instances by unusual height in relation to diameter. The fact that one had a hole drilled in its base suggests a secondary use as a planter.

The same restraint in decoration is shown by the two *albarelos* in Figure 110, which have identical decoration of bold horseshoe scrolls separated by fleur-de-lis and large dots placed facing each other at top and bottom of the decoration field. Small, four-dot clusters are fillers off the scroll opening.

In regard to form, both jars lack the angled basal profile, wasp waists, and pronounced shoulder angles. Both have straight rather than flared necks.

In Figure 111, the popular vine appears alone as banding on two small jars which can be considered modifications of the *albarelo* form. One has a pronounced shoulder swell in copy of eighteenth-century Spanish style. The other is more typical in profile, with a brief, flared neck. The restricted design, its place-

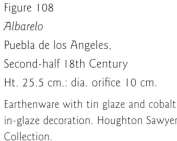

Figure 108
Albarelo
Puebla de los Angeles,
Second-half 18th Century
Ht. 25.5 cm.: dia. orifice 10 cm.

Earthenware with tin glaze and cobalt in-glaze decoration. Houghton Sawyer Collection.

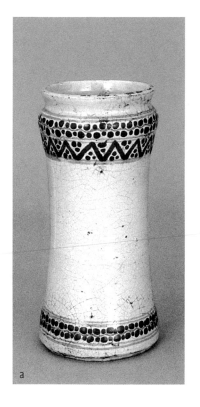

a

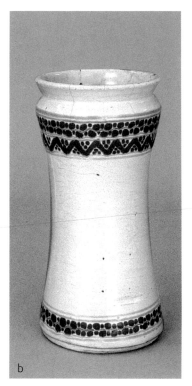

b

c

d

Figure 109
Four *Albarelos*
Puebla de los Angeles,
Second-half 18th Century

(a) Ht. 22.2 cm.
Earthenware with tin glaze and cobalt in-glaze decoration. Houghton Sawyer Collection.

(b) Ht. 24 cm.

Earthenware with tin glaze and cobalt in-glaze decoration. Houghton Sawyer Collection.

(c) Ht. 27.5 cm.

Earthenware with tin glaze and cobalt in-glaze decoration. Houghton Sawyer Collection.

(d) Ht. 32 cm.

Earthenware with tin glaze and cobalt in-glaze decoration. Houghton Sawyer Collection.

a

b

Figure 110
Two *Albarelos*
Puebla de los Angeles,
Second-half 18th Century

(a) Ht. 25.5 cm.; dia. orifice 8.5 cm.

Earthenware with tin glaze and cobalt in-glaze decoration.

(b) Ht. 15.5 cm.; dia. orifice 3 cm.

Earthenware with tin glaze and cobalt in-glaze decoration. Houghton Sawyer Collection.

Figure 111
Two *Albarelos*
Puebla de los Angeles,
Second-half 18th Century

(a) Ht. 13.5 cm.; dia. orifice 8.5 cm.
Earthenware with tin glaze and cobalt in-glaze decoration. Houghton Sawyer Collection.

(b) Ht. 13 cm.; dia. orifice 6 cm.
Earthenware with tin glaze and cobalt in-glaze decoration. Houghton Sawyer Collection.

ment, and its specific content are thoroughly in keeping with late-eighteenth-century conventions of Mexican maiolica design.

A rectangular, moldmade tray, or *bandeja*, in Figure 112 is decorated across the center field with curved sprays of flowers and petals executed in two shades of blue. Leafy branches cover the low walls, which bear vertical fluting at the corners. Exterior decoration is absent.

The vessel exemplifies a late period of eighteenth-century manufacture at Puebla, with numerous imperfections of glaze, firing, and formation.

The ultimate deterioration of the interesting bit of architectural art previously referred to in Figures 82 and 94 decorates the center of the molded, scallop-edged oval platter in Figure 113. The facade of the indicated building has moved to the viewer's right, the flagpole remaining fixed at the opposite corner. Walls and sloping gable virtually merge because both are filled with layered, vertical lining. The dome, less precisely ribbed, is crowned by a lantern of the simple shed outline which appears elsewhere as a chapel, house, or other small edifice. Reduced ground and fuzzily drawn framing branched trees are faint reminders of previous renditions. The only fillers in the ground surrounding the central pattern are hastily drawn groups of light, parallel lines and one dotted twist beneath the building. Poor workmanship is displayed in the heavy border of dark, arched lines and dots outlined in narrower light lines. Retouching can be detected on dome, lantern, walls, and one tree trunk, those lines now being matte. Ovoid, molded vessel shape, mindless repetition of a long-familiar theme, declining appreciation for sharp delineation, and reduction of number of ground fillers suggest this platter was made in the decades spanning the eighteenth and nineteenth centuries.

Figure 112
Bandeja
Puebla de los Angeles,
Second-half 18th Century
Lgth. 22 cm.; wdt. 18.5 cm.

Earthenware with tin glaze and cobalt
in-glaze decoration.

Figure 113
Bandeja
Puebla de los Angeles, Late 18th–
Early 19th Century
Ht. 2.5 cm.

Earthenware with tin glaze and cobalt
in-glaze decoration. Houghton Sawyer
Collection.

Nineteenth Century

Among the most outstanding innovations with which Puebla maiolists introduced the nineteenth century was a light-blue glaze which they called *aperlado* (pearly). There had been an earlier interest in such a ground shown by increasing the use of blue wash to cover the entire decorative field rather than merely filling a motif as in imitation of some Chinese elements. This led to a stylistic variation which was white on one surface, washed in blue on the other, with darker blue pattern drawn over the wash. The *aperlado*, on the contrary, was not a wash but was a fired blue glaze used on all vessel surfaces which was created by the addition of a tiny amount of cobalt to the white base solution. There also seems to have been alteration in composition of the base glaze itself because, generally speaking, the blue glaze is not as riddled with defects as the earlier whites had been. Light pastes of fine texture continued to be preferred at Puebla.

The designs placed upon the blue ground were a continuation of themes taken from the late blue-on-white sequence of the latter eighteenth century with the incorporation of new ideas as they evolved early in the nineteenth century. They, too, show considerable refinement in style and application, at the same time losing some of the spontaneous charm of earlier work. Fields of design continued to be horizontally banded, though lightness of fillers made the units less obvious. Some of the Oriental medallion paneling survived on jars, as did vertical compartmentalization on bowl exteriors. In motifs, the emphasis was upon dainty, rigidly structured florals with which occasional human figures were combined. These humans were most often animated Orientals, although Westerners also appear (Barber 1911, fig. 116; Cervantes 1939: Vol. 1, 255; Peón Soler and Cortina Ortega 1973, figs. 18, 22). All were drawn as though captured in action by a camera. Other motifs were more realistically treated than at earlier periods. Undecorated grounds retained the importance given them on the late-eighteenth-century blue on whites, but decorators could not resist dot clusters as space fillers.

The pitcher in Figure 114 is a particularly interesting example of the *aperlado* movement for several reasons. It is the oldest pitcher of Mexican maiolica in the collection. Furthermore, its decoration, which represents direct transference from the blue-on-white mode, is only in two shades of blue. It may therefore be an intermediary step between the blue-on-white tradition which had dominated the output for one hundred fifty years and the bright polychromes of the nineteenth century. The field remains banded in the more or less customary way, and all individual motifs have been seen from the earliest days of Mexican maiolica. The vertical neck is covered with a framed, broad, diamond diaper, large, dark dots at intersections of lines, and small dotted rosettes at midpoints in the diamond spaces. Below a blank zone is an encircling pattern of pendant, heavy hooked scrolls, groups of dots, and suspended dotted floral sprays. Nine-dot clusters are spaced around the lower body. A narrow light line marks the ring base. A dark vine runs down the single handle. Major design is laid in dark blue; outlining, framing, or connecting lines are light blue.

Figure 114
Pitcher
Puebla de los Angeles,
End 18th–Beginning 19th Century
Ht. 24 cm.; dia. orifice 10.5 cm.
Earthenware with tin glaze and cobalt in-glaze decoration.
Houghton Sawyer Collection.

The shape of this vessel aptly reflects the plasticity of the medium, its rounded lower body swollen to contain liquids, the throat narrowed to assure proper pouring, the neat foot providing good basal definition and stability. The pouring spout was not pulled down over the neck wall but was left erect so as to eliminate dripping. The handle was attached in what had become the usual Mexican way by pushing one loop of clay up on the body and pinching off the base into a V. Due to a slight hesitancy on the part of the potter while applying the limp handle, there is a minor awkward angle at midpoint.

Exactly the same plate form used for late-eighteenth-century blue-on-white specimens, as depicted in Figures 99, 100, and 101 continued into the first half of the nineteenth century, of which Figure 115 is a typical example. A broad, flat-based central area was set apart by a narrow, almost vertical cavetto from a wide brim with foliated, thickened edge.

This vessel is covered with a lustrous, relatively unmarred pale-blue glaze over which on the obverse only is a typical, carefully drawn, bright, polychromed pattern in yellow, orange, dark blue, and green. Black is used to define some parts of the composition and as connecting stems to tie the pattern together. The single large flower with balanced side branches gracefully curled to cover most of the field was taken from the Talaveran *adormidera* (opium poppy) design which came into common use in Castile during the late eighteenth century in imitation of Alcoran work (Martínez Caviró 1968, figs. 222a, b, 223a; 1969, figs. 40a, 42a). The form it takes, on the other hand, is most reminiscent of the palmette first used on Mexican maiolica of the late sixteenth century. It required a specific orientation of the plate to be viewed properly. The grouping of three round elements, as in the secondary flowers of this pattern, also came from Alcoran design as interpreted by Talaverans (Martínez Caviró 1969, fig. 41a). On Spanish vessels decorated with these large, single flowers the cavetto remained undecorated, as is the case here. Rim decoration was usually one of two varieties—floral groups or, as on this sample, the encircling vine which had appeared on many Mexican blue on

Figure 115
Plate
Puebla de los Angeles,
End 18th–First-half 19th Century
Dia. 33.5 cm.

Earthenware with tin glaze and cobalt, copper, antimony, and iron in-glaze decoration.

whites of the second half of the eighteenth century. Customary dotted rosettes serve as space fillers, as they had throughout the seventeenth and eighteenth centuries. Suggested temporal differences within the nineteenth-century blue-ground types (Barnes 1972, 11–12) must await verification in further archaeological studies. However, the content of this pattern and its precisely defined outlines, as well as strong colors, suggest a later time of manufacture than that for the pitcher above.

The pattern on the comparable blue ground plate in Figure 116 is only slightly less rigidly balanced than the above, a drooping, yellow blossom at the lower left replacing the more customary three round dots used to represent small flowers. The rim vine has been eliminated in favor of alternating rosettes and floral sprays, such pattern and their placement being common on late-eighteenth-century Alcora examples (Martínez Caviró 1968, fig. 274). The glaze, decorative colors, and form are exactly that of the previous specimen.

The deep, hemispherical bowl which became a part of Mexican form grammar during the eighteenth century, as shown in Figures 82–83, continued to be made in the early nineteenth century. Two examples having related decoration are in this collection of *aperlado* wares. That in Figure 117 remains undecorated on the interior, the exterior wall being divided vertically by six diamond ladders into six zones. Each of those zones is filled with one of two floral variations. One is the same heart-shaped poppy with matched side branches as

Figure 116
Plate
Puebla de los Angeles,
End 18th–First-half 19th Century
Dia. 34.5 cm.

Earthenware with tin glaze and cobalt, copper, antimony, and iron in-glaze decoration. Houghton Sawyer Collection

seen on the contemporary plate centers. The other is the three-round-dot flower with attached petals and fern used on the rim of the plate in Figure 116. Dotted rosettes and pyramidal constructions of arched lines go back to Spanish Muslim times. The bottom of the decorative field is closed by a dark-blue egg-and-dart band of exactly the same rendition as those dating from the early seventeenth century. The decorative colors are the same bright yellow, orange, dark blue, copper green, and black as on the *aperlado* plates, all contrasting sharply with the light-blue ground.

The smaller bowl in Figure 118 is decorated with the same compart-

Figure 117
Bowl
Puebla de los Angeles,
End 18th–First-half 19th Century
Dia. 35.8 cm.

Earthenware with tin glaze and cobalt,
copper, antimony, and iron in-glaze
decoration.

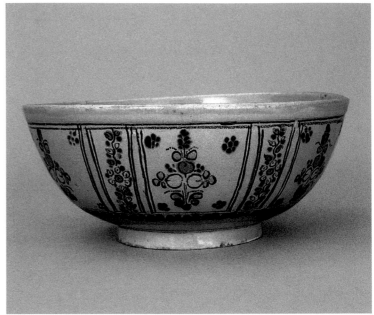

Figure 118
Bowl
Puebla de los Angeles,
End 18th–First-half 19th Century
Dia. 28 cm.

Earthenware with tin glaze and cobalt,
copper, antimony, and iron in-glaze
decoration. Houghton Sawyer Collection.

mentalized field, the narrow vertical divider panels containing erect vines of blue, yellow, and orange alternating dots and wide, yellow strips outlined in black at each side. The larger segments have a repeated pattern of upright floral sprays composed of the three round yellow and orange dots, green leaves, and dark-blue fern. The corners of these panels are filled with dark-blue dot rosettes. The lower field is banded by a blue egg-and-dart chain. A very narrow blue line encircles the ring foot.

Draftsmanship is more exact than that on many earlier blue-on-white specimens in this collection. Design is colorful, neat, and static. There is no interior decoration.

It should not be assumed that *aperlado* bowls were always banded in the manner of these two specimens. A great variation of treatment, within the constrictions arbitrarily imposed on the mode, is known.

At some time after the blue-ground vogue became well-established, Mexican maiolists began experimenting with other colored glazes, as seen in Figure 116. One pale citrus-green plate bearing a decoration similar to that on the *aperlado* vessel in Figure 116 is illustrated in Cervantes 1939: Vol. 1, 257.) There are no vessels of this color at the Museum of International Folk Art, nor are many known elsewhere. More pop-

ular was a canary-yellow coating which saw rather frequent application on hollow ware and tiles of the early nineteenth century. Greater variation of decoration upon them suggests a possible date of manufacture somewhat later than the main blue-ground sequence, although comparable styles do occur on both grounds.

Using the identical molded-plate form seen earlier in Figures 99, 100, and 101, the vessel in Figure 119 is glazed in a brilliant yellow coating. Its only design is the familiar vine encircling the rim, this time composed of green dots off a black stem line. The exterior is undecorated.

Figure 120 pictures a large, hemispherical bowl of the Chinese "export" shape, likewise coated in a yellow glaze of the same hue. Its design, confined to the exterior wall, is carried only in black. Banded by encircling lines top and bottom, the decoration zone is not segmented vertically. An allover arrangement of fine florals made vaguely diagonal by interspaced dotting or lining covers the body. Around the lower border is an egg-and-dart band, a single line and narrow zigzag below that at the foot.

The matched pair of small, thin bowls in Figure 121 have the same footed profile illustrated in Figures 82 and 83. They are yellow with black designs of florals between framers. Line work is cruder than on the previously described large, yellow bowl. On shields on each side of the bowls are the words CORTÉS and GUADALUPE in script, most likely referring to the name of the owner. No decoration appears on the interior of either specimen.

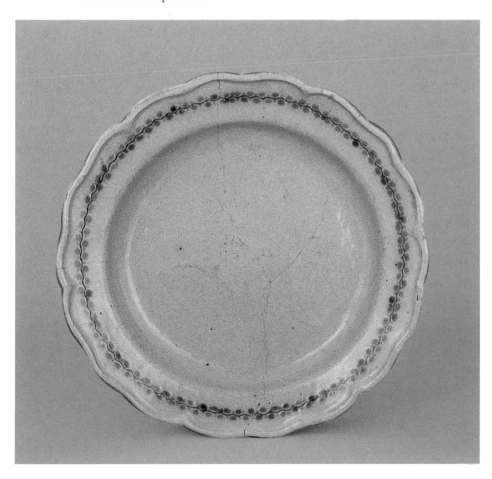

Albarelo forms continued to be made into the nineteenth century in Mexico, though in decreasing numbers as time passed and probably with no intended pharmaceutical function. Two fine specimens in Figures 122a and 122b possess the usual indrawn waist, pronounced basal and shoulder angles, and short, straight necks.

The glossy glaze covering these jars is cream rather than

Figure 119
Plate
Puebla de los Angeles,
First-half 19th Century
Dia. 33.5 cm.
Earthenware with tin glaze and copper and iron in-glaze decoration. Houghton Sawyer Collection.

147

Figure 120
Bowl
Puebla de los Angeles,
First-half 19th Century
Dia. 27.6 cm.
Earthenware with tin glaze and iron
in-glaze decoration.

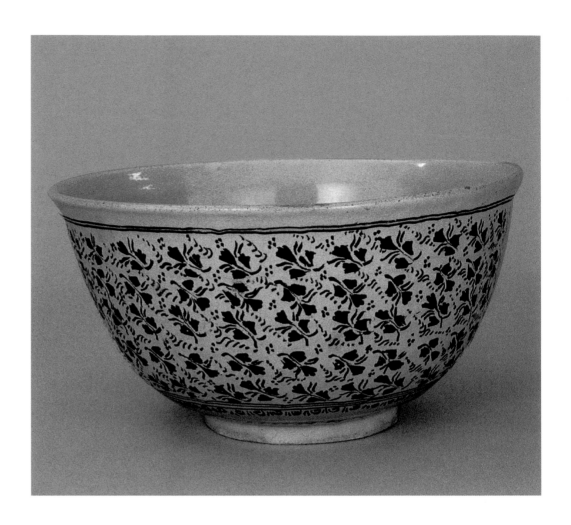

Figure 121
Two Bowls
Puebla de los Angeles,
First-half 19th Century

(a) Dia. 18.5 cm.
Earthenware with tin glaze and iron
in-glaze decoration.

(b) Dia.18 cm.
Earthenware with tin glaze and iron
in-glaze decoration.

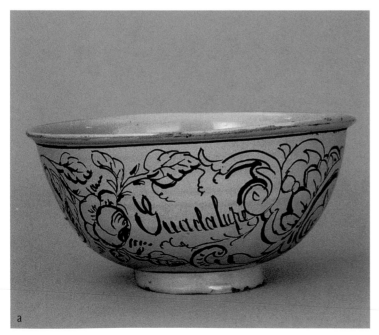

a

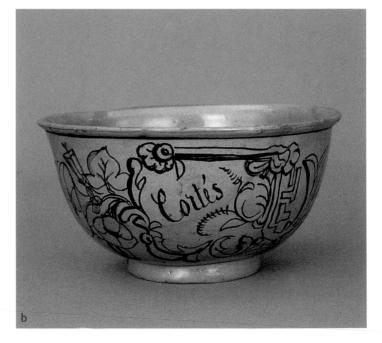

b

Figure 122
Two *Albarelos*
Puebla de los Angeles,
First-half 19th Century

(a) Ht. 23.5 cm.
Earthenware with tin glaze and antimony,
copper, and iron in-glaze decoration.
Houghton Sawyer Collection.

(b) Ht. 21.5 cm.
Earthenware with tin glaze and antimony,
copper, and iron in-glaze decoration.
Houghton Sawyer Collection.

149

white, with the imperfections expected in the Mexican product. Decoration follows a layout well-established during the late eighteenth century of banding at top and bottom of the field. Between paired, narrow, black, encircling lines and wider yellow lines overlaid with black chevrons are stylized, shaded orange fruits and paired copper leaves off black stems. As with other ceramic decorative work of the period, the patterns on these jars are refined, neat, and colorful. The minor variations between the two pieces may have resulted from different artisans in the same workshop assigned to one order.

An intriguing blend of ideas from many sources is present on the large, mid-nineteenth-century plate in Figure 123. Over a cream glaze the design on a narrow, flat brim is framed in fine lines of mauve, a color not achieved until about the third decade of the century. Between these lines is a chain of contiguous diamonds outlined on black, enriched by green dots at their junctures and at their centers by tiny, four-dot clusters in orange. Pendant from a narrow light-blue encircling line at the top of the cavetto are small-scaled, feathered swags in mauve, green, orange, and black based upon Berain mannerisms characteristic of late-eighteenth-century Alcoran wares (Martínez Caviró 1968, figs. 243–44). The colors being subdued, and the element size small, the effect is neither gaudy nor blatant.

In the center of the plate bottom stands a whimsical lion, body dotted in the old way but less obviously because of the use of the same colors for body and dots. He is placed on a ground originally borrowed from the Chinese—convoluted, washed solid in color, accented by dotting. Here it is green, whereas a century earlier in Mexican application it would have been blue. The vertical floral framers at either end of the scene, from Spanish design, have become a single arched configuration, like a rainbow, now composed of more realistically portrayed flowers and leaves. The leaves are outlined in black, but the flowers are shaded in one color. The triad fillers below the ground, dots in the older blue interpretations, have been converted to petal shape in brown.

Potting and decorating are of the highest quality on this specimen, but, nevertheless, the usual technical imperfections of glaze are present. The decoration is greatly restricted when compared to vessels of similar style displayed at the Museo Bello in Puebla.

A broad plate with flat center in Figure 124 has a modest bishopric insignia of Bible, a miter or liturgical headdress, and crosier or crooked pastoral as its center pattern. The rim is banded by a black chain framed by green and mauve lines. Glaze is cream. Because of the principal design, this plate may be assumed to once have belonged to a nineteenth-century ecclesiastical establishment.

Many small-footed bowls of a size suitable for individual servings appear among assortments of Mexican maiolica from the seventeenth century to the present. Because they were *entrefino* or *común* dishes meant to see frequent use, perhaps as cups as well as serving bowls, they seldom have survived to become part of museum collections, though their fragments are common among archaeological findings at sites of the colonial period. The earlier Spanish *taza* of comparable size and function typically had a bulky profile due to thick walls and a sharp angle at the lower wall. In Mexico, the *taza* (small bowl) appears to have been a form most characteristic of the sixteenth century when Spanish direction of the ceramic industry was

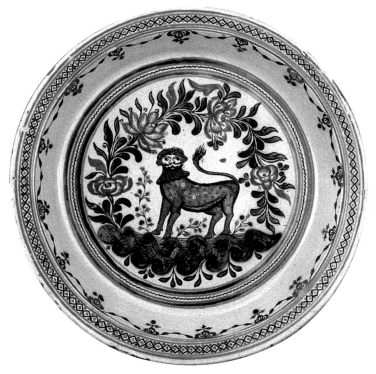

Figure 123
Plate
Puebla de los Angeles,
Mid 19th Century
Dia. 40 cm.

Earthenware with tin glaze and antimony,
manganese, cobalt, copper, iron in glaze
decoration.

Figure 124
Plate
Puebla de los Angeles,
Mid-19th Century
Dia. 35.2 cm.

Earthenware with tin glaze and copper,
iron, manganese in-glaze decoration.

strong. The Chinese rice bowl, which came from the Orient by the thousands nested together in large chests, was the model for most individual-size bowls made in Mexico after the end of the sixteenth century. This form possesses an elegant outline, thin, rounded walls rising above a narrow ring foot.

Four nineteenth-century examples of this form are in this collection. All are delicate, with horizontally banded patterns ranging from complete coverage of exterior wall to a narrower border below the bowl lip. The vessel with the most restricted pattern is that having a brown linear and chain motif shown in Figure 125a. Brown used alone or with several other colors came into the usual palette during the middle to late nineteenth century. A companion bowl, Figure 125b, shows a combination of wide blue bands and three narrow brown lines. The third specimen, which is shown in Figure 125c, is the most elaborately decorated, with paired blue lines bordering a black chain of squared links, an encircling pattern of blue-dotted rosettes, green and orange leaves and brown stem, and a basal frame of two blue lines. Obviously a vessel aimed for a low-quality market, the fourth small bowl, Figure 125d, has a thin cream glaze which crawled extensively and was contaminated on the interior by cobalt. Its exterior pattern of a series of encircling blue lines of

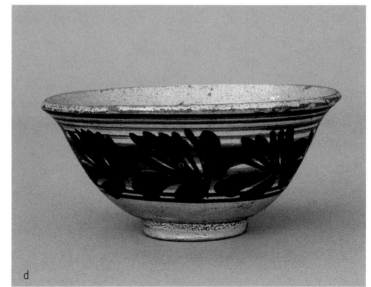

Figure 125
Four Small Bowls
Puebla de los Angeles,
Mid- to Late 19th Century

(a) Dia. 11 cm.
Earthenware with tin glaze and iron
in-glaze decoration.

(b) Dia. 13.5 cm.
Earthenware with tin glaze and cobalt
and iron in-glaze decoration.

(c) Dia. 11.5 cm.
Earthenware with tin glaze and cobalt,
iron, antimony, and copper in-glaze
decoration.

(d) Dia. 15.5 cm.
Earthenware with tin glaze and cobalt
in-glaze decoration.

Figure 126
Sugar Bowl
Puebla de los Angeles,
Mid- to Late 19th Century
Dia. 9.8 cm.

Earthenware with tin glaze and cobalt
and iron in-glaze decoration.

varying widths overlaid by leafy, darker-blue motifs was such a common one from the late eighteenth century onward that its more specific dating is questionable.

The contrast of rich cobalt blue against lustrous white ground continued to be appreciated, even though new color combinations were tried out throughout the nineteenth century, as is illustrated on a sugar bowl and a cup. The small, globular sugar jar in Figure 126 may have been part of a set of serving vessels and has a pair of typically looped ribbon handles. Probably it was once outfitted with a domed lid. A brush charged with dark-blue pigment had passed around the rim for its only decoration. The word CAPUCHINAS stenciled in black across the body was a property mark. The cup, pictured in Figure 127, is neatly decorated below the lip with a small framed egg-and-dart modification and Vs down the curved handle. That latter feature and the broad, squat body suggest a nineteenth-century date of manufacture, at which time Mexican potters freely imitated European cup styles. Earlier the taller, slenderer, handleless Oriental teacup, or *posillo*, had been the common drinking vessel for all hot beverages and perhaps wine.

The bottle in Figure 128 is not easily categorized because it has the appearance of being a nineteenth-century piece made after a hazily recalled earlier mode. Its form, while not unique, is not seen among most collections of colonial Mexican maiolica. The basic format of decoration, executed only in a poorly prepared dark cobalt, echoes Chinese division of field into horizontal bands, the principal one also being vertically segmented into three diamonds. Within each diamond is an erect flower on a stem with a leaf at each side. Spaces between the compartments are filled at top with pendant swags, at bottom with graduated lines and a simplified building. Pointing upward around the neck are contiguous zigzag lines.

153

Figure 127
Cup
Puebla de los Angeles,
Mid- to Late 19th Century
Dia. 9.5 cm.

Earthenware with tin glaze and cobalt
in-glaze decoration. Houghton Sawyer
Collection.

Figure 128
Bottle
Puebla de los Angeles, 19th Century
Ht. 18.5 cm.; dia. orifice 2.5 cm.

Earthenware with tin glaze and cobalt
in-glaze decoration. Houghton Sawyer
Collection.

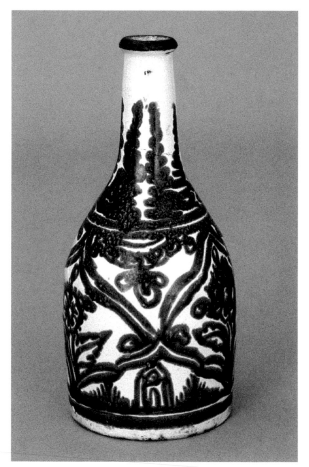

Among the most typical maiolica forms from nineteenth-century Puebla is the *maceta*, or large, Neoclassic, urn-shaped jardiniere. Whether it also made an appearance among Spanish maiolicas is not known because nineteenth-century types have not received much attention in the literature. Nevertheless, a European origin for the vessel shape is definitely indicated. It assumed the role of earlier *tibores* and *barriles* as a container for the many plants Mexicans like to keep in their inner patios. Over a relatively narrow but distinct foot, a deep body broadened and rounded up one-third of the vessel height to a restricted, flared throat which comprised the upper two-thirds of the pot. A looped handle, often of a size inadequate for use, was attached to each side. For greater strength and ornamentation, rims around broad orifices were thickened, flattened vertically, grooved, or pinched. Central drainage holes were punched into leather-hard vessel bottoms. The contour of the piece suggested zones of decoration, the round body and more vertical neck usually being treated differently.

The *maceta* in Figure 129 is glazed in a creamy white on the otherwise undecorated interior surface. The exterior has a harsh yellow ground that was brushed on as the vessel revolved on the wheel, the brush marks remaining visible. This is overlaid with a bright blue pattern and some brown detailing.

In a mode remembered from the Chinese era, the 12 cm. of the upper body between dark band lines is divided vertically into four large and four small compartments. The same lack of exact draftsmanship shown

Figure 129
Maceta
Puebla de los Angeles,
Second-half 19th Century
Ht. 29.5 cm.; dia. orifice 32 cm.

Earthenware with tin glaze and cobalt, iron, and antimony in-glaze decoration. Houghton Sawyer collection.

on seventeenth- and eighteenth-century jars is seen here in larger segments ranging in width from 16.5 cm. to 14 cm. at panel top and 13 cm. to 11 cm. at panel base. Within each panel the ground is coated with blue, scrolls left in reserve yellow around a large quatrefoil containing an erect, symmetrical flower. The lower body displays an encircling looped line with pendant, broadly brushed sprays. The four-dot clusters and wavy basal line so common through the continuum of Mexican maiolica are present.

Although the potting of this vessel is adequate, it is not expert. The stubby handles are not of a size suitable for grasping, and their low position is distracting. The most offensive aspect of the jar, however, is the harsh color combination and pigments that became bubbled, granular, or discolored in firing.

When a *maceta* form is attached to a pedestal base, it becomes a *macetón*. A matched pair is illustrated in Figure 130. Even though they suffered damage in the San Francisco quake, much of their beauty still can be observed. It can also be noted that in most aspects of shaping and decorating there had been earlier precedents. These *macetónes* are of a graceful urn configuration which gains increased importance

Figure 130
Two *Macetones*
Puebla de los Angeles,
Second-half 19th Century

(a) Ht. 36.5 cm.

Earthenware with tin glaze and cobalt, antimony, iron, and manganese in-glaze decoration. Houghton Sawyer Collection.

(b) Ht. 39 cm.

Earthenware with tin glaze and cobalt, antimony, iron, and manganese in-glaze decoration. Houghton Sawyer Collection.

Figure 131
Macetón
Puebla de los Angeles, Late 19th Century
Ht. 36 cm.; dia. orifice 31 cm.
Earthenware with tin glaze and antimony,
copper, and iron in-glaze decoration.
Houghton Sawyer Collection.

through the secondary addition of the foot support that repeats the upper flare of the neck. The rim edge impressed with groupings of three spaced indentations and the looped handles continue older mannerisms. One notable difference in treatment is that on the interior only the upper portion of the flared vessel throat is glazed. But upon this flare there appears the same fern motif as is on the inner flared rim of the *bacín* in Figure 74 and the inner flare of a *macetón* at the Museo Bello in Puebla (see Peón Soler y Cortina Ortega 1973, fig. 25). The polychrome decoration on exteriors consisting of dark and light blue, yellow, black, and mauve is subdued, carefully executed, and familiar. Horizontal and vertical paneling, in this case equal dimensions being carefully maintained, symmetrical florals composed of dots and petals, dot cluster fillers, egg-and-dart, basal body lines, and guilloche have reappeared continually in this survey.

Another *macetón* in this collection is that in Figure 131. It represents a mass-produced, low-quality flower pot which, although not a carefully made object, would have provided a colorful accent to a home patio. Line work and decoration obviously are weak, but it is interesting that the customary paneling and reserve medallion patterns continued to be identified in the minds of artisans with this form.

The small pitcher shown in Figure 132 is considered here to be representative of the work at Puebla during the second half of the nineteenth century rather than concurrent work at Guanajuato, which is similar. Its very white glaze, greater elaboration of the encircling broad floral chain placed within a framed zone, more overlapping of colors, greater use of black in leaves and petal accents, shading, and the continuation of the centuries-old four-dot cluster fillers support this opinion.

157

Figure 132
Pitcher
Puebla de los Angeles,
Second-half 19th Century
Ht. 13.6 cm.; dia. orifice 3 cm.;
wt. .5 kg.

Earthenware with tin glaze and cobalt,
antimony, copper, and iron in-glaze
decoration.

During the course of the nineteenth century, a maiolica industry arose in Guanajuato to the north of the Valley of Mexico whose products shared a number of characteristics with contemporary Puebla. Both centers by then relied on clay bodies which fired to a bright red color, both made extensive use of new brick-red and copper-green colorants, and in at least one decorative vogue both painted similar motifs. Determining place of origin is difficult now because of such similarities.

GUANAJUATO

Nineteenth Century

With Mexican independence from Spain early in the nineteenth century and the unrelated collapse of the guild system, a number of maiolica-making centers appeared around the country at such widely scattered cities as Oaxaca, Guadalajara, and Aguascalientes. There are no examples of the products of these factories in this collection. More important was the industry established at the city of Guanajuato in the heartland of the Mexican 1810 revolution. There the earliest products, some of which were mold-made, appear to have been covered on the decorative surface with white slip through which designs were worked in a sgraffito technique and over which green and yellow colorants were daubed. The decorated surface received a final coating of transparent lead glaze. The exact source from which this mode of vessel enhancement reached central Mexico is undetermined, though it must be noted that engraving was a fre-

quent aboriginal method of decorating pottery. Whether this process carried over into a Hispanic craft is unclear, but in any event, the method was neither Chinese nor Spanish. It was, however, very typical of earlier Italian production, and its appearance at Guanajuato may represent the late phase in the evolution of a type of sgraffito pottery just now being encountered in archaeological deposits in the Mexican highlands which has been identified in Italy as similar to seventeenth-century Pisan wares (personal communication). Although there are several examples of this kind of Guanajuato pottery at the Museum of International Folk Art, they are not included in this study, which is restricted to maiolica.

The first of the standard maiolica wares at Guanajuato were vessels bearing generally patriotic themes, which were most appropriate in view of the area's importance in the long fight for the Republic. The national emblem, the national flag, and persons waving banners and dressed in costumes of the times are frequent centerpieces. Although figural depictions remained popular, later the most usual patterns for common wares were large, leafy flowers and petals, only occasionally with added veins or shading. These elements lost the stiffness of the somewhat earlier blue-ground wares at Puebla because they were not so formally structured into precisely symmetrical positions, they were not outlined in a darker color, and their individual shapes varied. Although they generally were laid on as contiguous bands around upper shoulders of closed forms and brims of flatware, suspended from a rim line or vine, they were not the banded panels known for so long at Puebla.

Guanajuato paste was very red. The glaze used over it tended to be buff or pinkish rather than pure white, and it was subject to even greater blemishes than usual Puebla solutions. Forms were within the framework of usual Mexican shapes and were almost entirely thrown—large, round-shouldered jars recalling the *tibor*, hemispherical bowls with ring feet, fat-bodied, lidded jars for sugar or sweets, pitchers with spouts which were not trilobed into typical Spanish contour, and plates with gently sloping wide brims on which were dense border patterns to frame a light, central decoration. The ribbon handle also was borrowed from Puebla repertoires, the midloops or folds at base attachment often playfully exaggerated into five or six nubbins which played an important role in vessel decoration. The accompanying group of figures, Figures 133–141, illustrates the range of the Guanajuato decorative mode.

The earliest maiolica introduced to Mexico probably was the plain white common ware of Sevilla, and it appears to have been quickly copied locally. It is likely then that from this sixteenth-century beginning undecorated whites continued to be made for use in kitchens, hospitals, convents, and roadside inns. The 1653 Puebla guild ordinances refer to such plain *común* wares (Cervantes 1939: Vol. 1, 23, 28). There is no indication as yet that the Mexicans ever acquired the taste for sheer perfection of form over pattern, though some large, white jars which must have been special pieces were made at Guanajuato. As such ordinary objects, forms probably altered little through the years, except to reflect coeval potting expertise. Because no further decoration was added, and except for distinguishing late moldmade forms, it is virtually impossible now to place the few known examples within a satisfactory temporal context. This is most unfortunate because often white fragments comprise the largest part of ceramics recovered archaeologically. Many of the

133

134

Figure 133
Tibor
Guanajuato, Late 19th Century
Ht. 32.5 cm.; dia. orifice 14 cm.

Earthenware with tin glaze and cobalt, copper, antimony, and iron in-glaze decoration.

Figure 134
Tibor
Guanajuato, Late 19th Century
Ht. 27 cm.; dia. orifice 13 cm.

Earthenware with tin glaze and cobalt, copper, antimony, and iron in-glaze decoration.

Figure 135
Tibor with Lid
Guanajuato, Late 19th Century
Ht. 30 cm.; dia. orifice 12 cm.

Earthenware with tin glaze and copper, antimony, and iron in-glaze decoration.

135

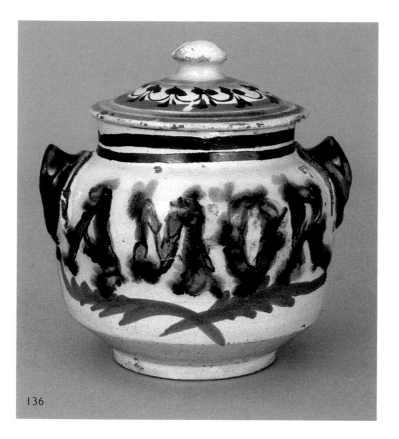

136

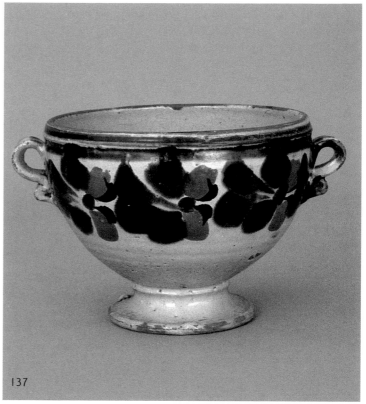

137

Figure 136
Covered Jar
Guanajuato, Late 19th Century
Ht. 16 cm.; dia. orifice 9.5 cm.

Earthenware with tin glaze and copper, antimony, and iron in-glaze decoration.

Figure 137
Footed Bowl
Guanajuato, Late 19th Century
Ht. 13 cm.; dia. orifice 16.5 cm.

Earthenware with tin glaze and cobalt, antimony, copper, and iron in-glaze decoration.

Figure 138
Jar
Guanajuato, Late 19th Century
Ht. 17.5 cm.; dia. orifice 4.75 cm.

Earthenware with tin glaze and cobalt, antimony, copper, and iron in-glaze decoration.

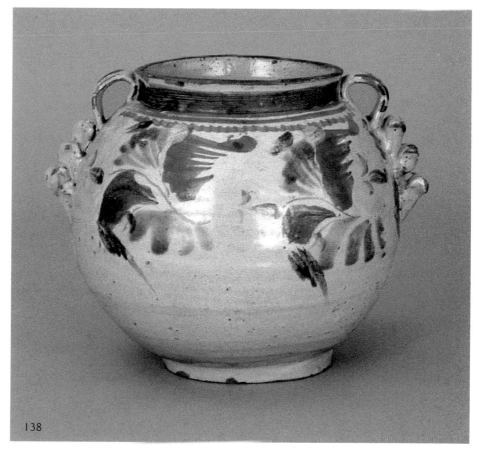

138

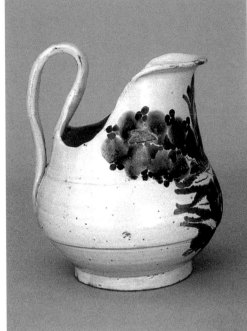

Figure 139
Pitcher
Guanajuato, Late 19th Century
Ht. 21 cm.; dia. orifice 12.5 cm.

Earthenware with tin glaze and cobalt, antimony, copper, and iron in-glaze decoration.

Figure 140
Plate
Guanajuato, Late 19th Century
Dia. 29.3 cm.

Earthenware with tin glaze and cobalt, antimony, copper, and iron in-glaze decoration.

Figure 141
Bowl
Guanajuato, Late 19th Century
Dia. 24 cm.

Earthenware with tin glaze and cobalt, antimony, and copper in-glaze decoration.

163

Figure 142
Four Undecorated Vessels
Guanajuato, Late 19th Century

(a) Bowl
Dia. 24 cm.

Earthenware with tin glaze and no decoration.

(b) Bowl or laver
Dia. 33 cm.

Earthenware with tin glaze and no decoration.

(c) Small jar or creamer
Ht. 9 cm.; dia. orifice 7 cm.

Earthenware with tin glaze and no decoration.

(d) *Albarelo*
Ht. 9.5 cm.; dia. orifice 6 cm.

Earthenware with tin glaze and no decoration.

white sherds undoubtedly are undecorated portions of recognizable painted types, but aside from an analysis of paste, base glaze, and on large sample vessel contours, there is little that can be learned from them. Inasmuch as utilitarian vessels seldom have survived the centuries or found their way into museums, undecorated white Mexican maiolica has remained largely unknown.

There are four examples in this collection, all of useful household shapes. Two broad, shallow bowls, Figure 142a and Figure 142b, most certainly were coarsely fashioned at Guanajuato, and the small-handled jar or creamer in Figure 142c may be from the same place. All may be late nineteenth century in date. The tiny *albarelo* illustrated in Figure 142d is included with other white pieces from Guanajuato, with the realization that its lighter paste may indicate a Puebla source.

SAYULA

Nineteenth Century

About the middle of the nineteenth century, a small, short-lived maiolica industry operated in Sayula, Jalisco, established there by a potter formerly of Puebla. Inevitably designs from the south were transferred to the new operation. The two deep-footed bowls illustrated in Figures 143 and 144 are of the Chinese "export" series in use at Puebla a century earlier. The upper two-thirds of the vessel walls were decorated along a modified Oriental horizontal banded and vertically segmented format, with important use

Figure 143
Bowl
Sayula, Second-half 19th Century
Dia. 26 cm.
Earthenware with tin glaze and cobalt, antimony, copper, and iron in-glaze decoration.

Figure 144
Bowl
Sayula, Second-half 19th Century
Dia. 20.5 cm.
Earthenware with tin glaze and cobalt, antimony, copper, and iron in-glaze decoration.

of reserve white medallions. This mode continued in use at Puebla at least through the blue-ground series of the first half of the nineteenth century. The principal colors on the Sayula specimens, both said to have been made before 1880 by one Epigmenio Vargas, were a rust and salmon combined with dark green and black, which were not usual Puebla colors.

A third bowl, Figure 145, believed to be from Sayula, is rare in having a fluted wall, which probably was channeled with a tool rather than a mold. The dark-brown plume pattern is also unusual for Sayula. The specimen must be approximately contemporaneous with the above because the business is thought to have been discontinued after the death of the owner in 1880.

Figure 145
Bowl
Sayula, Second-half 19th Century
Dia. 22.6 cm.

Earthenware with tin glaze and cobalt, antimony, and iron in-glaze decoration.

References

Ainaud de Lasarte, Juan
 1952 *Cerámica u Vidrio. Ars Hispaniae.* Vol. 10.
 Editorial Plus Ultra, Madrid.

Allan, J. W.
 1971 *Medieval Middle Eastern Pottery.*
 Ashmolean Museum, Oxford University,
 Oxford.

Artes de México
 1971 *El Galeón de Manila.* Vol. 18, No. 143, pp.
 1–123. México, D.F.

Ayers, John
 1969 *The Baur Collection.* Vol. 2: *Chinese
 Ceramics.* Geneva, Switzerland.

Barber, Edwin Atlee
 1906 *Tin Enameled Pottery.* Pennsylvania
 Museum, Philadelphia.

 1908 *The Maiolica of Mexico.* Art Handbook,
 Pennsylvania Museum, Philadelphia.

 1911 *Catalogue of Mexican Maiolica Belonging to
 Mrs. Robert W. de Forest.* Hispanic Society
 of America, New York.

 1915a *Mexican Maiolica in the Collection of the
 Hispanic Society of America.* Pub. 92.
 Hispanic Society of America, New York.

 1915b *Spanish Maiolica in the Collection of the
 Hispanic Society of America.* Pub. 91.
 Hispanic Society
 of America, New York.

Barnes, Mark R.
 1972 *Majolica of the Santa Cruz Valley, Arizona.*
 Occasional Paper No. 2. Pacific Coast
 Archaeological Society, Costa Mesa,
 California

Batllori Munné, Andrés, and Luis M. Llubiá
 Munné
 1949 *Cerámica Catalana Decorada.* Sanz,
 Barcelona.

Benitez, Fernando
 1965 *The Century after Cortes.* University of
 Chicago Press, Chicago.

Cervantes, Enrique A.
 1939 *Loza Blanca y Azulejo de Puebla.* 2 vols.
 México, D.F.

Charleston, Robert J.
 1968 *World Ceramics.* Paul Hamlyn, London.

Deagan, Kathleen
 1987 *Artifacts of the Spanish Colonies of Florida
 and the Caribbean, 1500–1800.*
 Smithsonian Institution Press,
 Washington, D.C.

Fairbanks, Charles H.
 1974 *Spanish Artifacts at the Fortress of
 Louisbourg, Cape Breton Island.* Conference
 on Historic Site Archaeology, Papers, Vol.
 9, pp. 30–59. Institute of Archeology and
 Anthropology, University of South
 Carolina, Columbia.

Frothingham, Alice Wilson

1938 *Museum and Library Collection, Ceramics.* The Hispanic Society of America, New York.

1941 *Apothecaries' Shops in Spain.* Notes Hispanic, pp. 100–23. Hispanic Society of America, New York.

1943 *Talavera Pottery Decoration Based on Designs by Stradanus.* Notes Hispanic, pp. 97–117. Hispanic Society of America, New York.

1944a *Aragonese Lusterware from Muel.* Notes Hispanic, pp. 78–91. Hispanic Society of America, New York.

1944b *Talavera Pottery, with a Catalogue of the Collection of the Hispanic Society of America.* Hispanic Society of America, New York.

1951 *Lustreware of Spain.* Hispanic Notes and Monographs. Hispanic Society of America, New York.

1969 *Tile Panels of Spain, 1500–1650.* Hispanic Society of America, New York.

1974 "Spanish Pottery and Its Exportation to the New World." In *Europe in Colonial Amercia.* Antiques Forum, 5–7. Williamsburg, Virginia.

Gaiger-Smith, Alan

1973 *Tin-Glaze Pottery, in Europe and the Islamic World.* Faber and Faber, London.

Garner, Harry

1954 *Oriental Blue and White.* Faber and Faber, London.

Gestoso y Pérez, José

1903 *Historia de los Barros Vidriados Sevillanos Desde Sus Orígenes Hasta Nuestros Días.* Tipografía la Andalucía Moderna, Sevilla.

1919 *Cerámica Sevillana.* Boletín, Vol. 27, pp. 2–19. Sociedad Española de Escursiones, Sevilla.

Goggin, John M.

1968 *Spanish Majolica in the New World, Types of the Sixteenth to Eighteenth Centuries.*

No. 72. Yale University Publications in Anthropology, New Haven.

González Martí, Manuel

1944 *Cerámica del Levante Español. Siglos Medievales.* 3 vols. Editorial Labor, Barcelona.

1954 *Cerámica Española.* 2d ed. Editorial Labor, Barcelona.

Joseph, Adrian M.

1971 *Ming Porcelains, Their Origins and Development.* Bibelot, London.

Lane, Arthur

1957 *Later Islamic Pottery. Persia, Syria, Egypt, Turkey.* Pitman, New York.

Lister, Florence C. and Robert H. Lister

1969 "Majolica, Ceramic Link Between Old World and New." *El Palacio*, Vol. 76, No. 2, pp. 1–15. Santa Fe.

1974 "Maiolica in Colonial Spanish America." *Historical Archaeology*, Vol. 8, pp. 17–51. Columbia.

1975a "Non-Indian Ceramics from the Mexico City Subway." *El Palacio*, Vol. 81, No. 2, pp. 25–48. Santa Fe.

1975b "An Overview of Moroccan Maiolica." Collected Papers in Honor of Florence Hawley Ellis. *Papers of the Archaeological Society of New Mexico*, No. 2. Santa Fe.

1976 *A Descriptive Dictionary for 500 Years of Spanish-Tradition Ceramics [13th Through 18th Centuries].* Special Publication No. 1. Society for Historical Archaeology.

1982 *Sixteenth Century Maiolica Pottery in the Valley of Mexico.* Anthropological Papers of the University of Arizona No. 39. University of Arizona Press, Tucson.

1987 *Andalusian Ceramics in Spain and New Spain. A Cultural Register from the Third Century B.C. to 1700.* University of Arizona Press, Tucson.

Liverani, Giuseppe
 1960 *Five Centuries of Italian Majolica.* McGraw Hill, New York.

Llorens Artigas, José, and José Corredor Matheos
 1970 *Cerámica Popular Española Actual.* Editorial Blume, Barcelona.

Llubiá, Luis M.
 1967 *Cerámica Medieval Española.* Editorial Labor, Barcelona.

Lopez Rosado, Diego
 1965 *Historia Económica de México.* Vol. 1. Editorial Pormaca, México, D.F.

McQuade, Margarita Connors
 1999 *Talavera Poblana. Four Centuries of a Mexican Ceramic Tradition.* Hispanic Society of America, New York.

Martínez Caviró, Balbina
 1968 *Catálogo de Cerámica Española.* Instituto Valencia de Don Juan, Madrid.

 1969 *Cerámica de Talavera.* Instituto Valencia de Don Juan, Madrid.

Palacios, Enrique Juan
 1917 *Puebla, Su Territorio y Sus Inhabitantes.* Secretaría de Fomento, México, D.F.

Peón Soler, Alejandra, and Leonor Cortina Ortega
 1973 *Talavera de Puebla.* Ediciones Comermex, México, D.F.

Phillips, John Goldsmith
 1956 *China-Trade Porcelain.* Harvard University Press, Cambridge.

Pleguexuelo Hernándex, Alfonso
 1985 *Cerámica de Triana.* Caja General de Ahorros, Monte de Piedad, Granada.

Pope, John Alexander
 1956 *Chinese Porcelains from the Ardebil Shrine.* Freer Gallery of Art. Smithsonian Pub. No. 4231. Washington, D.C.

Rubín de la Borbolla, Daniel F.
 1961 *Las Artes Populares Guanajuatenses.* Universidad de Guanajuato, Guanajuato.

Smith, Hale G.
 1972 "Historic Figurines from Florida and Mexico." *Historical Archaeology*, Vol. 6, pp. 47–56. Columbia.

Subias Galter, Juan
 1948 *El Arte Popular en España.* Editorial Seix Barral, Barcelona.

Torres Balbás, Leopoldo
 1934 "Cerámica Doméstica de la Alhambra." *Al-Andalus*, Vol. 2, pp. 387–88.

Toussaint, Manuel
 1967 *Colonial Art in Mexico.* University of Texas Press, Austin.

Vaca González, Diodoro, and Juan Ruíz de la Luna Rojas
 1943 *Historia de la Cerámica de Talavera de la Reina y Algunos Datos Sobre la de Puente de Arzobispo.* Editora Nacional, Madrid.

Valenstein, Suzanne G.
 1970 *Ming Porcelains, a Retrospective.* China Institute in America, New York.

 1975 *A Handbook of Chinese Ceramics.* Metropolitan Museum of Art, New York.

Victoria and Albert Museum
 1957 *Hispano Moresque Pottery.* Her Majesty's Stationery Office, London.

Welty, Johanna Van Nest
 1999 "Treasured Talavera." *Tradición Revista*, Vol. 4, No. 3, 45–52. Albuquerque.

Wilkinson, Charles K.
 1973 *Nishapur: Pottery of the Early Islamic Period.* Metropolitan Museum of Art, New York.

Sources for Maiolica at the Museum of International Folk Art

Fig. 2: Frothingham 1938, 121; 1951, 106, fig. 66; González Martí 1944: Vol. I, fig. 534; Instituto Valencia de Don Juan, Madrid; Lister and Lister 1976, 26; 1987, figs. 35, 52d; Llubiá 1967, 153, fig. 241; Museo de Cerámica, Barcelona; Victoria and Albert Museum 1957, fig. 12. **Fig. 3**: Ainaud de Lasarte 1952, 108, fig. 283; Deagan 1987, fig. 4.22; Frothingham 1951, 198; González Martí 1944: Vol. I, 545, fig. 658; 1954, 149, fig. 93; Instituto Valencia de Don Juan, Madrid; Museo de Cerámica, Barcelona. **Fig. 4**: Frothingham 1951, 270–01; González Martí 1944: Vol. I, fig. 16; Museo de Cerámica, Barcelona. **Fig. 5**: Ainaud de Lasarte 1952, 109, fig. 286; González Martí 1954, 102, fig. 57; Instituto de Valencia de Don Juan, Madrid. **Fig. 6**: Martínez Caviró 1968, figs. 294–9; Museo de Artes Decorativas, Madrid; Museo de Cerámica González Martí, Valencia. **Fig. 7**: Martínez Caviró 1968, figs. 294–9; Museo de Artes Decorativas, Madrid; Museo de Cerámica González Martí, Valencia. **Fig. 8**: Martínez Caviró 1968, figs. 294–9; Museo de Artes Decorativas, Madrid; Museo de Cerámica González Martí, Valencia. **Fig. 9**: Martínez Caviró 1968, figs. 294–9; Museo de Artes Decorativas, Madrid; Museo de Cerámica González Martí, Valencia. **Fig. 10**: Martínez Caviró 1968, figs. 294–9; Museo de Artes Decorativas, Madrid; Museo de Cerámica González Martí, Valencia. **Fig. 11**: Martínez Caviró 1968, figs. 294–9; Museo de Artes Decorativas, Madrid; Museo de Cerámica González Martí, Valencia. **Fig. 12**: Martínez Caviró 1968, figs. 294–9; Museo de Artes Decorativas, Madrid; Museo de Cerámica González Martí, Valencia. **Fig. 13**: Martínez Caviró 1968, figs. 294–9; Museo de Artes Decorativas, Madrid; Museo de Cerámica González Martí, Valencia. **Fig. 14**: Martínez Caviró 1968, figs. 294–9; Museo de Artes Decorativas, Madrid; Museo de Cerámica González Martí, Valencia. **Fig. 15**: Martínez Caviró 1968, figs. 294–9; Museo de Artes Decorativas, Madrid; Museo de Cerámica González Martí, Valencia. **Fig. 16**: Martínez Caviró 1968, figs. 294–9; Museo de Artes Decorativas, Madrid; Museo de Cerámica González Martí, Valencia. **Fig. 17**: Martínez Caviró 1968, figs. 294–9; Museo de Artes Decorativas, Madrid; Museo de Cerámica González Martí, Valencia. **Fig. 18**: Martínez Caviró 1968, figs. 294–9; Museo de Artes Decorativas, Madrid; Museo de Cerámica González Martí, Valencia. **Fig. 19**: Ainaud de Lasarte 1952, 178, fig. 493; Barber 1915b, fig. 17 (44); González Martí 1944: Vol. I, 589, fig. 697; 596, fig. 701; Museo de Cerámica, Barcelona. **Fig. 20**: Ainaud de Lasarte 1952, 178, fig. 493; 172, fig. 474; González Martí 1944: Vol. I, 596, fig. 701; 589, fig. 697; Lister and Lister 1969, 7; Museo de Cerámica, Barcelona. **Fig. 21**: Museo de Cerámica, Barcelona. **Figs. 22, 22a** (top view), **22b** (side view): Ainaud de Lasarte 1952, 176, 179, fig. 501; Museo de Artes Decorativas, Madrid; Museo de Cerámica, Barcelona. **Fig. 23**: Ainaud de Lasarte 1952, 176, 179, fig. 501; Lister and Lister 1969, 6; Museo de Artes Decorativas, Madrid; Museo de Cerámica, Barcelona. **Fig. 24**: Ainaud de Lasarte 1952, 176, 179, fig. 501; Museo de Artes Decorativas, Madrid; Museo de Cerámica, Barcelona. **Fig. 25**: Ainaud de Lasarte 1952, 176, 179, fig. 501; Museo de Artes Decorativas, Madrid; Museo de Cerámica, Barcelona. **Fig. 26**: Museo de Artes Decorativas, Madrid. **Fig. 27**: Ainaud de Lasarte 1952, 263, fig. 688; Frothingham 1944b, 31; Museo de Arqueología, Madrid. **Fig. 28**: Instituto Valencia de Don Juan, Madrid; Martínez Caviró 1968, 48, 59, 60, figs. 78, 79, 82. **Fig. 29**: Instituto Valencia de Don Juan, Madrid; Martínez Caviró 1968, fig. 80. **Fig. 30**: Ainaud de Lasarte 1952, 137, figs. 367–9; Batllori Munné and Llubiá Munné 1949, figs. 148, 149a, 150a, b; González Martí 1954, fig. 11; Martínez Caviró 1969, fig. 14a, b; Museo de Cerámica, Barcelona. **Fig. 31**: Batllori Munné and Llubiá Munné 1949, figs. 168–71, 200–01; Museo de Cerámica, Barcelona; Museo Nacional de Cerámica González Martí, Valencia; Subias Galter 1948, 276, fig. 155. **Fig. 32**: Batllori Munné and Llubiá Munné 1949, 78, fig. 249a, b; Deagan 1987, fig. 4.34; Museo de Cerámica, Barcelona. **Fig. 33**: Batllori Munné and Llubiá Munné 1949, 78, fig. 249a, b; Deagan 1987, fig. 4.34; Museo de Cerámica, Barcelona. **Fig. 35**: Batllori Munné and Llubiá

Munné 1949, 236–7, figs. 222b, 223a, c; Museo de Cerámica, Barcelona. **Fig. 36:** Ainaud de Lasarte 1952, 291, figs. 776–7; Batllori Munné and Llubiá Munné 1949, figs. 236a, b. **Fig. 37:** Frothingham 1944b, 111, fig. 104; Lister and Lister 1969, 9; Martínez Caviró 1968, figs. 155, 156; 1969, 111, fig. 10a; Museo de Arqueología, Madrid; Museo de Cerámica, Barcelona; Museo de Cerámica Ruíz Luna, Talavera de la Reina. **Fig. 38:** Frothingham 1944b, 110, fig. 103; Martínez Caviró 1968, figs. 203–05; Museo de Cerámica Ruíz Luna, Talavera de la Reina. **Fig. 39:** Barber 1915b, fig. 1 (2); Frothingham 1944b, 130, fig. 118; Lister and Lister 1969, 10; Martínez Caviró 1968, 137, fig. 182; 1969, figs. 20a, b, 21a; Museo de Cerámica Ruíz Luna, Talavera de la Reina. **Fig. 40:** Ainaud de Lasarte 1952, 272, fig. 726; 273, fig. 732; Barber 1908, fig. 16 middle; Frothingham 1944b, 58, fig. 51; 130, fig. 118; Martínez Caviró 1969, figs. 20b, 21a. **Figs. 41, 41b** (opposite side): Ainaud de Lasarte 1952, 274, fig. 735; Frothingham 1944b, 52, fig. 44; Martínez Caviró 1969, fig. 34a; Museo de Arqueología, Madrid. **Figs. 42, 42b** (opposite side): Ainaud de Lasarte 1952, 262, fig. 697; Martínez Caviró 1968, 142, figs. 192–3; Museo de Artes Decorativas, Madrid; Museo de Cerámica Ruíz Luna, Talavera de la Reina. **Fig. 43:** Ainaud de Lasarte 1952, 268, fig. 718; Martínez Caviró 1968, 143, fig. 196; Museo de Cerámica Ruíz Luna, Talavera de la Reina. **Fig. 44:** Lister and Lister 1969, 8; Martínez Caviró 1969, fig. 37a; Museo de Cerámica Ruíz Luna, Talavera de la Reina. **Fig. 45:** Ainaud de Lasarte 1952, 277, fig. 738; Barber 1911, fig. 161; 1915b, fig. 5 (9); Frothingham 1944b, 129, fig. 117; Museo de Cerámica Ruíz Luna, Talavera de la Reina. **Fig. 46:** Ainaud de Lasarte 1952, 263, fig. 222; Frothingham 1944b, 118, fig. 109; 119, fig. 110; 120, fig. 111; Lister and Lister 1969, 8; Martínez Caviró 1969, fig. 37a. **Fig. 47:** Ainaud de Lasarte 1952, 278, fig. 746; Frothingham 1944b, 134–5, figs. 121–2. **Figs. 48, 48a** (top view), **48b** (side view): Ainaud de Lasarte 1952, 280, figs. 752–3; Barber 1908, figs. 4–5; 1915b, fig. 12 (39); Frothingham 1944b, 154, figs. 140–01; Museo de Cerámica Ruíz Luna, Talavera de la Reina. **Fig. 49:** Ainaud de Lasarte 1952, 281, figs. 752–3; Barber 1915b, fig. 12 (39); Frothingham 1944b, 152–3, figs. 138–9; 154–5, figs. 140–01; Lister and Lister 1969, 11; Martínez Caviró 1969, fig. 48b; Museo de Cerámica Ruíz Luna, Talavera de la Reina. **Figs. 50, 50b** (opposite side): Ainaud de Lasarte 1952, 280, figs. 752–3, 755; Museo de Cerámica Ruíz Luna, Talavera de la Reina. **Fig. 51:** Ainaud de Lasarte 1952, 280–01, fig. 757; Frothingham 1944b, 150, figs. 136–7; Lister and Lister 1969, 11; Martínez Caviró 1969, fig. 47b; Museo de Cerámica Ruíz Luna, Talavera de la Reina. **Fig. 52:** Ainaud de Lasarte 1952, 280, fig. 754; Lister and Lister 1969, 11; Museo de Cerámica Ruíz Luna, Talavera de la Reina. **Fig. 53:** Pleguexuelo Hernández 1985, figs. 87, 91–92. **Fig. 54:** Pleguexuelo Hernández 1985, figs. 87, 91–92. **Fig. 55:** Barber 1915b, fig. 3 (5); Martínez Caviró 1969, figs. 31, 38; Museo de Artes y Costumbres Populares, Sevilla. **Fig. 56:** Ainaud de Lasarte 1952, 223, figs. 592–5; 256, figs. 680–01; Instituto Valencia de Don Juan, Madrid; Martínez Caviró

1968, figs. 150–51, 169; 1969, figs. 12a, 17a; Pleguexuelo Hernández 1985, figs. 16, 18. **Fig. 57:** Barber 1915b, figs. 4 (7), 5 (8), 7 (13); Frothingham 1944b, 119, fig. 110; 162, fig. 146; 165, fig. 149; 167, fig. 151; Gestoso y Pérez Collection, Museo de Bellas Artes, Sevilla. **Figs. 58, 58a** (top view), **58b** (side view): Ainaud de Lasarte 1952, 232, fig. 620; Museo Casa de los Tiros, Granada. **Fig. 59:** Lister and Lister 1969, 6; Museo Casa de los Tiros, Granada. **Figs. 60, 60a** (top view), **60b** (side view): Lister and Lister 1969, 6; Museo Casa de los Tiros, Granada. **Figs. 63, 63b, c, d** (opposite sides): Artes de México 1971, 74, 84, 90, 91; Barber 1908, 55, fig. 12; 65, fig. 20; Garner 1954, figs. 19, 51, 54; Lister and Lister 1987, fig. 141; Museo Bello, Puebla de los Angeles; Pope 1956, fig. 68 (29.399); fig. 42 (29.312). **Fig. 64:** Barber 1908, fig. 15; Cervantes 1939, Vol. I: 175, 183; Museo Bello, Puebla de los Angeles; Peón Soler and Cortina Ortega 1973, figs. 8, 10. **Fig. 65:** Ayers 1969, fig. 137; Garner 1954, figs. 3, 63, 69; Museo Bello, Puebla de los Angeles; Phillips 1956, fig. 12; Pope 1956, fig. 53 (29.447, 29.448). **Fig. 66:** Museo Bello, Puebla de los Angeles; Peón Soler and Cortina Ortega 1973, fig. 3. **Fig. 67:** Artes de México 1971, 74, 84, 90, 91; Barber 1915a, fig. 10 (14); Cervantes 1939, Vol. I: 161; Charleston 1968, fig. 459; Goggin 1968, fig. 17d; Lister and Lister 1987, fig. 142b; Museo Bello, Puebla de los Angeles; Pérez de Salazar Collection, Mexico City. **Fig. 68:** Barber 1915a, fig. 7 (11); 1915b, fig.s 13 (40), 14 (41); Charleston 1968, fig. 511; Martínez Caviró 1969, figs. 34a, 35b; McQuade 1999, Pls. 17–19; Museo Bello, Puebla de los Angeles. **Figs. 69, 69b** (reverse): Cervantes 1939, Vol. I: 161, 185; Lister and Lister 1987, fig. 142c; McQuade 1999, Pl. 14; Museo Bello, Puebla de los Angeles; Pérez de Salazar Collection, Mexico City; Welty 1999, 46. **Fig. 70:** Artes de México 1971, 74, 84, 90, 91; Barber 1915a, fig. 3 (6); Goggin 1968, fig. 16h; Museo Bello, Puebla de los Angeles; Pérez de Salazar Collection, Mexico City. **Figs. 71, 71b** (reverse): Lister and Lister 1987, fig. 142c; McQuade 1999, Pl. 14; Museo Bello, Puebla de los Angeles; Pérez de Salazar Collection, Mexico City. **Fig. 72:** Artes de México 1971, 90; Museo Bello, Puebla de los Angeles. **Fig. 73:** Artes de México 1971, 74, 84, 85, 90, 91; Goggin 1968, fig. 17d; Museo Bello, Puebla de los Angeles; Pérez de Salazar Collection, Mexico City. **Fig. 74:** Barber 1908, 73, fig. 29; 1911: 139, fig. 49; Cervantes 1939, Vol. I: 241, 287; González Martí 1944, Vol. I: fig.s 302–03; Museo Bello, Puebla de los Angeles; Museo de Artes y Costumbres Populares, Sevilla; Museo del Virreinato, Tepotzotlán; Pérez de Salazar Collection, Mexico City. **Fig. 75:** Barber 1908, fig. 19; Charleston 1968, fig. 511; Martínez Caviró 1969, figs. 34a, 35b; Museo Bello, Puebla de los Angeles; Pérez de Salazar Collection, Mexico City. **Fig. 76:** Charleston 1968, fig. 511; Goggin 1968, fig. 18a; McQuade 1999, Pl. 18; Museo Bello, Puebla de los Angeles. **Fig. 77:** Artes de México 1971, 74, 84, 90, 91; Barber 1915a, fig. 9 (13); Cervantes 1939, Vol. I: 201, 215; McQuade 1999, Pl. 19; Museo Bello, Puebla de los Angeles; Peón Soler and Cortina Ortega 1973, 13; Pérez de Salazar Collection, Mexico City. **Fig. 78:** Museo Bello,

Puebla de los Angeles; Pérez de Salazar Collection, Mexico City; Toussaint 1967, fig. 243; Welty 1999, 52. **Fig. 79:** Museo Bello, Puebla de los Angeles; Pérez de Salazar Collection, Mexico City. **Fig. 80:** Barber 1915a, fig. 8 (12); Garner 1954, fig. 33a; Museo Bello, Puebla de los Angeles; Phillips 1956, fig. 16; Pope 1956, fig. 87 (29.371), fig. 95 (29.376). **Fig. 81:** Barber 1915a, fig. 8 (12); Museo Bello, Puebla de los Angeles. **Fig. 82:** Cervantes 1939, Vol. I: 193, 215, 221, 223, 245; Museo Bello, Puebla de los Angeles; Phillips 1956, fig. 16. **Fig. 83:** Cervantes 1939, Vol. I: 193, 215, 221, 223, 245; Museo Bello, Puebla de los Angeles. **Fig. 84:** Barber 1906, fig. 11; 1908, 59, fig. 15; 1915a, fig. 9 (13); Museo Bello, Puebla de los Angeles; Pérez de Salazar Collection, Mexico City. **Fig. 85:** Goggin 1968, fig. 17a; Museo Bello, Puebla de los Angeles; Peón Soler and Cortina Ortega 1973, 16. **Fig. 86:** Barber 1908, 56, fig. 13; Museo Bello, Puebla de los Angeles. **Fig. 87:** Barber 1911, fig. 6, 27b; fig. 21, 27a; 1915a, fig. 6 (10); Cervantes 1939, Vol. I: 233, 235, 246; Museo Bello, Puebla de los Angeles; Toussaint 1967, fig. 243; Welty 1999, 52. **Fig. 88:** Barber 1908, fig. 25; 1911, figs. 22, 71; 1915a, fig. 6 (10); Cervantes 1939, Vol. I: 233, 235, 246; Museo Bello, Puebla de los Angeles; Peón Soler and Cortina Ortega 1973, fig. 15; Toussaint 1967, fig. 243; Welty 1999, 52. **Fig. 89:** Goggin 1968, fig. 15c; Museo Bello, Puebla de los Angeles. **Fig. 90:** Museo Bello, Pueblo de los Angeles; Pérez de Salazar Collection, Mexico City. **Fig. 91:** Museo Bello, Puebla de los Angeles. **Fig. 92:** Barber 1908, 69, fig. 26; Museo Bello, Puebla de los Angeles. **Fig. 93:** Museo Bello, Puebla de los Angeles. **Fig. 94:** Cervantes 1939, Vol. I: 221, 223, 245; Museo Bello, Puebla de los Angeles; Pérez de Salazar Collection, Mexico City. **Fig. 95:** Museo Bello, Puebla de los Angeles. **Fig. 96:** Museo Bello, Puebla de los Angeles. **Fig. 97:** Museo Bello, Puebla de los Angeles. **Fig. 98:** Museo Bello, Puebla de los Angeles. **Fig. 99:** Cervantes 1939, Vol. I: 221, 223; Museo Bello, Puebla de los Angeles. **Fig. 100:** Cervantes 1939, Vol. I: 223, 243; Museo Bello, Puebla de los Angeles. **Fig. 101:** Cervantes 1939, Vol. I: 223; Museo Bello, Puebla de los Angeles. **Fig. 102:** Cervantes 1939, Vol. I: 215, 217, 253, 286, 287; Barber 1915a, fig. 11 (15); Museo Bello, Puebla de los Angeles. **Fig. 103:** Museo Bello, Puebla de los Angeles; Pérez de Salazar Collection, Mexico City. **Fig. 104:** Museo Bello, Puebla de los Angeles; Pérez de Salazar Collection, Mexico City. **Fig. 105:** Cervantes 1939, Vol. I: 263; Museo Bello, Puebla de los Angeles; Toussaint 1967, fig. 160. **Fig. 106:** Barber 1908, fig. 15, lower rt.; 1915a, fig. 2 (4); Cervantes 1939, Vol. I: 243; Martínez Caviró 1968, figs. 251–4; McQuade 1999, Pl. 11 (left); Museo Bello, Puebla de los Angeles; Pérez de Salazar Collection, Mexico City. **Fig. 107:** Barber 1911, fig. 9 (17); 1915a, fig. 1 (2); Museo Bello, Puebla de los Angeles; Pérez de Salazar Collection, Mexico City. **Figs. 108, 108b** (opposite side): Barber 1911,

fig. 9 (17); Cervantes 1939, Vol. I: 236; Museo Bello, Puebla de los Angeles; Pérez de Salazar Collection, Mexico City. **Fig. 109:** Museo Bello, Puebla de los Angeles. **Fig. 110:** Barber 1911, fig. 10 (19); Cervantes 1939, Vol. I: 263, top center; Museo Bello, Puebla de los Angeles. **Fig. 111:** Museo Bello, Puebla de los Angeles. **Fig. 112:** Martínez Caviró 1968, fig. 219; Museo Bello, Puebla de los Angeles; Pérez de Salazar Collection, Mexico City. **Fig. 113:** Barber 1911, fig. 36 (146); Museo Bello, Puebla de los Angeles. **Fig. 114:** McQuade 1999, Pl. 21; Museo Bello, Puebla de los Angeles. **Fig. 115:** Barber 1911, figs. 117, 126–9; Cervantes 1939, Vol. I: 249, 253; Museo Bello, Puebla de los Angeles. **Fig. 116:** Barber 1911, figs. 117, 126–9; Cervantes 1939, Vol. I: 249, 253; Museo Bello, Puebla de los Angeles. **Fig. 117:** Museo Bello, Puebla de los Angeles. **Fig. 118:** Museo Bello, Puebla de los Angeles. **Fig. 119:** Barber 1911, Figs. 49 (104), 45 (114); Museo Bello, Puebla de los Angeles. **Fig. 120:** Barber 1911, fig. 14 (107); Museo Bello, Puebla de los Angeles. **Fig. 121:** Museo Bello, Puebla de los Angeles; Pérez de Salazar Collection, Mexico City. **Fig. 122:** Barber 1911, fig. 8 (91); Museo Bello, Puebla de los Angeles. **Fig. 123:** Cervantes 1939, Vol. I: 263; Museo Bello, Puebla de los Angeles; Pérez de Salazar Collection, Mexico City. **Fig. 124:** Museo Bello, Puebla de los Angeles. **Fig. 125:** Deagan 1987, figs. 4.50–4.51; Garner 1954, fig. 65; Museo Bello, Puebla de los Angeles; Phillips 1956, figs. 31, 53. **Fig. 126:** Museo Bello, Puebla de los Angeles. **Fig. 127:** Deagan 1987, figs. 4.50–4.51; Museo Bello, Puebla de los Angeles. **Fig. 128:** Museo Bello, Puebla de los Angeles. **Fig. 129:** Barber 1915a, fig. 4 (7); Cervantes 1939, Vol. I: 285; Museo Bello, Puebla de los Angeles; Peón Soler and Cortina Ortega 1973, fig. 25. **Fig. 130:** Museo Bello, Puebla de los Angeles; Peón Soler and Cortina Ortega 1973, fig. 20. **Fig. 131:** Cervantes 1939, Vol. I: 281; Museo Bello, Puebla de los Angeles. **Fig. 132:** Barber 1911, figs. 34 (90), 35 (92, 140); Cervantes 1939, Vol. I: 286–7; McQuade 1999, Pl. 23; Museo Bello, Puebla de los Angeles. **Fig. 133:** McQuade 1999, Pl. 23; Museo de la Alhóndiga, Guanajuato; Rubín de la Borbolla 1961, 95. **Fig. 134:** McQuade 1999, Pl. 23; Museo de la Alhóndiga, Guanajuato; Rubín de la Borbolla 1961, 95. **Fig. 135:** Museo de la Alhóndiga, Guanajuato; Rubín de la Borbolla 1961, 95; Pérez de Salazar Collection, Mexico City. **Fig. 136:** Museo de la Alhóndiga, Guanajuato. **Fig. 137:** McQuade 1999, Pl. 23; Museo de la Alhóndiga, Guanajuato. **Fig. 138:** McQuade 1999, Pl. 23; Museo de la Alhóndiga, Guanajuato; Rubín de la Borbolla 1961, 95. **Figs. 139, 139b** (side view): Museo de la Alhóndiga, Guanajuato. **Fig. 140:** Museo de la Alhóndiga, Guanajuato; Rubín de la Borbolla 1961, 95. **Fig. 141:** Museo de la Alhóndiga, Guanajuato; Rubín de la Borbolla 1961, 95.

Index of Illustrations
by figure number